Cutting Edge
Web Design

THE NEXT GENERATION

CAPE TOWN
OLYMPIC
VOICE OF

ROCKPORT PUBLISHERS
GLOUCESTER, MASSACHUSETTS

ROCKPORT
PUBLISHERS

BOOK
 Design: Interactivist Designs/Daniel Donnelly
 Front Cover Typography: Daniel Donnelly
 Back Cover Design: Florian Brody/Sarah Anastasia Hahn
 Design Associate: Christian Memmott

 Introduction: David Carson/David Carson Design
 Essays: Auriea Harvey/Entropy8, David Decheser and Eric Dinyer/Dreamless Studios
 Simon Dixon/Attik Design, Florian Brody and Sara Anastasia Hahn/BRODYNewmedia

CD-ROM
 Design: Interactivist Designs
 Production: Jerry Garcia
 Programming: William Donnelly

WEBSITE
 http://www.inyourface.com

First published in the United States of America by:
Rockport Publishers, Inc.
33 Commercial Street
Gloucester, Massachusetts 01930-5089
Telephone: (978) 282-9590
Facsimile: (978) 283-2742

Distributed to the book trade and art trade in the United States by:
North Light Books, an imprint of
F & W Publications
1507 Dana Avenue
Cincinnati, Ohio 45207
Telephone: (800) 289-0963

Other Distribution by:
Rockport Publishers, Inc.
Gloucester, Massachusetts 01930-5089

ISBN 1-56496-419-1
10 9 8 7 6 5 4 3 2 1

Printed in China.

THE NEXT GENERATION

Preface

About a year ago I started collecting Websites for a series of web design books—while sorting through thousands of bookmarks and links, it became clear that some sites had a certain quality, or edge, absent in other sites. The design of these sites, mostly personal or self-promotional, were perfectly executed, highly expressive, and individualistic; they extended the Web by disregarding existing Web and print design conventions. They often used JavaScript, Shockwave, GIF89a animations, or other Web tools to make the computer screen do more than what we've come to expect from yesterday's Web. But more than the tools they use, the inherent design of these sites expresses the unconventional—be it in terms of color, typography, imagery, or interactivity. These sites seem to me to be the Web of the next generation (a generation that is still defining itself as technology evolves). These sites weren't easy to locate at first, but as the months pass, these kinds of sites (thankfully) become easier to find.

Each site exemplifies "cutting edge" in a different way—though often the term is relative. The Pepsi World site (page 62), for example, features a radical design that is surprising for a corporate site, yet it serves the purpose of conveying a product or brand image. The Jodi.org site (page 146) is cutting-edge, but conveys no literal content and no discernible message—viewers add their own meaning, or perhaps, as I suggest, the content remains within the "mind" of the computer.

The essays featured in the book can help you come to terms with your own definition of cutting-edge web design. Acclaimed print designer David Carson explores this issue in the introduction. Carson broke ground for a new style of design and typography for print over a decade ago and has remained influential ever since. More than a few of the sites here pay homage, overtly or not, to his influence. Each of the four sections— "Design Firms," "Commercial Websites," "Self-Promotion," and "Global Websites"—is opened by a short essay written and designed by well-known cutting-edge print and web designers.

The companion CD-ROM offers direct Web access to the seventy-two Websites featured here, plus more than two hundred additional sites that comprise, each in their own way, the next generation of Web design. In the process of writing and designing this book I've gained a new appreciation for Web design. I hope you will find this collection to be a valuable resource for your own creative expression.

—Daniel Donnelly

content

introduction

DAVID CARSON

Why Are You Holding This Book?

I came across a surprising development recently while judging a student print design competition in New York. Young designers were beginning to appropriate Web-page designs into their print work. Magazine spreads, for instance, looked alarmingly similar to some appalling homepages I've seen. I was caught off guard since, traditionally, the best print design has always driven other media into more experimental planes.

Print's role has changed. As David Byrne says, "Print will no longer be obliged to simply carry the news." But while print design lumbers along in a rather confused state, Web and Internet design are becoming the media of change, growth, and innovation.

Within these pages of "pages" are some of the designers at the frontier of this new development. Some will eventually be seen as originators and early developers of quite possibly the most exciting realm of design—one that will change dramatically in the next few years (it's changing as you read this) and will succeed, in part, because of the groundwork created by these digital pioneers.

Far more than simply "information architects," the designers represented here realize that the Net is not print. It demands a different approach—one that takes into account not only the medium itself, but the subject matter, concept, and intended audience.

But even as graphic design evolves into this new direction, certain aspects will remain constant. The same folks who have been doing boring print work over

the years will now graduate to doing boring Internet work. While clarity and simplicity often distinguish the most successful sites, it's an amazingly thin line between "simple and power-ful" and "simple and boring," a difficult line that few transcend.

It's been said these are the black-and-white television days of the Internet. With this book, though, we begin to see the flicker of technology moving forward and, unlike television when it went to color, intelligence and sophistication are often the rule. Some of the sites in this book already have changed and evolved. Such is the nature of the beast.

If you're a Website designer, read the various descriptions of the sites. Absorb, reflect, then put the book down. Turn your screen on (remember, this work was never intended to be printed) and dig deep within, to some unex-plored personal space for inspiration and direction. And have some fun.

The late William Burroughs, in the experimental film *The End of Print*, said, "All serious and dedicated artists attempt the miraculous: the creation of life." Look closely at the work presented in these pages. Heartbeats can be heard.

—David Carson

dcarson@earthlink.net

Cutting Edge
Design Firms

(TABULA RASA

BY FLORIAN BRODY & SARAH ANASTASIA HAHN)

Aurea prima sata est ætas, quae vindice nullo,
The golden age was first; when Man yet new,
sponte sua, sine lege fidem rectumque colebat.
No rule but uncorrupted reason knew,
And, with a native bent, did good pursue.
Unforc'd by punishment, un-aw'd by fear,
His words were simple, and his soul sincere.

From Ovid, *Metamorphoses, book I, Ætas
aurea;* translated into English verse under the
direction of Sir Samuel Garth, 1717.

THE GOLDEN AGE OF DESIGN is neither gone, nor has it arrived: observing the desktop-publishing disasters on one side and the incredible potential of digital design tools on the other, we investigate the relations between digital media—both as a creative tool and as delivery medium—and design. By combining the grids of the Golden Mean with the layering capabilities of digital design software, we aim to understand the way design communicates in new media and how the wisdom of traditional forms can be integrated into a dynamic non-linear form. We need to break up the old structures—as gently as possible—and to leave space for new forms to grow within both new and traditional media. ¶ Being on the cutting edge is always somewhat unstable—one longs for it, like traces of a strange and sweet scent that is also repulsive like the smell of decay. One follows the scent unconsciously, embarrassed and not even admitting the attraction to oneself. Looking for the "other," the unknown, is necessarily an outside view, a view from abroad, a process of observing, never a state of being. Cutting-edge design is always an investigation into form, structure, and function—like children cutting open their favorite teddy bear to find the underlying structure beneath a perfect surface. There is something very æsthetically clean about surgery, about a perfect cut that reveals a fresh emotion glittering in the sunlight like seaweed on wet sand. ¶ Are we advancing in design because of advances in technology? Is cutting-edge design necessarily connected to state-of-the-art technology? If yes, what is the state-of-the-art of design? It is not the computer that initiates cutting-edge design but the social and cultural shifts implied by its usage. Understand the technological implications of a new medium, work within the given limitations and at the same time break the rules that have not yet been fully established. ¶ We need to go much further. SCHŒNGEIST™, a conceptual model for design, integrates old and new elements. "The image of man in the 21st century needs to be shown with enough clarity to allow man to recognize and learn about himself and life in the new century." (WIM WENDERS, TOKYO-GA, A FILMED DIARY, 1995) SCHŒNGEIST™ as the Æesthete—the one, who longs for life, who wants to lo

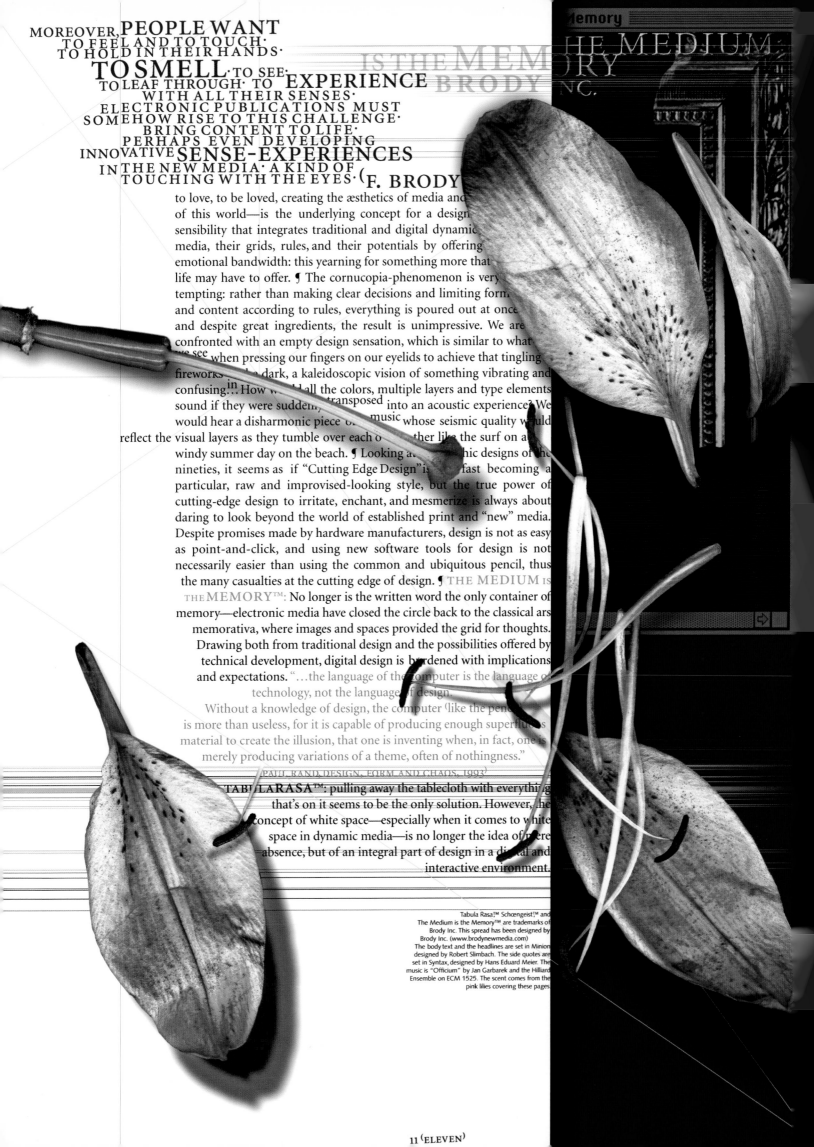

MOREOVER, **PEOPLE WANT**
TO FEEL AND TO TOUCH·
TO HOLD IN THEIR HANDS·
TO SMELL·TO SEE·
TO LEAF THROUGH· TO **EXPERIENCE**
WITH ALL THEIR SENSES·
ELECTRONIC PUBLICATIONS MUST
SOMEHOW RISE TO THIS CHALLENGE·
BRING CONTENT TO LIFE·
PERHAPS EVEN DEVELOPING
INNOVATIVE **SENSE-EXPERIENCES**
IN THE NEW MEDIA· A KIND OF
TOUCHING WITH THE EYES·(F. BRODY

IS THE MEMORY
BRODY

THE MEDIUM
RY
NC.

to love, to be loved, creating the æsthetics of media and
of this world—is the underlying concept for a design
sensibility that integrates traditional and digital dynamic
media, their grids, rules, and their potentials by offering
emotional bandwidth: this yearning for something more that
life may have to offer. ¶ The cornucopia-phenomenon is very
tempting: rather than making clear decisions and limiting form
and content according to rules, everything is poured out at once,
and despite great ingredients, the result is unimpressive. We are
confronted with an empty design sensation, which is similar to what
we see when pressing our fingers on our eyelids to achieve that tingling
fireworks in the dark, a kaleidoscopic vision of something vibrating and
confusing... How would all the colors, multiple layers and type elements
sound if they were suddenly transposed into an acoustic experience? We
would hear a disharmonic piece of music whose seismic quality would
reflect the visual layers as they tumble over each other like the surf on a
windy summer day on the beach. ¶ Looking at graphic designs of the
nineties, it seems as if "Cutting Edge Design" is fast becoming a
particular, raw and improvised-looking style, but the true power of
cutting-edge design to irritate, enchant, and mesmerize is always about
daring to look beyond the world of established print and "new" media.
Despite promises made by hardware manufacturers, design is not as easy
as point-and-click, and using new software tools for design is not
necessarily easier than using the common and ubiquitous pencil, thus
the many casualties at the cutting edge of design. ¶ THE MEDIUM IS
THE MEMORY™: No longer is the written word the only container of
memory—electronic media have closed the circle back to the classical ars
memorativa, where images and spaces provided the grid for thoughts.
Drawing both from traditional design and the possibilities offered by
technical development, digital design is burdened with implications
and expectations. "...the language of the computer is the language of
technology, not the language of design
Without a knowledge of design, the computer (like the pencil)
is more than useless, for it is capable of producing enough superfluous
material to create the illusion, that one is inventing when, in fact, one is
merely producing variations of a theme, often of nothingness."
PAUL RAND, DESIGN, FORM AND CHAOS, 1993

TABULA RASA™: pulling away the tablecloth with everything
that's on it seems to be the only solution. However, the
concept of white space—especially when it comes to white
space in dynamic media—is no longer the idea of mere
absence, but of an integral part of design in a digital and
interactive environment.

BAU-DA DESIGN LAB INC

SELF-PROMOTION

The Bau-Da Design Lab Inc. Website displays simplicity with an edge. Bold, retro typography, an old-fashioned vacuum tube image, and a basic color scheme combine to demonstrate a clear sense of style and confidence.

The splash page sequence to the right shows how the "Design-o-matic" logo is animated using two halves of a butterfly shape. JavaScripting allows the Bau-Da vacuum tube to cycle through two glow levels as though heating up and cooling down. Viewers click on the tube to link to the home page, below.

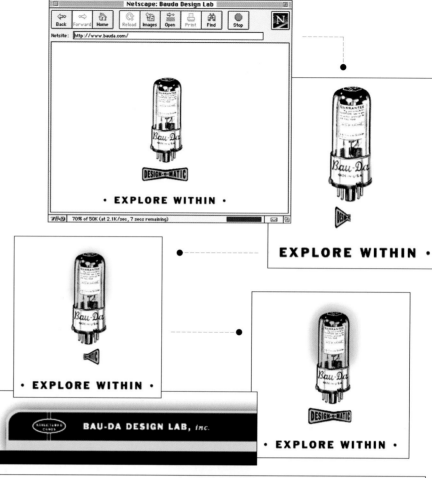

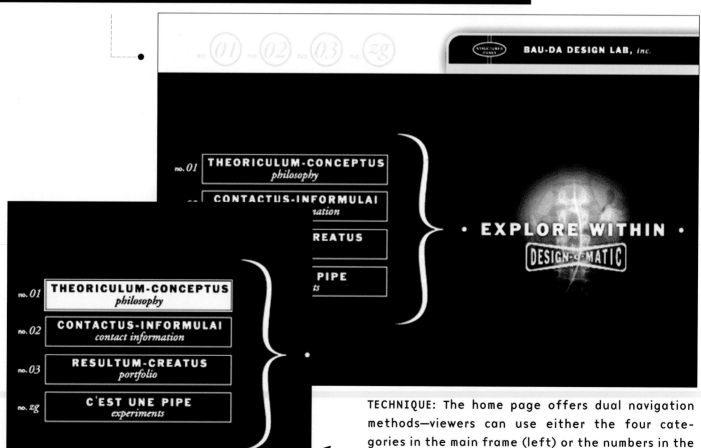

TECHNIQUE: The home page offers dual navigation methods—viewers can use either the four categories in the main frame (left) or the numbers in the upper frame (above). Clicking on the Bau-Da Design tab returns viewers to the home page. All the buttons and categories use JavaScript rollovers to highlight when the cursor rolls over them.

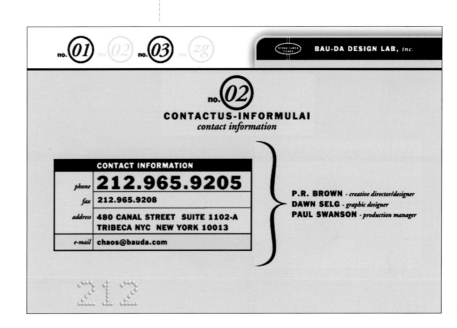

Design Firm: Bau-Da Design Lab Inc.

Design: P. R. Brown

Programming: Eric Brown/Readynetgo

Features: GIF89a animation, JavaScript

BLIND VISUAL PROPAGANDA

SELF-PROMOTION

Blind Visual Propaganda uses a highly interactive home page to pull viewers into the site. The designers created Shockwave buttons and slider bars that give visitors a satisfying sense of visual feedback and control.

For example, the slider bar to the right of the eye chart (right) changes what the viewer sees from "Blind.com" to "Visual Propaganda." Similarly, clicking the "T" button at the right of the page causes the vertical column of dashes to resolve into the company's phone number.

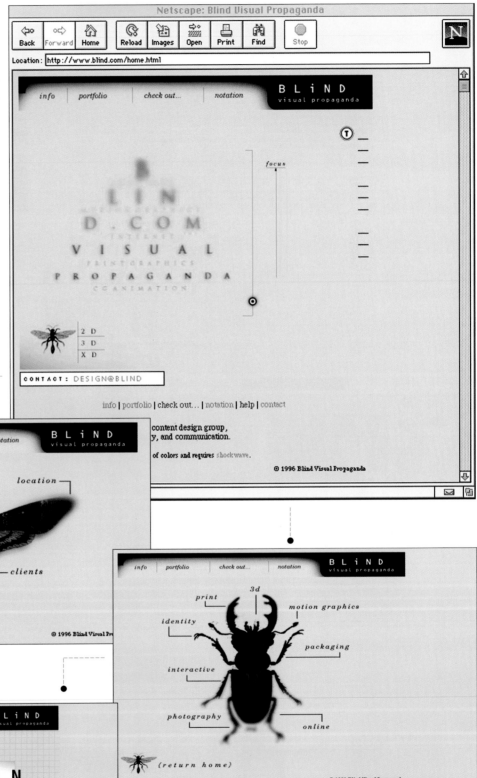

Insects are used as a theme throughout the site—clicking on the insects in the image at left links viewers to a corresponding page that is itself a navigation system linking to more pages. The blurriness applied to the lower legs and abdomen of the insect above contrasts with the relative clarity of the rest of the insect, recalling the dynamic viewers experienced with the eye chart and telephone number on the home page.

TECHNIQUE: The dynamic between clarity and fuzziness is again demonstrated with the cycling of the company's name in the navigation bar (left).

The images below form a pulsating animated sequence for the splash page. Viewers click on the word-image to enter the site.

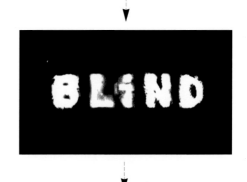

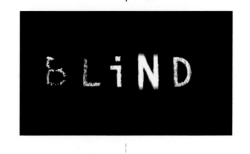

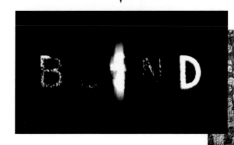

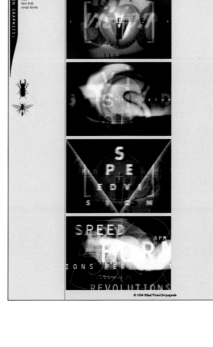

untitled 1

untitled 2

untitled 3

untitled 4

untitled 5

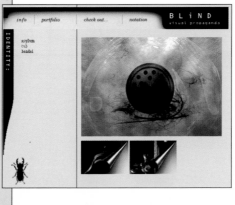

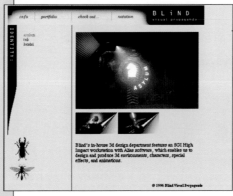

Blind's in-house 3d design department features an SGI High Impact workstation with Alias software, which enables us to design and produce 3d environments, characters, special effects, and animations.

@ 1996 Blind Visual Propaganda

Design Firm: Blind Visual Propaganda
Design: Christopher Do, Jessie Huang,
Michelle Dougherty
Photography: Fiel Valdez
Programming: Arthur Do
Features: GIF89a animation,
Shockwave

BRODYNEWMEDIA

SELF-PROMOTION

The BRODYnewmedia Website explores the ebb and flow of content within a variety of areas—print, music, visual art. Black backgrounds with subtle shadow images and minimal color characterize the opening pages.

After viewers click on the splash screen (right), a new window sized for optimal viewing opens with a scrolling horizontal navigation frame (below).

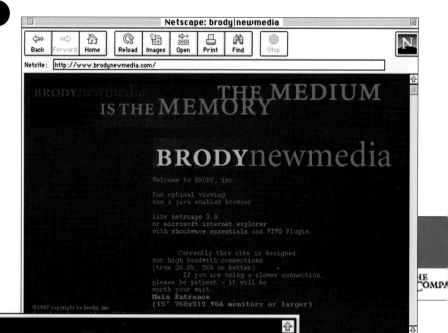

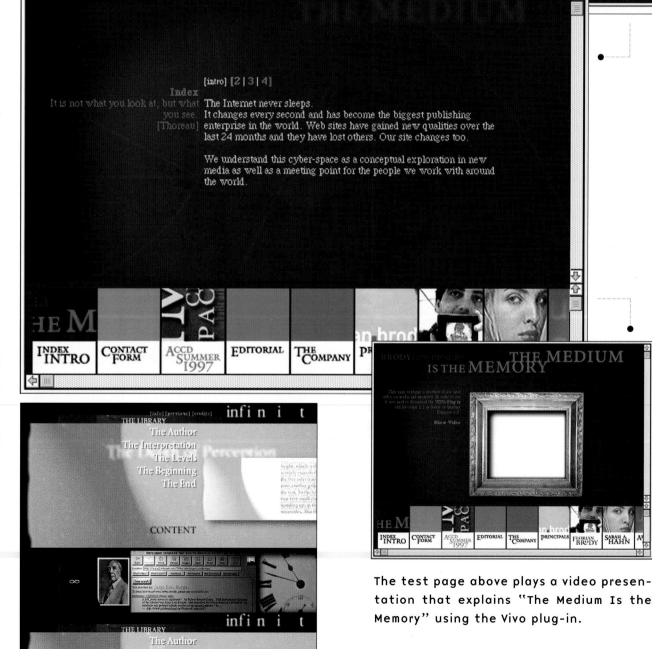

The test page above plays a video presentation that explains "The Medium Is the Memory" using the Vivo plug-in.

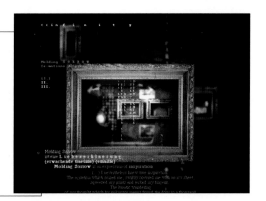

TECHNIQUE: Viewers access all areas of the site via a scrolling strip at the bottom of each screen. The navigation strip resides in its own frame at the bottom of every page in the site, providing a highly durable scheme to begin and continue exploring the content of the site.

How much will the image replace the word, how much the digital word the world? a book is a book is a book was a book is a library: Like Ariadna I am retracing the labyrinthian world of the www, which Jorge Luis Borges foresaw, when he wrote "The Library of Babel". By meandering and weaving my red thread through the world of literature, I am designing electronic books to be experienced both from the inside and the outside. I am obsessed by books. I like how they sound, smell and feel.

Sarah Anastasia Hahn is Principal and Creative Director of **brodynewmedia**. She is a designer, writer and artist specialising in both computergraphics and animation as well as the concept of the book. >

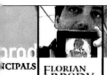

Project: The Medium Is the Memory
Design Firm: BRODYnewmedia
Design: Florian Brody, Sarah Anastasia Hahn
Features: GIF89a animation, Vivo, JavaScript

SPIROLLEL DESIGN

SELF-PROMOTION

The simplicity of Spirollel's Website shows that a well-designed site doesn't always have to incorporate all the bells and whistles technology has to offer. A basic color palette and generous white space facilitate an extremely fast download. The main navigation element is the navigation frame (below), which incorporates simple JavaScript rollovers. When the viewer rolls the cursor over a small square, the title of the directed page displays in the bottom area of the frame and a thin line directs the viewer's focus toward the descriptive text block.

Spirollel Design specializes in the design, production, and maintenance of creative websites. Our work is meant to stand out. Our clients must have open minds, willing to listen to our ideas.
It is more convenient to meet a customer in person, but phone conversations and e-mail allow us to interact with clients not from the New Orleans area.

contact us:

In the experimental "Distrakt!" area of the Website (below), Spirollel designers voice their opinions on design and discuss design-related issues.

Design Firm: Spirollel Design

Design: Jonathan Magee

Features: GIF89a animation, JavaScript, Shockwave

http://www.thegatlinggroup.com/~spiro

SELF-PROMOTION

Creative Internet Design (CID) employs both engineers from the California Institute of Technology and designers from the Art Center College of Design, resulting in a mix of stylized, contemporary typography with the industrial imagery of steel-cased monitors and electric cables.

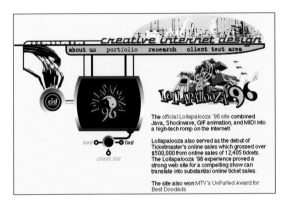

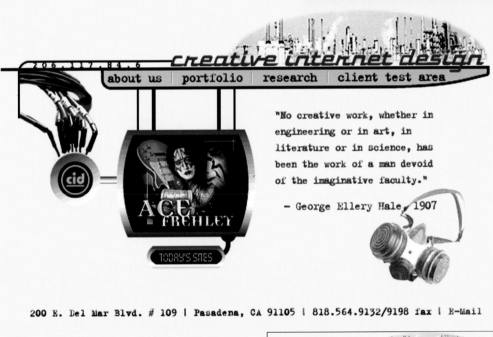

TECHNIQUE: The metallic three-dimensional monitor hanging off the navigation bar (left) is the main viewing area for the design firm's images. GIF89a animations showcase the images as they flash onto the monitor's screen.

Design Firm: Creative Internet Design

Design: Aurelius Prochazka, Mike Lin

Illustration: Mike Lin

Programming: Aurelius Prochazka

Features: GIF89a animation, Shockwave, JavaScript

[http://www.cid.com]

C°2 MEDIA

SELF-PROMOTION

The splash page to the C02 Media Website (above right) offers "static" and "Shocked" versions of the home page. Both versions are similar in design, with the Shockwave version offering moving typography and dynamic rollover navigation buttons. Each page features beautiful photomanipulated illustrations and typographically creative layouts that showcase the company's strengths in designing for the Web.

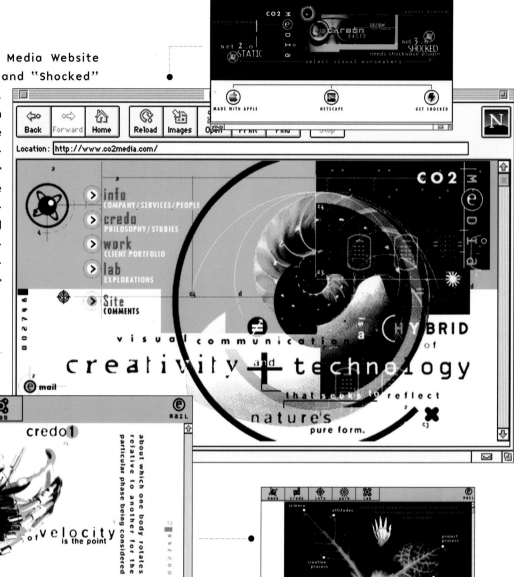

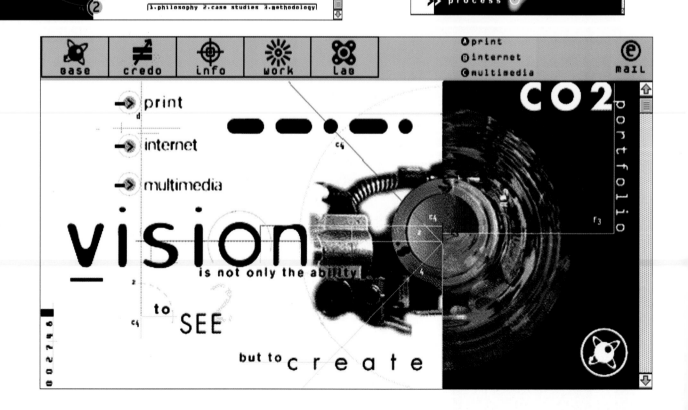

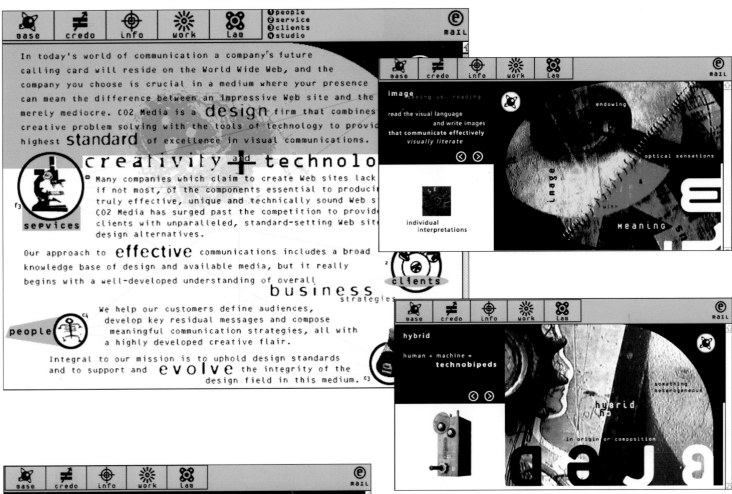

TECHNIQUE: JavaScript rollovers highlight the icon-based horizontal navigation bar featured at the top of each page. Frames containing the navigation bar and the main viewing areas keep the navigation bar from reloading each time the viewer clicks to enter a new area of the site.

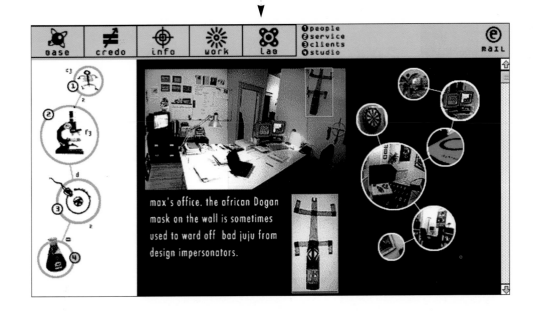

Design Firm: CO2 Media

Design: Max McNeil, Jeff Wilt

Programming: Mark Lundquist

Features: GIF89a animation, Shockwave, Shockwave Flash

CONTEMPT PRODUCTIONS

SELF-PROMOTION

Sung H. Chang doesn't hold back when letting viewers know about his "contempt" for bad Web design. His own Website attempts to show what great Web design should look and act like—and it succeeds. Sung created a clean and easily navigable site using frames. The bottom frame on each page—which incorporates red highlighting rollovers that turn yellow when viewers enter a specific area—serves as the main navigation device. Shockwave streaming audio, QuickTime video, and JavaScripting work together to showcase Sung's grasp of the technologies.

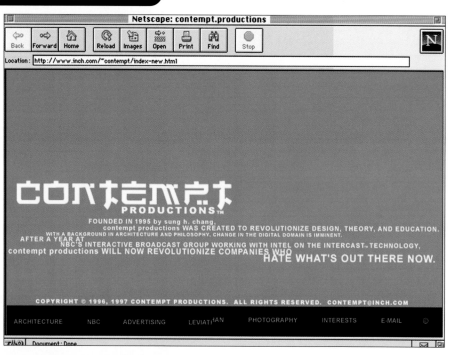

Shockwave streaming audio in the "Interests" area showcases the music and voice of Faye Wong, one of the designer's favorite singers (below left).

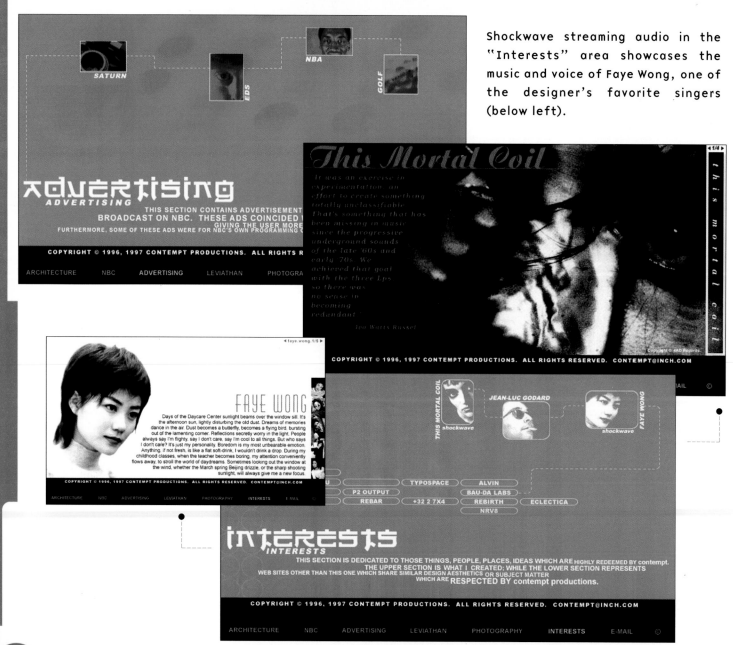

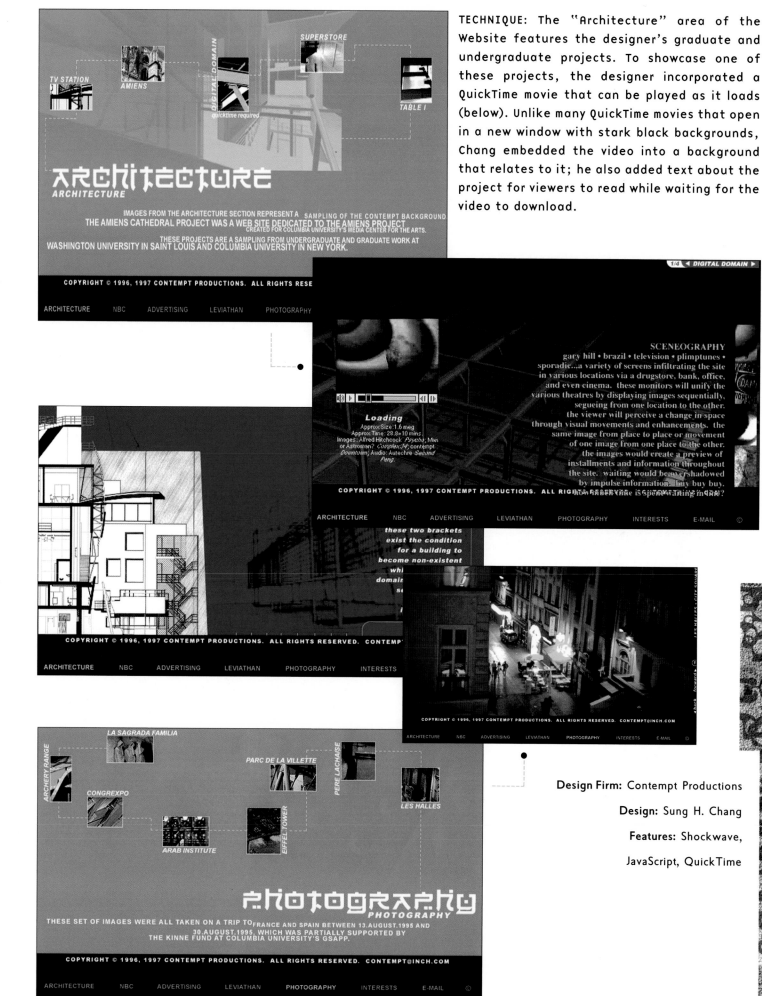

TECHNIQUE: The "Architecture" area of the Website features the designer's graduate and undergraduate projects. To showcase one of these projects, the designer incorporated a QuickTime movie that can be played as it loads (below). Unlike many QuickTime movies that open in a new window with stark black backgrounds, Chang embedded the video into a background that relates to it; he also added text about the project for viewers to read while waiting for the video to download.

Design Firm: Contempt Productions
Design: Sung H. Chang
Features: Shockwave,
JavaScript, QuickTime

CONSTRUCT INTERNET DESIGN

SELF-PROMOTION

Construct's design philosophy is "evolve or die." Rather than follow the latter part of its philosophy, the design firm has evolved into a company that creates multi-user, multi-protocol Websites integrating many of the newest high-end technologies—including VRML and Java—to create online environments and Web experiences.

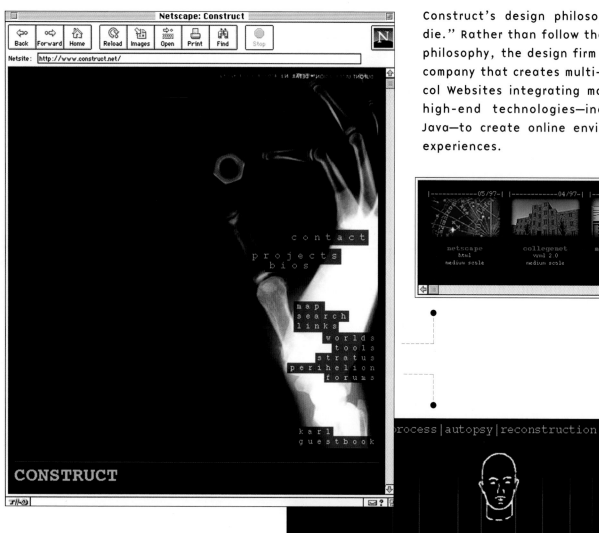

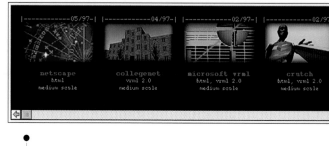

The home page (above) features an image-mapped x-ray with links to the main areas of the Website. Other interesting navigational imagery, such as the "autopsy" screen (right), shows up throughout the site.

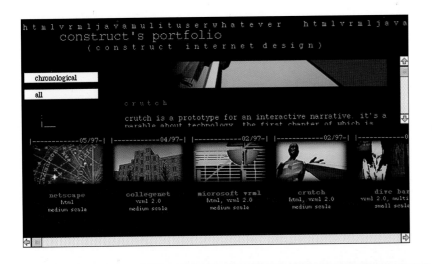

TECHNIQUE: To showcase their projects, the designers created a horizontal scrolling frame (below and left) that shows a large selection of their work. Clicking on a project takes the viewer to the specific piece of work, such as the "Crutch" story (bottom) that incorporates HTML and VRML to tell the story. Pop-up menus allow the viewer to choose all or some of the projects (below left).

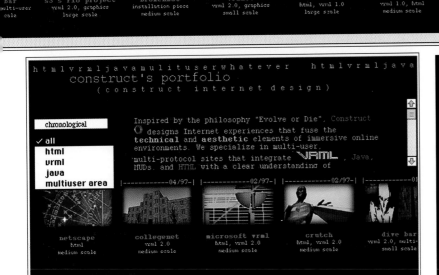

Design Firm: Construct Internet Design

Design: Annette Loudon, Michael Gough, Stinkfoot

Illustration: Annette Loudon, Mike Whistler, Stinkfoot

Programming: Cynsa Bonorris, John Shiple, Stinkfoot

Features: JavaScript, Java, VRML, MPEG, RealAudio

DREAMLESS STUDIOS

SELF-PROMOTION

Dreamless Studios is a joint new media venture of designer David DeCheser and artist Eric Dinyer. This self-promotional Website showcases the high-quality design and artistry of both individuals and offers viewers a look at current work and projects. Throughout the site, both artist and designer collaborate on pages featuring stunning visuals and beautifully rendered typographic layouts.

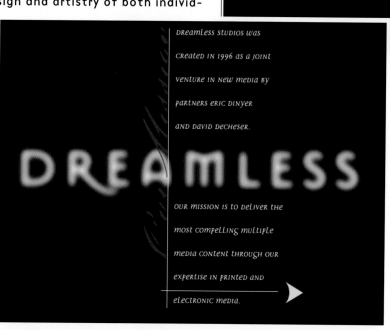

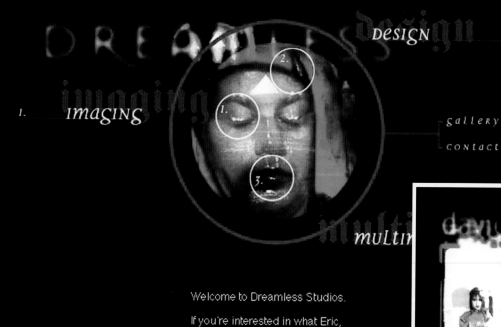

Welcome to Dreamless Studios.

If you're interested in what Eric, David, and the group at Dreamless are up to, check out our announcements page.

The designers gave glowing, lava-like treatments to the richly textured typography on many of the pages, including the portfolio pages of David DeCheser's design (right) and Eric Dinyer's paintings (opposite page).

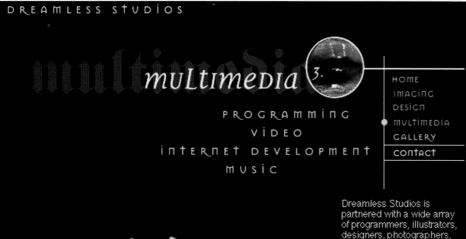

TECHNIQUE: The design follows the look and form of the Dreamless multimedia portfolio featured on the *Alternative Pick Sourcebook CD-ROM*. Dreamless offers viewers the chance to download the full 15 MB interactive portfolio piece (about an hour and a half at 33.6 Kbps), or they can choose to view the Shockwave version located on the site.

Dreamless Studios is partnered with a wide array of programmers, illustrators, designers, photographers, musicians, studio engineers, and digital video experts.

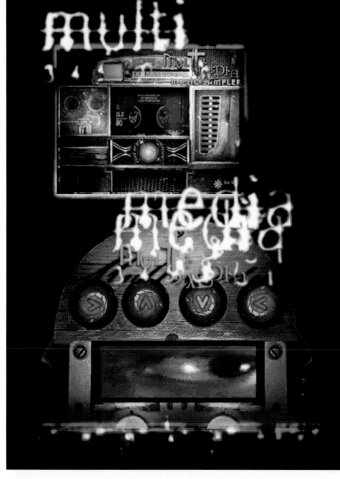

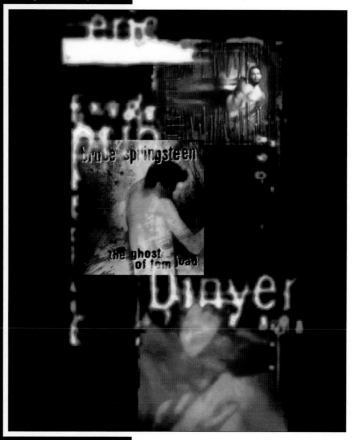

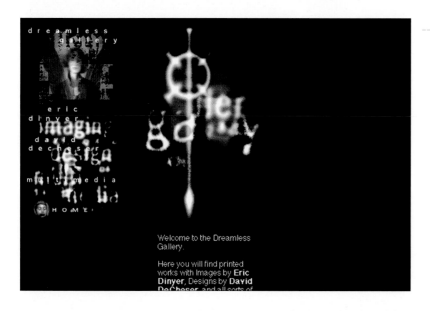

Design Firm: Dreamless Studios

Design: David DeCheser

Illustration: Eric Dinyer

Photography: Eric Dinyer

Programming: David DeCheser

Features: GIF89a animation, Shockwave, Shockwave Flash, QuickTime

ELOGIC COMMUNICATIONS

SELF-PROMOTION

ELogic's Website displays standard Web port-
folio elements such as client lists, contacts,
and employment information—but more than
this, the design firm's site is a "billboard" of
its own work. Layered typography and images
demonstrate the definitive style seen
throughout the site, displayed in its dynamic
layouts.

Multiple variations on eLogic's home page
(bottom two images and images on facing
page) give viewers and potential clients a
visual tour of past designs, and they also
show the firm's grasp of the tools used to
create cutting-edge Web page designs.

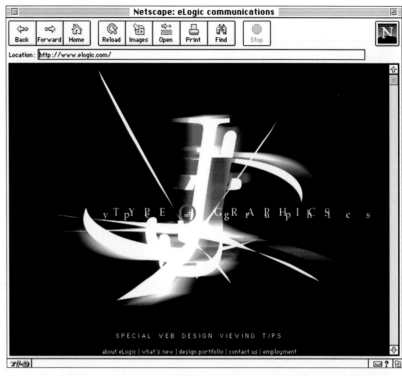

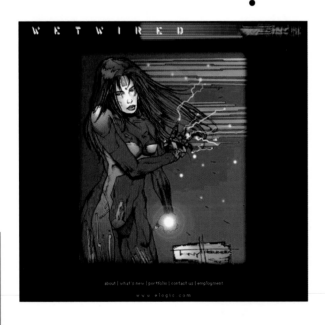

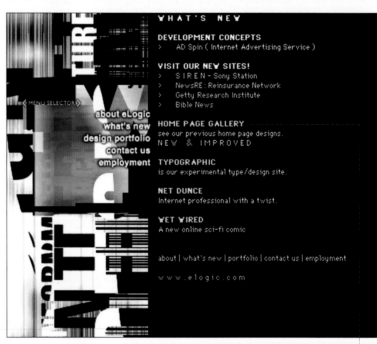

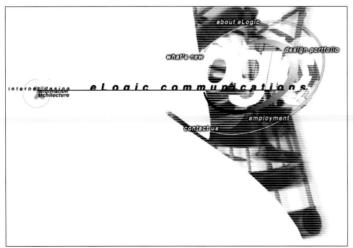

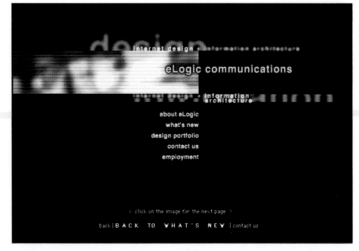

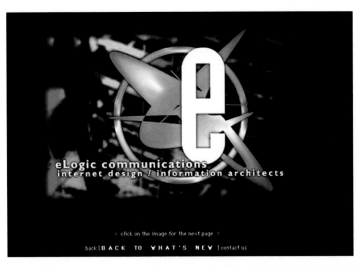

TECHNIQUE: The home page design shown below features eLogic's use of Photoshop's transparent GIFs to create a quick-loading image. The graphic is split into two pieces, a top image and a bottom image, which are placed in a two-cell table to create the full graphic. The top image loads first, giving viewers something to keep their attention as the second piece loads.

Viewing the images in Netscape Navigator (using the "Open Image" command) shows the distinctive look of a transparent GIF image without the background (inset below).

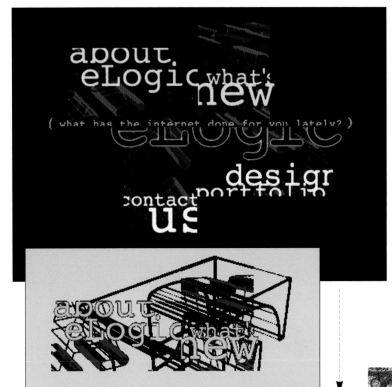

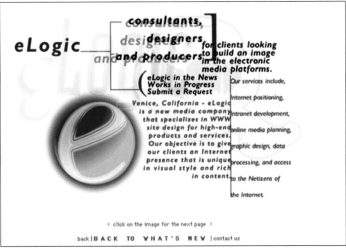

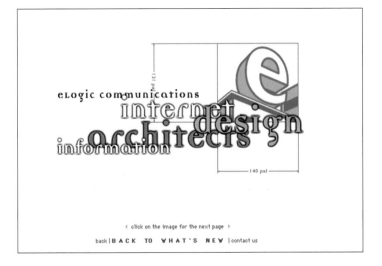

Design Firm: eLogic Communications

Design: Jimmy Chen

Programming: Jimmy Chen,

Bill Nash

Features: GIF89a animation,

JavaScript

ENTROPY8

SELF-PROMOTION

Entropy8's designer, Auriea Harvey, wanted to create a Website that would make viewers respect Web design as an artistic medium. This was accomplished with multiple-textured, full-screen collage backgrounds, contemporary type treatments, and unique navigation technology, all of which sets this site at the forefront of Web design.

Entropy8's Website pushes the limits of bandwidth by placing graphic-intensive pages throughout the site, but compensates for this with clear navigation tools and interesting, beautiful content that is worth the wait.

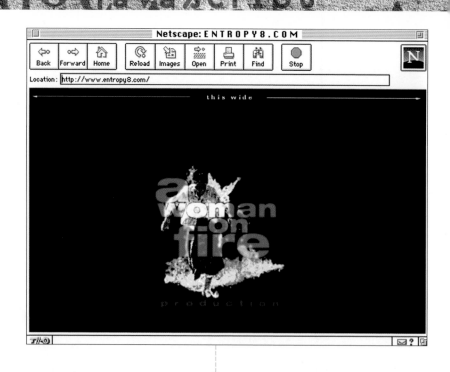

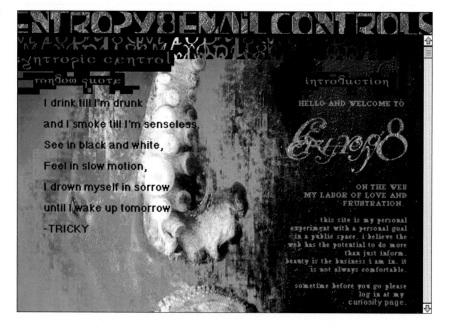

TECHNIQUE: The navigation bar (top) is a 24-pixel x 168-pixel Netscape frame called from the splash page through JavaScript. This navigation bar—hidden after clicking on one of its links—can be brought forward by choosing the "controls" link shown at the top of the contents page (right).

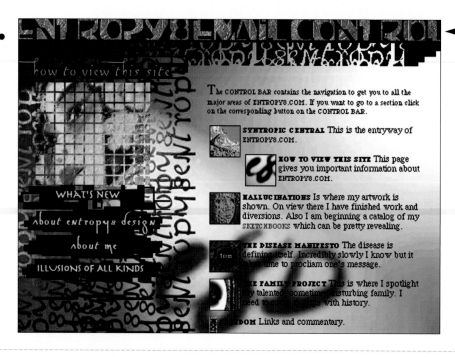

"Hallucinations" is one of the many dynami-cally designed pages on the Entropy8 site. The curled scribble running the full length of the page is a looped GIF89a animation that whips back and forth until the viewer chooses a hyperlink to another page.

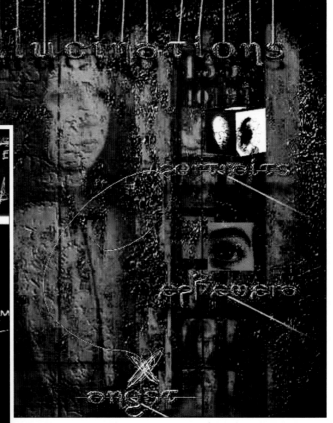

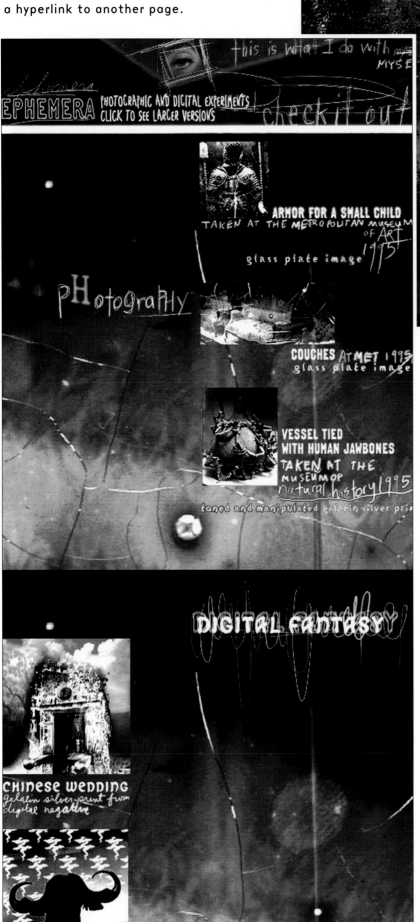

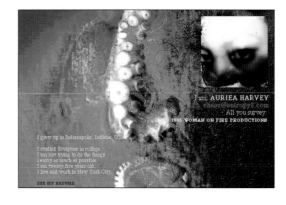

Design Firm: Entropy8

Design: Auriea Harvey

Programming: Auriea Harvey,

Marc Antony Vose

Features: GIF89a animation,

JavaScript

EYE CANDY

SELF-PROMOTION

Eye Candy showcases other Websites based on their design merit. The site itself is well-designed and engaging. The "Noise" feature is found in a new window that opens when viewers enter the site. It allows viewers to subscribe to an e-mail list that notifies them of updates to specific areas on Eye Candy.

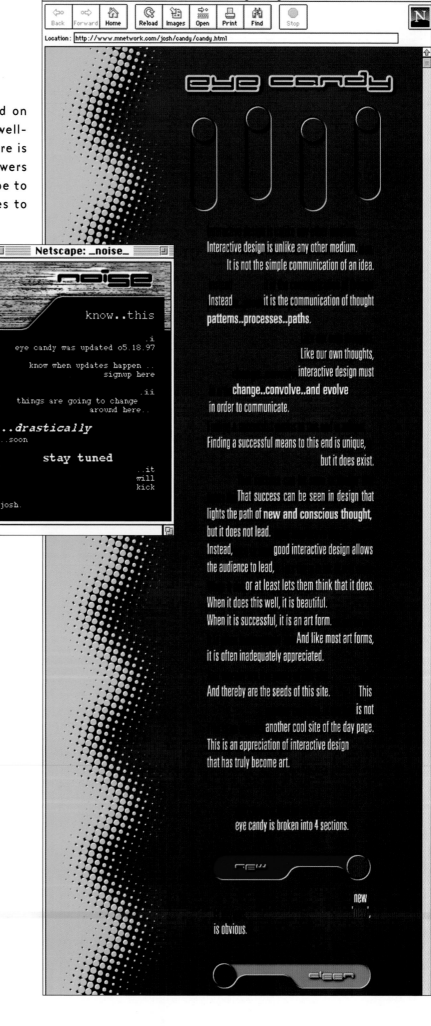

TECHNIQUE: JavaScript rollover slider bars at the top of the home page (right) display a brief description of the linked area and link to the desired page when clicked.

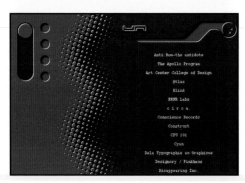

Project: Eye Candy

Design Firm: New Media Development Group

Design: Josh Ulm

Features: JavaScript

http://www.mnetwork.com/josh/candy

Netscape: _eye candy_

Location: http://www.mnetwork.com/josh/candy/candy.html

eye candy

Interactive design is unlike any other medium.
It is not the simple communication of an idea.

Instead it is the communication of thought
patterns..processes..paths.

 Like our own thoughts,
 interactive design must
 change..convolve..and evolve
in order to communicate.

Finding a successful means to this end is unique,
 but it does exist.

 That success can be seen in design that
lights the path of **new and conscious thought,**
but it does not lead.
Instead, good interactive design allows
the audience to lead,
 or at least lets them think that it does.
When it does this well, it is beautiful.
When it is successful, it is an art form.
 And like most art forms,
it is often inadequately appreciated.

And thereby are the seeds of this site. This
 is not
 another cool site of the day page.
This is an appreciation of interactive design
that has truly become art.

 eye candy is broken into 4 sections.

new
'new'
is obvious.

Netscape: _noise_

noise

know..this

 .i
eye candy was updated o5.18.97

 know when updates happen ..
 signup here
 .ii
 things are going to change
 around here..

..drastically
..soon

 stay tuned
 ..it
 will
 kick
josh.

The Rotordrive site promotes the Rotor clothing line with an online game and a "soft hardware PDA," which allows viewers to access Rotor print advertising and allows online ordering of Rotor products.

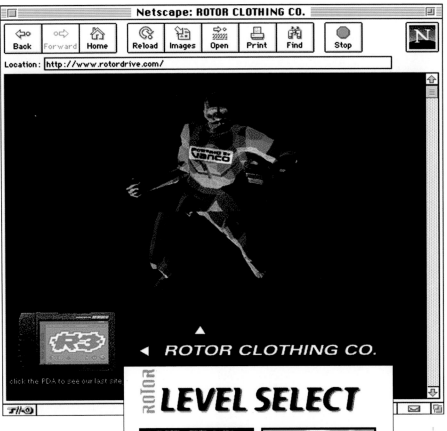

Netscape: ROTOR CLOTHING CO.

Location: http://www.rotordrive.com/

click the PDA to see our last site

◄ ROTOR CLOTHING CO.

LEVEL SELECT

Nofriendo

ROTOR CLOTHING CO.

...TAINS JAVA AND **FUTURESPLASH**. IF YOU DON'T HAVE THEM, GET THEM.

PLAYER SELECT

VS.

...OR CLOTHING OPTION, CLICK PLAYER

YOWANA FEELMORE

Druuna Dress

heavy duty nylon construction w/high density poly-lycra strech contrast

designed to withstand high impacts

TEAM 1

TECHNIQUE: The dancing figure on the Rotordrive home page links to a mock battle game in which viewers choose among various characters wearing Rotor clothing. Clicking on the character pulls up a larger image and background info. Thus, potential consumers are encouraged to identify with the character and, of course, its clothing.

Project: Rotordrive

Client: Rotor Clothing Co.

Design Firm: DCAF Aftermath

Design: Mark Vanco

Illustration: Jason Fields, Glenn Kaino

Photography: Mark Vanco, Charles Costa

Programming: Jason Fields, Glenn Kaino

Features: GIF89a animation

[http://www.rotordrive.com]

FoCUS 2

SELF-PROMOTION

The designers of the Focus2 group describe themselves as "crossmedia architects," or designers still tied to traditional print and broadcast media—but with a decidedly philosophic, heady feeling about the emerging digital design wave. The splash page features a long introductory animation of Focus2's logo (four images to the right), which then opens into a Cubist-inspired navigation collage for the home page (below right).

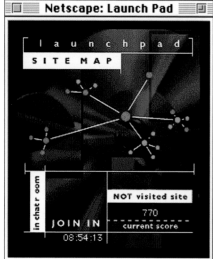

The Launch Pad (above) is a Java-based site navigation device that schematically maps the site's structure. As each area of the site is visited, the schematic shows a purple dot—the visitor's tour through the site is assigned a score based on how much of the site has been navigated. The Launch Pad is also a gateway to a Java-based chat room about new media-related topics.

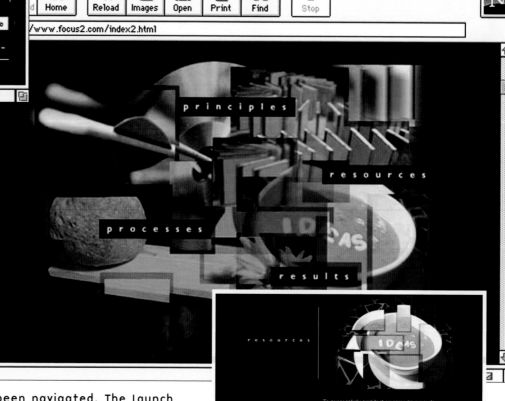

TECHNIQUE: The "Portfolio" section of the site uses frames and JavaScripting to manage a database of images and text. These images show the loading sequence of the frames. A checklist appears in a frame by itself, which allows visitors to construct their own portfolio viewing list. The selected images are viewed using the slider bar in the bottom right frame of the screen (below).

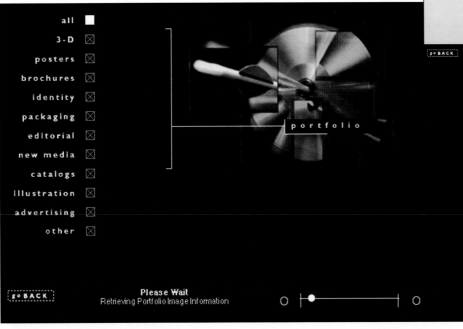

Design Firm: Focus2

Design: Shawn Freeman, Todd Hart, Cort Langworthy, Brad Walton

Illustration: Shawn Freeman, Cort Langworthy

Photography: Dick Patrick, Jake Dean, Richard Seagraves

Programming: David Adams, Walker Hale IV

Features: JavaScript

FORM STUDIO

SELF-PROMOTION

Form Studio is a hybrid design office featuring architecture and new media services. Form designers created the Website to showcase their ideas and goals, as well as to create an online portfolio for potential clients. Viewers navigate the site through a main navigation bar that changes to orange when the viewer enters a specific area, and also through the use of visual elements and icons such as the "city" and "pointing finger" icons (below).

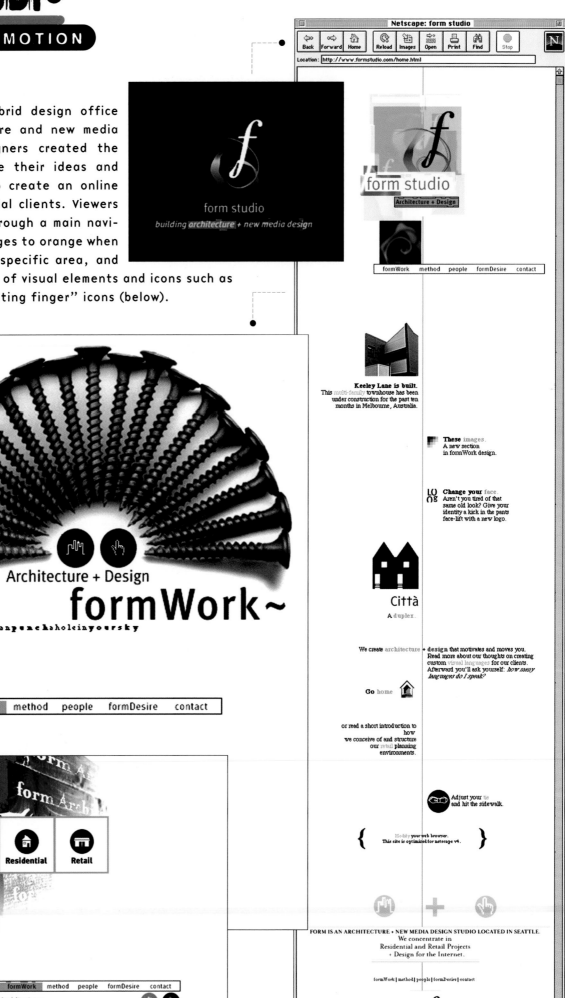

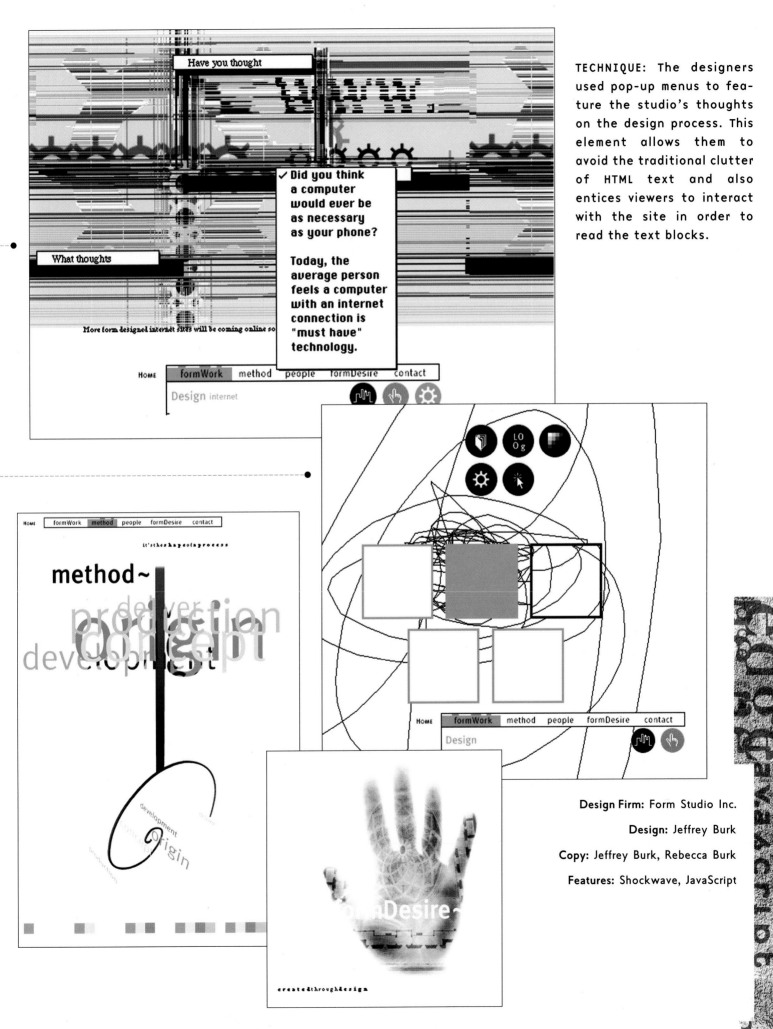

Have you thought

✓ Did you think
a computer
would ever be
as necessary
as your phone?

Today, the
average person
feels a computer
with an internet
connection is
"must have"
technology.

What thoughts

More form designed internet sites will be coming online so

HOME formWork method people formDesire contact

Design internet

TECHNIQUE: The designers
used pop-up menus to fea-
ture the studio's thoughts
on the design process. This
element allows them to
avoid the traditional clutter
of HTML text and also
entices viewers to interact
with the site in order to
read the text blocks.

HOME formWork method people formDesire contact

Design

LO
Og

HOME formWork method people formDesire contact

it'stheshapeofaprocess

method~

deliver
production
concept
development

development

origin

formDesire~

createdthroughdesign

Design Firm: Form Studio Inc.

Design: Jeffrey Burk

Copy: Jeffrey Burk, Rebecca Burk

Features: Shockwave, JavaScript

FRANK FORD DESIGN

Frank Ford decided it was time to create a Website when he realized he was running out of printed samples to show prospective clients. The site features his bio, portfolio, and links to the fonts Ford creates, which he sells through online font companies (bottom). The portfolio section promotes and showcases his newest font creations, such as the "Avid" font (below). Each page features image-mapped graphics—no HTML text is used within the site.

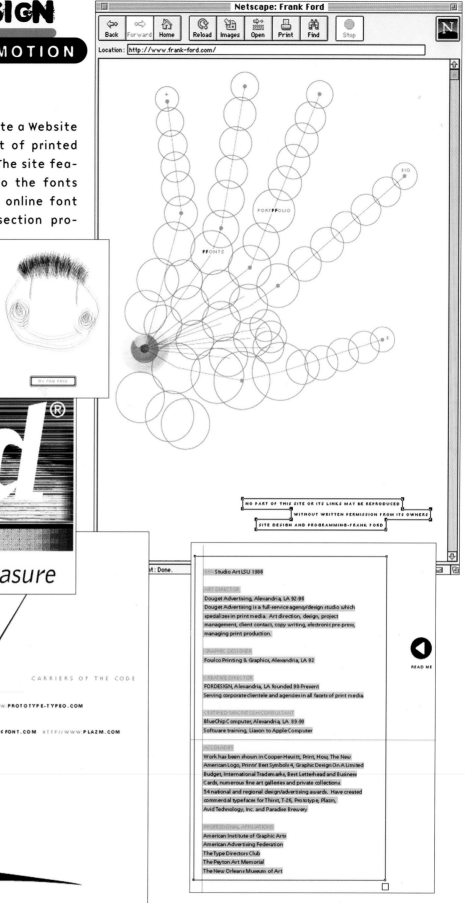

Project: Frank Ford Portfolio

Design: Frank Ford

People

Press

phoenix pop

flux Toolbox

synergy Accordian Model

Studio

on-line design Online Solutions

printed print Print Solutions

the people

bruce

simon

rian

paul

rachel

rebecca

flux 3p design on-line design printed print synergy

The Phoenix POP portfolio has gone through several designs during its existence, ending with the current version shown here. To make the home page easily navigable, the designers chose various sections of each page and cropped them to fit a vertical image-mapped navigation bar. Then they used the same images as headers on each page. This vertical treatment adds continuity throughout the site.

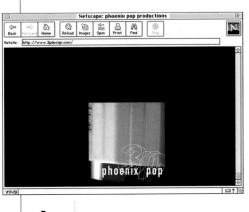

Time Thematic Unit

The TTU was our second project for the Computer Curriculum Corporation with Amy Franceschini as a design consultant developed publishing tools, survey results generator and database administration as part of a 6 week educational activity for the 6th through 8th grade.

The Samsung Group

Concept Development for the Samsung Corporate Website in collaboration with Conerstone Consulting and Twenty2 Product. All aspects of design and production. Content negotiation and interactive interface programming.

Identity Thematic Unit

The ITU was a project for the Computer Curriculum Corporation with Geoff Katz as a project consultant. We developed publishing tools, survey results generator and a madlib game as part of a 6 week educational activity for the 6th through 8th grade.

EA Sports

EA Sports College Cup tour site designed and produced by phoenix pop and Stefan Eder. The site facilitates the online publication of tournaments results and player standings for 40 campuses.

Project: Phoenix POP Portfolio

Design Firm: Phoenix POP Productions Inc.

Design: Simon Smith, Bruce Falck, David Lazzarini

Illustration: Simon Smith, David Lazzarini

Photography: Simon Smith

Programming: Bruce Falck

Features: GIF89a animation, browser recognition, user tracking

NRV8

Edwin Chong, the creator of nrv8, designed this e-zine to appeal to multiple audiences. The site reflects the designer's preference for design that interprets (or reinterprets) source material by emphasizing multiple layers of meaning and imagery over the delivery of text. The result is a 'zine that is conceptually interesting—over and above its readability. Frames, combined with layered type and images, and the use of GIF89a animations (such as the rotating nrv8 logo on the home page) allow the designer to treat textual and visual content equally.

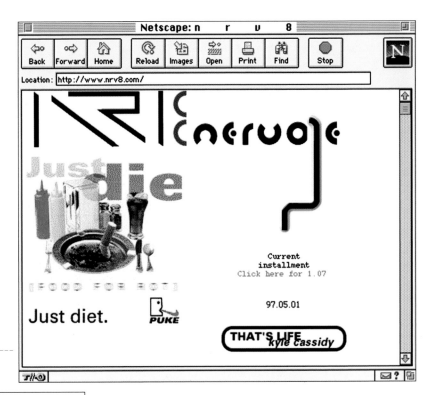

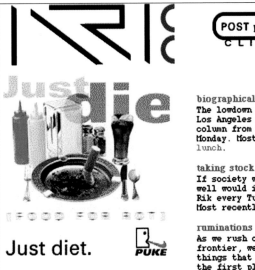

biographical biopsies
The lowdown on the lowlifes in Los Angeles and beyond. A new column from Diana Stoneberg every Monday. Most recently: a free lunch.

taking stock
If society was a business, how well would it be doing? New from Rik every Tuesday, more or less. Most recently: whining bankers.

ruminations
As we rush out into the digital frontier, we shouldn't forget the things that brought us here in the first place. Rod Amis gives you his thoughts from San Francisco every Wednesday. Most recently: modern violence.

Frames split the home page (above and left) into two separate areas. The left side displays a constant image that helps viewers locate where they are, while the right side contains a scrolling contents area that lists the current issue's features. The same frames feature is used on each of the following pages within the site.

To add further interest to the home page, the designer used a GIF89a animation of the nrv8 logo: two purple half-circles (top) that rotate to form the figure eight.

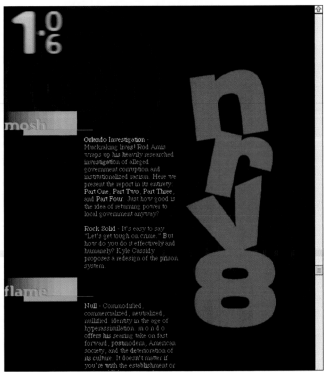

TECHNIQUE: In issue 1.05 of nrv8 the designer created a running dialog presented as a GIF89a animation created with GifBuilder and Photoshop. Shown below are three frames of the larger animation, in which the issue's title and date rotate and bitmapped text set at three separate angles loops as an animation, repeating until the viewer clicks to continue into the 'zine.

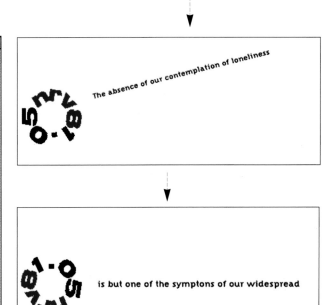

Project: nrv8

Design: Edwin Chong

Features: GIF89a animation,

LiveAudio, JavaScript

p2 OUTPUT

SELF-PROMOTION

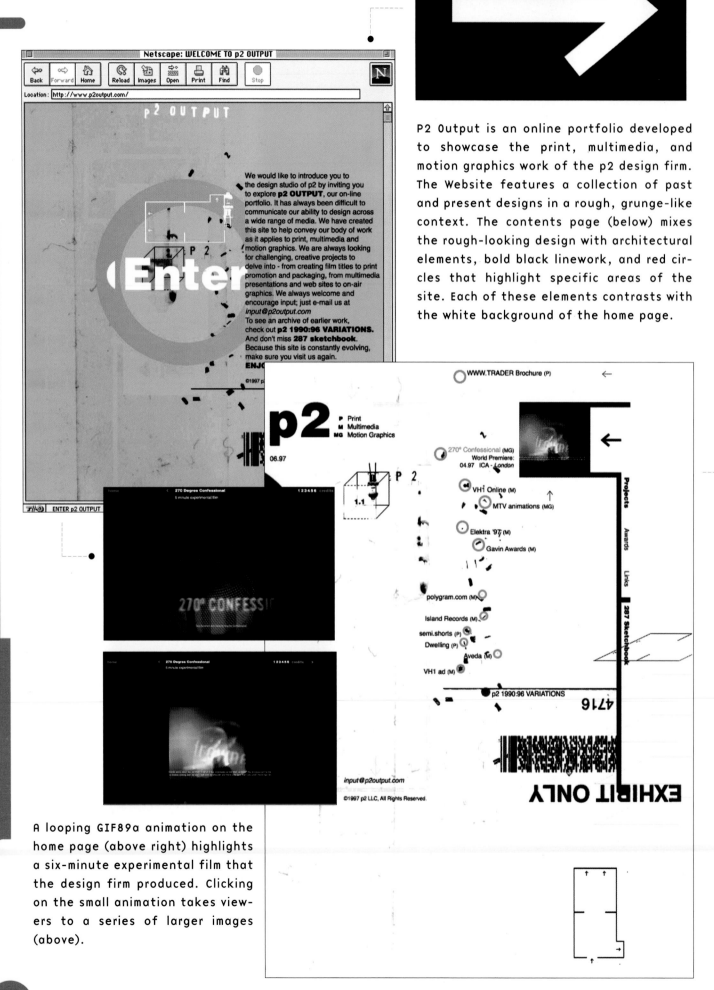

P2 Output is an online portfolio developed to showcase the print, multimedia, and motion graphics work of the p2 design firm. The Website features a collection of past and present designs in a rough, grunge-like context. The contents page (below) mixes the rough-looking design with architectural elements, bold black linework, and red circles that highlight specific areas of the site. Each of these elements contrasts with the white background of the home page.

A looping GIF89a animation on the home page (above right) highlights a six-minute experimental film that the design firm produced. Clicking on the small animation takes viewers to a series of larger images (above).

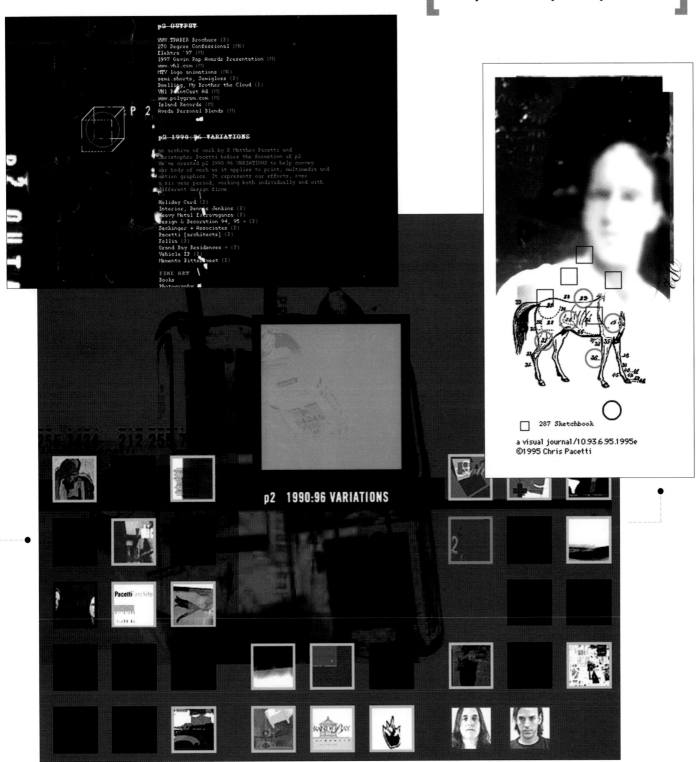

TECHNIQUE: The "1990:96 Variations" area is a collection of p2's past design projects. Clicking on a square (above) reveals a larger image. The large red square leads viewers to an electronic sketchbook (right); the rotating "p2" icon within the small red square (above) takes viewers to the firm's mission statement.

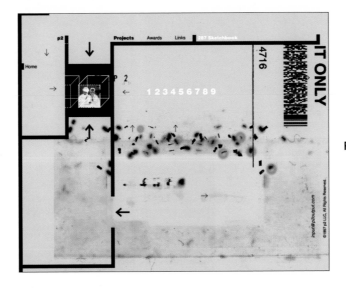

Project: p2 Output

Design Firm: p2

Design: Christopher Pacetti,

R. Matthew Pacetti

Programming: Christopher Pacetti

PITTARD SULLIVAN

SELF-PROMOTION

The splash page of the Pittard Sullivan Website welcomes viewers and advises that Shockwave Flash is required to view the site. The opening Shockwave Flash animation (below and below right) incorporates music and rotating, morphing shapes. Clicking on the animation takes viewers to the home page, where the oval shapes from the splash page are repeated.

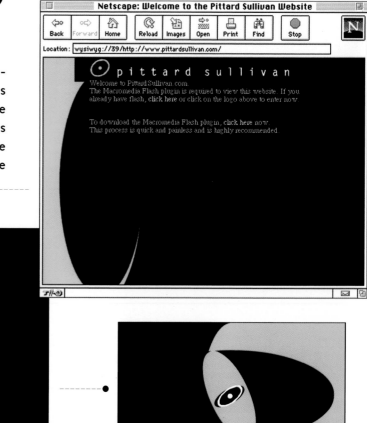

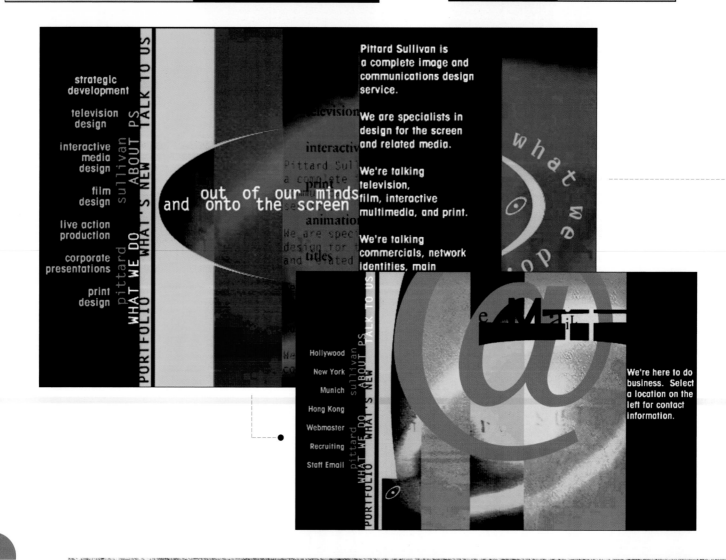

TECHNIQUE: JavaScripting is used to open a new Netscape window with the toolbar and location removed. The designers used frames to divide the page into two areas: the navigation frame, where JavaScript rollovers highlight specific links, and the main frame area, where new pages are loaded.

tv
main
titles

tv
identities

tv
commercials

film
main
titles

portfolio
highlights

kids &
teens

Magical World of Disney
CBS IDs
ER
TNT Projector Man
Junior
CNN Headline News
Paramount ShoWest '97

Portfolio
Highlights

Waterworld
Four Rooms
Dumb & Dumber
The Indian in the Cupboard
Benny & Joon
Forget Paris
The Brady Bunch
Silent Fall
The Client
Wyatt Earp
City Slickers II
Maverick
Grumpy Old Men
Groundhog Day

WATERWORLD

Film Main
Titles

On April 4th, after much anticipation, Pittard Sullivan moved into the newly constructed 51,000-square-foot building envisioned by architect Eric Owen Moss--internationally known for creating buildings which punch holes into the sky. The structure, built in the ever-evolving Culver City, was commissioned as a unique space to inspire creativity while at the same time housing over 100 employees, computers and compositing bays.

Goes West

PS hits bullseye with Gun main title.

PS loads Gun

Top secret missions: success!

PS & Lockheed

Kabel 1 leaps into spring.

PS & Kabel 1

PS Goes West...in Style!

PS Goes West

Find out what conferences and events PS-ers will

Sharply angled edges combine with the oval cutouts of the orange border to separate the two main frames and add texture and movement to each page.

We're creative...visual and...fun.

It's an amazing place to work. We're the talk of the industry. In only ten years, Pittard Sullivan has assembled one of the most eclectic visual communication groups in the world.

That's right...the world. We're talking about creative centers in Los Angeles, New York City, Hong Kong, Munich, and we're still growing.

Who knows where we're going next?

We tackle every problem we encounter with an appreciation of the **unique** differences we encounter.

So do you wanna **join?** our team. Click here!

Design Firm: Pittard Sullivan
Design: Aaron King, Soo Chyun, Ron Romero
Programming: Bryan Keeling, Marvin Price
Executive Producer: Billy Pittard
Creative Directors: Brian Black, Dale Herigstad
Producer: Mary Jo Thatcher
Animator: Jennifer Grey
Music: Tony Morales
Copy: Will Hartman, Robert McGee
Features: GIF89a animation, ShockwaveFlash, JavaScript

PLUS

SELF-PROMOTION

The PLUS Website features a conservative layout and navigation structure that contrasts with the site's stylized buttons—in the form of anthropomorphic electrical outlets—and a fun pop-art visual style. Paul Lee, the designer, wanted to create recognizable visual elements representative of the word "PLUS" in terms of electrical positive and negative charges. Design elements such as halftone dots add movement and interest to potentially plain header graphics.

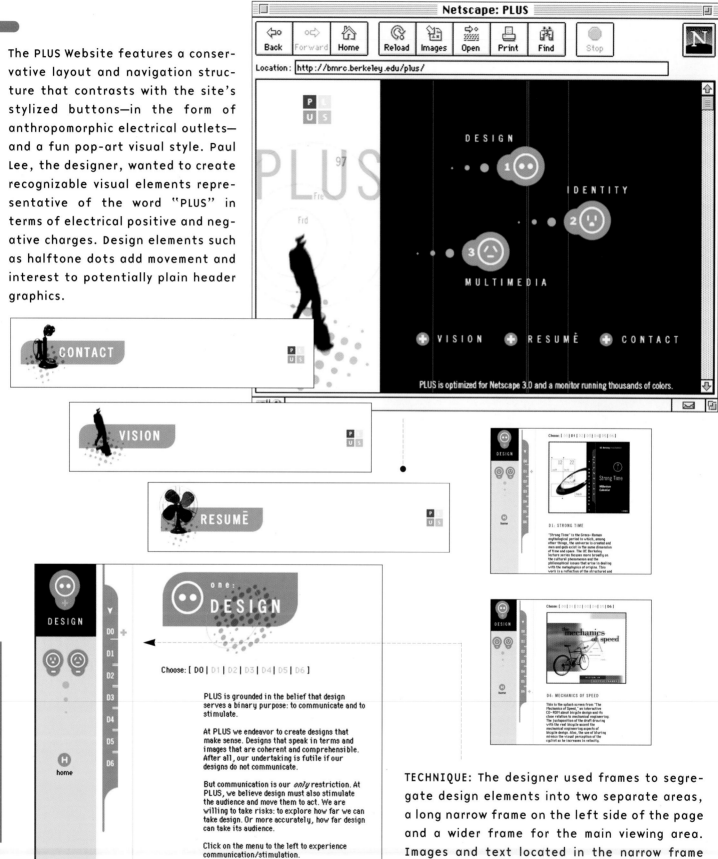

Location: http://bmrc.berkeley.edu/plus/

PLUS is optimized for Netscape 3.0 and a monitor running thousands of colors.

Choose: [D0 | D1 | D2 | D3 | D4 | D5 | D6]

PLUS is grounded in the belief that design serves a binary purpose: to communicate and to stimulate.

At PLUS we endeavor to create designs that make sense. Designs that speak in terms and images that are coherent and comprehensible. After all, our undertaking is futile if our designs do not communicate.

But communication is our *only* restriction. At PLUS, we believe design must also stimulate the audience and move them to act. We are willing to take risks: to explore how far we can take design. Or more accurately, how far design can take its audience.

Click on the menu to the left to experience communication/stimulation.

Project: PLUS

Design: Paul Lee

TECHNIQUE: The designer used frames to segregate design elements into two separate areas, a long narrow frame on the left side of the page and a wider frame for the main viewing area. Images and text located in the narrow frame stay cached, and refresh times are kept to a minimum. An added feature is the blue navigation bar in the main frame. Each time viewers click on a link, the bar is updated with a plus sign that shows viewers where they are within the site.

http://bmrc.berkeley.edu/plus

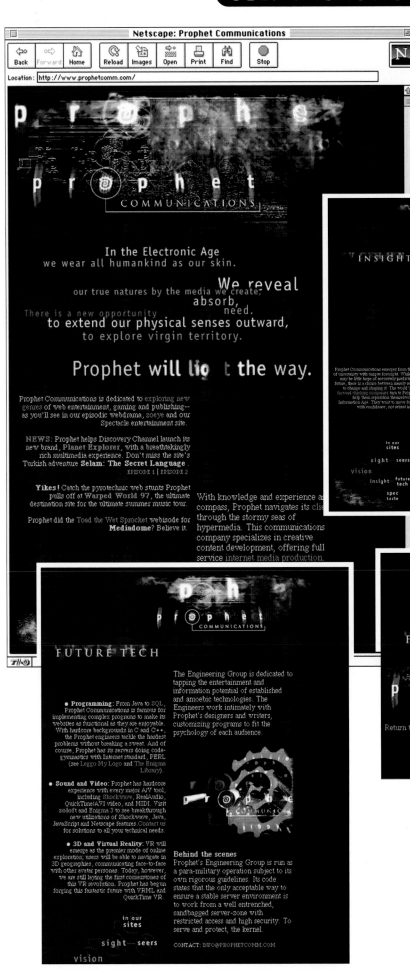

The Prophet Communications Website serves as a promotional tool for showcasing the new media design firm's client and self-promotional projects. The site's most striking features are textured, fiery headers located on each page. Gaussian blurs and motion-blurred text add movement to static headlines; colored, bitmapped body text set at various sizes gives a feeling of depth.

Colored HTML text complements header graphics, and the shades contrast with the gray backgrounds used throughout the site.

A single GIF89a animation—a light source traveling back and forth across the "Prophet will light the way" cutline—attracts the viewer's attention on the home page.

Project: Prophet Communications

Design: Josh Feldman

Programming: Jason Monburg

Features: GIF89a animation

Cutting Edge

Commercial
Websites

bout a year and a half ago my life was changed when i surfed a link to Prophet Communication's "iconoclast" Website (www.prophet-comm.com/iconoclast).

it asked what i felt was a very important question about this new medium: Where have all the designers gone? This was something no one had bothered to ask before. it was as if nobody thought it possible to harness primitive html coding language to actually design as if it were a medium like print, interactive cd-rom or video. It did not occur to many big businesses to make the web something more than a hunt for information. Not many designers tried to take control of html—instead they let it control them, resulting in many boring, very low bandwidth solutions. Where were all the designers, indeed. This new medium seemed to freeze the entire design community like a deer caught in the headlights of a speeding car. Was there a middle ground where the time-honored savvy of the experienced print designer and the young, inexperienced—but technologically knowledgeable new media designer could meet?

IN GENERAL, designers don't like rules. Rules impede creativity. Rules require the use of one's talents to serve someone else's interests and to put personal projects on hold. The Web is a brave new world, an uncharted territory where not all the rules have been written. It is no coincidence that some of the best sites are created by individuals or small collectives with their own goals in mind, or by artists seeking to promote and represent themselves. The World Wide Web is simply the most important tool for the individual. Ever. Period. As an individual on the Web you have freedom of the press staring you in the face. You have the power to communicate with other individuals, regardless of their geographic location. Your ability to communicate is not controlled by some outside power but by your own. What are you going to do? What are you going to say to the more than 50 million people who have access to the page (or site or world) you create? This is what cutting-edge web designers ask themselves. The end results are developed by just doing what COMES NATURALLY.

GIVEN THAT creating a Website is relatively easy and no special training is necessary for an already computer-savvy designer, one can see how individual creative effort is emphasized and rewarded in this medium. There is a certain advantage to taking a more relaxed attitude online. Being young and full of your own ideas is an advantage in some respects. The dogmatic aspects of process and formality haven't been worked out yet— nor will they ever be. On the Web the game you play is YOUR OWN.

MANY DESIGNERS throw caution to the wind and actually let their own personalities shine, thus giving potential clients an unprecedented, no-bull-shit look into their inner working. These designers ignore the rule of bandwidth and let their imaginations fly, though the tools are still catching up to the dreams of THE CREATORS.

THE WEB brings to fruition the deepest desires of creative individuals by giving them the power to not only realize their visions, but to broadcast them and receive feedback and perhaps even support. On the Web, the impulse to know the individual behind the creative act (whether it's a Website for personal expression or to represent a company or a product) is accompanied by an attitude to be yourself and show the world who you really are. Cutting-edge designers are not afraid that this will hurt their businesses or reputations, but rather they see it as advantageous to have their self-image in THE FOREFRONT.

SOME DESIGNERS do not look to emulate traditional print graphic design but look to the future of interactivity to create new ways to visualize information. They come out from behind the computer and show some of their own personal vision—instead of merely interpreting the client's message. What has separated cutting-edge designers from the rest of the pack are those qualities of fearlessness and realness and a desire to push away from what should be and into what they feel could be the future of art AND DESIGN.

THERE ARE few media in which one or two people are capable of creating, marketing, conceptualizing, and producing every piece of a project. The web's immediacy and flexibility make it possible to take a concept and make it a reality in a short period of time—if it doesn't match the vision, it can be reworked quickly. The cutting-edge web designer is free to pursue the quest for beauty and understanding and to communicate that desire and vision to the world. The Web allows that vision to evolve and mature and change as quickly as the designer does. Take as evidence a site such as Hypnagogue (www.hypnagogue.com) where basically two people took an idea and created a project combining cinema and CD-ROM into a Web experience. Before the Web, how could they have validated their desire to create this work without major financial backing and all the strings such an undertaking implies? The Web creates new venues for exhibiting and selling the fruits of their labors by allowing them to bring to light what they have seen only in the shadow of their mind's eye and to create in a way unique to THEIR SENSIBILITY.

—AURIEA HARVEY
ENTROPY8 DIGITAL ARTS
HTTP://WWW.ENTROPY8.COM

TEKCONNECT INTERNETWORKS

COMMERCIAL

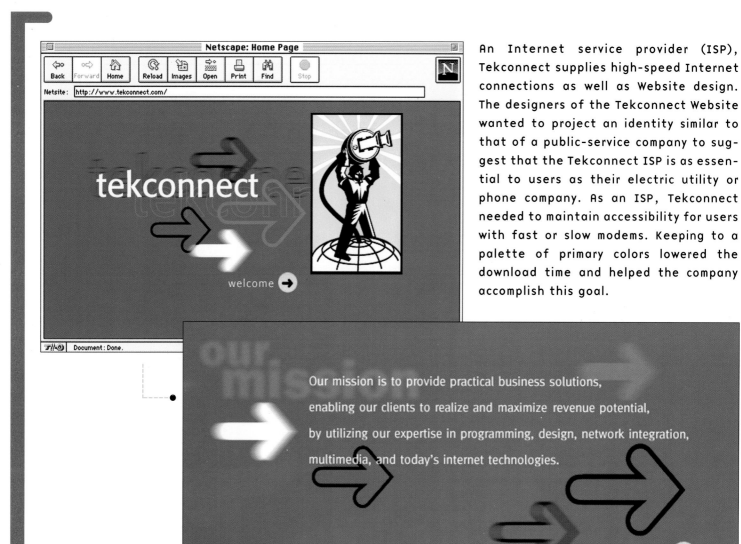

An Internet service provider (ISP), Tekconnect supplies high-speed Internet connections as well as Website design. The designers of the Tekconnect Website wanted to project an identity similar to that of a public-service company to suggest that the Tekconnect ISP is as essential to users as their electric utility or phone company. As an ISP, Tekconnect needed to maintain accessibility for users with fast or slow modems. Keeping to a palette of primary colors lowered the download time and helped the company accomplish this goal.

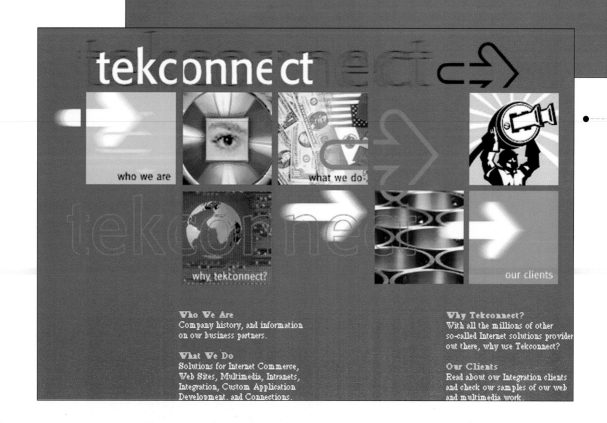

Who We Are
Company history, and information on our business partners.

What We Do
Solutions for Internet Commerce, Web Sites, Multimedia, Intranets, Integration, Custom Application Development, and Connections.

Why Tekconnect?
With all the millions of other so-called Internet solutions providers out there, why use Tekconnect?

Our Clients
Read about our Integration clients and check our samples of our web and multimedia work.

TECHNIQUE: To keep download times as short as possible, Tekconnect designers chose not to incorporate any bandwidth-hungry elements such as animation or audio files. To allow easier navigation, frames were used (left). Each main page is composed of three frames: a top horizontal frame that includes the main navigation links; a vertical frame on the left side of the page; and a larger middle frame that is updated by the other two frames.

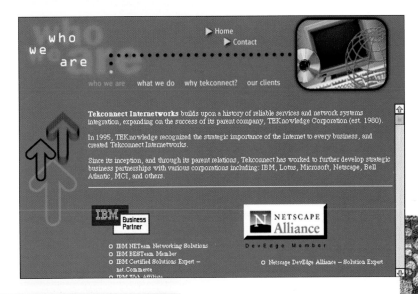

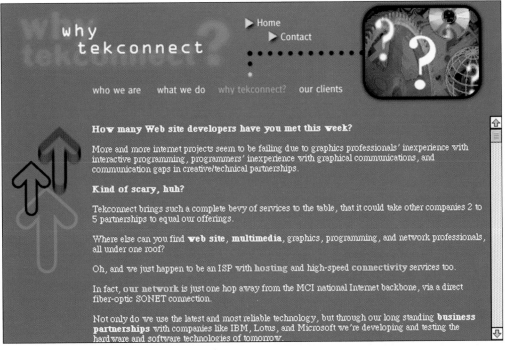

Project: Tekconnect Internetworks

Design Firm: Dreamless Studios

Design: David DeCheser

Illustration: Joseph Hasenauer

Programming: David DeCheser

Features: Shockwave Flash

DAVID BOWIE

COMMERCIAL

The premiere of the David Bowie Website, designed by N2K Entertainment, coincided with David Bowie's 50th birthday and the release of his *Earthling* album. The site offers two versions to visitors—a standard home page (right) which features looping GIF89a animations of album-related icons, and a Shockwave home page (below), which features a large animation that takes place in the "eye" area while displaying text about auras and Kirlian photography. Where the traditional site offers static buttons for navigation, the Shocked site offers animated rollover buttons.

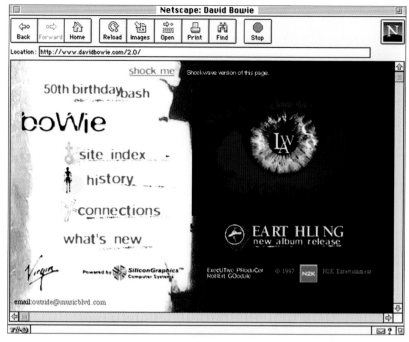

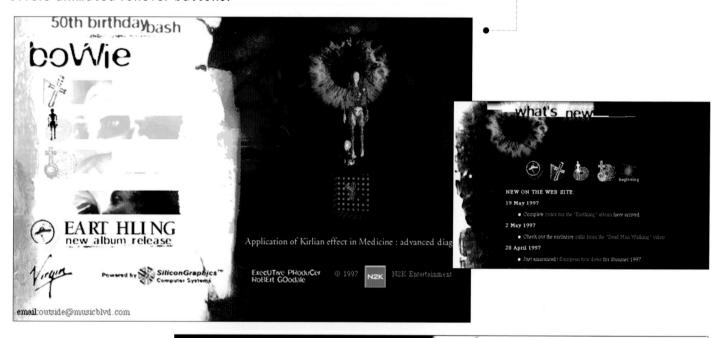

Another dynamic element offered by the Shocked version of the home page is the inclusion of an audio clip from Bowie's *Earthling* album.

DAVID BOWIE: The Official Web Site
Site Index

- **50th Birthday Bash** - Including...
 - □ Video from the Madison Square Garden concert
 - □ The transcript of the America Online chat 8 Jan 1997.
 - □ Hear the Danny Saber remix of "Little Wonder" from the Birthday Internet Release.

- New Album "EARTHLING"
 - □ Includes track samples and Bowie interview in RealAudio 3.0
 - □ Video Clips: Interviews and live concert footage.

- Connections

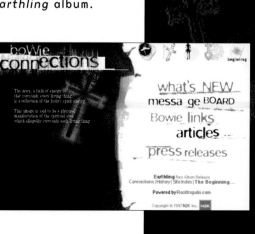

[http://www.davidbowie.com]

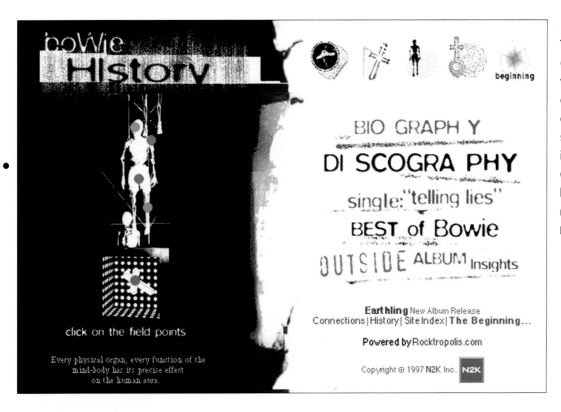

TECHNIQUE: The "History" area of the site allows viewers to explore different areas of the human body by clicking on animated hot-spots (field points) on the illustrated figure (left). Clicking on a field point links to biographical infor-mation related to David Bowie's life.

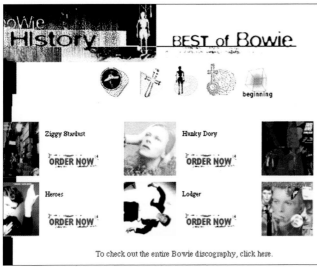

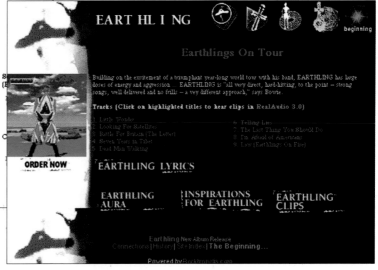

A "Fan Fiction" area (below) allows viewers to interact with the site and entices them to return to read future updates and entries.

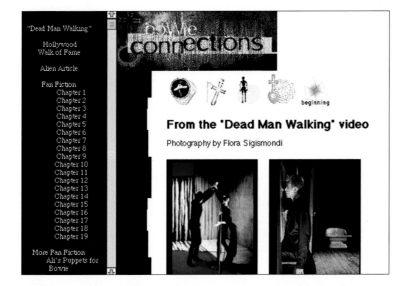

Project: davidbowie.com

Design Firm: N2K Entertainment

Client: Virgin Records

Design: Marlene Stoffers, Ben Clemens

Programming: Ben Clemens, Tim Nilson, Brian Warren

Features: GIF89a animation, Shockwave, JavaScript

ENIGMA3

COMMERCIAL

The design firm Prophet Communications used a variety of special features to create an intriguing site for the musical group Enigma. The site's extensive Shockwave games and CGI programming keep the viewer at the site playing games, while streaming audio keeps playing the music. The combination of simple games and music is surprisingly effective in encouraging the viewer to wait for downloads to complete.

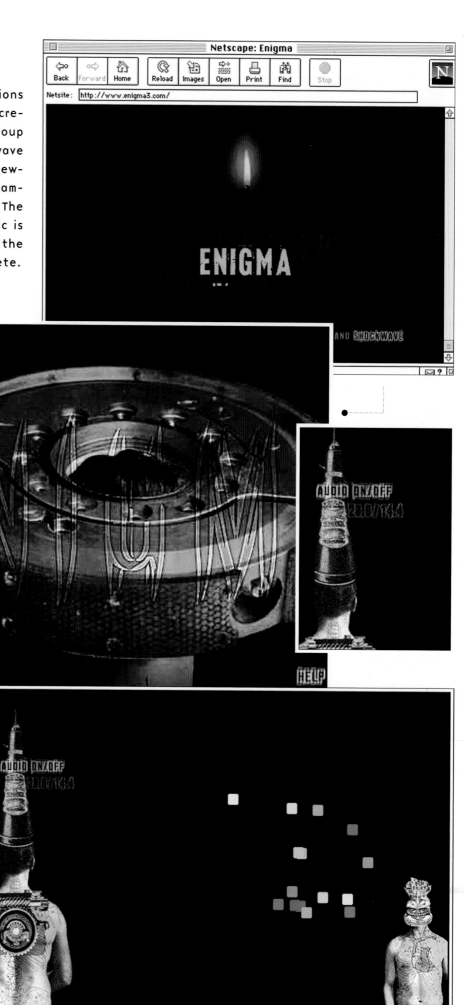

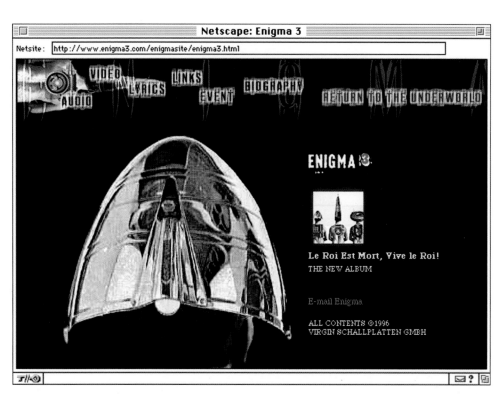

TECHNIQUE: The three images below are from a few of the many small game-type Shockwave movies from the site. The top image is from a game where the viewer can place an anamorphic image on a "reflecting" cylinder and view a normal image. The lower two images are part of a game in which the viewer assigns a temperament to each of five scenarios.

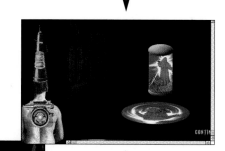

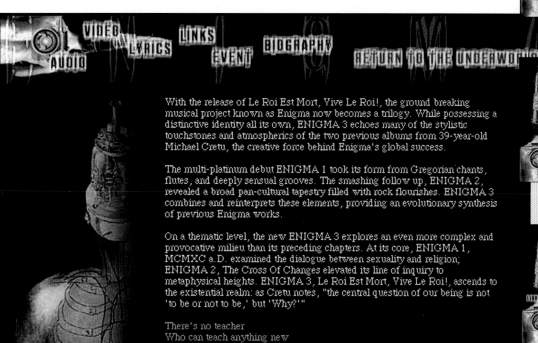

With the release of Le Roi Est Mort, Vive Le Roi!, the ground breaking musical project known as Enigma now becomes a trilogy. While possessing a distinctive identity all its own, ENIGMA 3 echoes many of the stylistic touchstones and atmospherics of the two previous albums from 39-year-old Michael Cretu, the creative force behind Enigma's global success.

The multi-platinum debut ENIGMA 1 took its form from Gregorian chants, flutes, and deeply sensual grooves. The smashing follow up, ENIGMA 2, revealed a broad pan-cultural tapestry filled with rock flourishes. ENIGMA 3 combines and reinterprets these elements, providing an evolutionary synthesis of previous Enigma works.

On a thematic level, the new ENIGMA 3 explores an even more complex and provocative milieu than its preceding chapters. At its core, ENIGMA 1, MCMXC a.D. examined the dialogue between sexuality and religion; ENIGMA 2, The Cross Of Changes elevated its line of inquiry to metaphysical heights. ENIGMA 3, Le Roi Est Mort, Vive le Roi!, ascends to the existential realm: as Cretu notes, "the central question of our being is not 'to be or not to be,' but 'Why?'"

There's no teacher
Who can teach anything new
He can just help us to remember
The things we always knew

Project: Enigma3

Client: Virgin Records

Design Firm: Prophet Communications

Design: Josh Feldman, Thor Muller

Original Artwork: Johann Zambryski

Illustration: Volker Streter

Features: GIF89a animation, Shockwave, Shockwave Streaming Audio

ALLSTAR MAGAZINE

COMMERCIAL

Allstar magazine is an online rock music publication offering readers a global look at the latest news, gossip, reviews, and interviews in the rock world. The home page (right) features a GIF89a animation of a sleeping dog with animated sleep "Z"s showing the movement. To feature the advertising on the site, looping GIF89a animations (such as "The Tragically Hip" ad, below) are placed in the lower left frame.

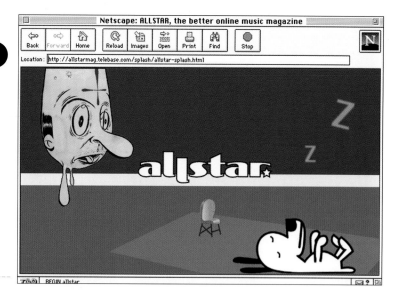

Netscape: ALLSTAR, the better online music magazine

Location: http://allstarmag.telebase.com/splash/allstar-splash.html

TECHNIQUE: Using frames, the designers broke the page into four separate blocks of information (below). The top and left-hand frames refresh the information in the middle frame without having to refresh themselves.

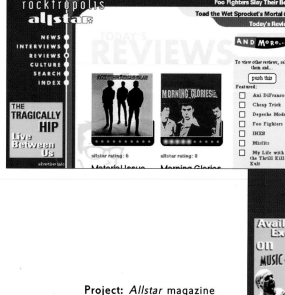

Project: *Allstar* magazine

Executive Producer: Robert Lord

Interactive Producer: Victor Bornia

Lead Graphic Artist: Michele Comas

Design Consultant: Trevor Gilchrest

Features: GIF89a animation

http://www.allstarmag.com

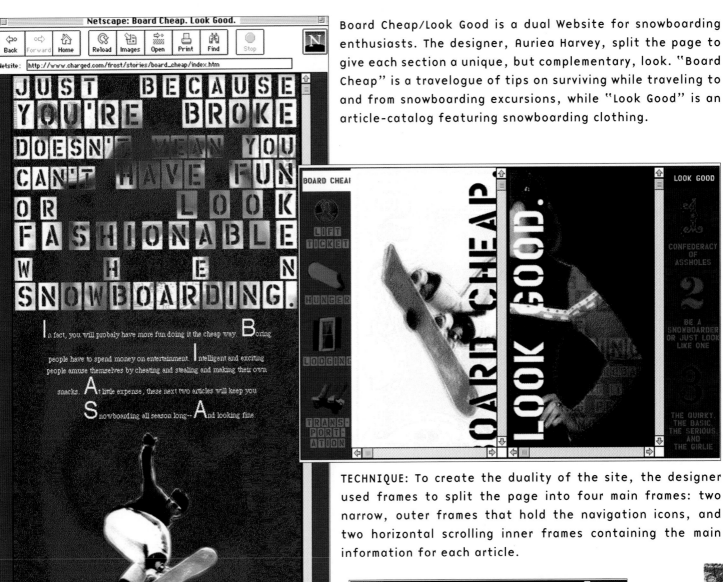

Board Cheap/Look Good is a dual Website for snowboarding enthusiasts. The designer, Auriea Harvey, split the page to give each section a unique, but complementary, look. "Board Cheap" is a travelogue of tips on surviving while traveling to and from snowboarding excursions, while "Look Good" is an article-catalog featuring snowboarding clothing.

TECHNIQUE: To create the duality of the site, the designer used frames to split the page into four main frames: two narrow, outer frames that hold the navigation icons, and two horizontal scrolling inner frames containing the main information for each article.

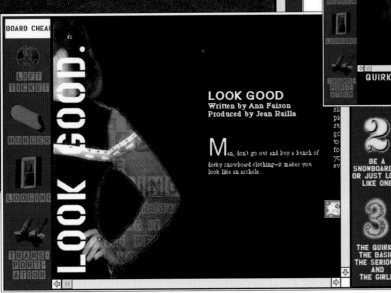

Project: Board Cheap/Look Good

Client: Charged

Design Firm: Entropy8 Digital Arts

Design: Auriea Harvey

Copy: Daniel Falcone

Producers: Daniel Falcone, Jean Railla

Features: GIF89a animation, JavaScript

The Motorbooty Worldwide Website is an online version of an underground magazine by the same name. Motorbooty Worldwide features comics, culture, and satirical humor, with illustrations by Mark Dancey. The designer, John Hill of 52mm, used bright colors to complement the printed magazine's wild content and outrageous illustrations.

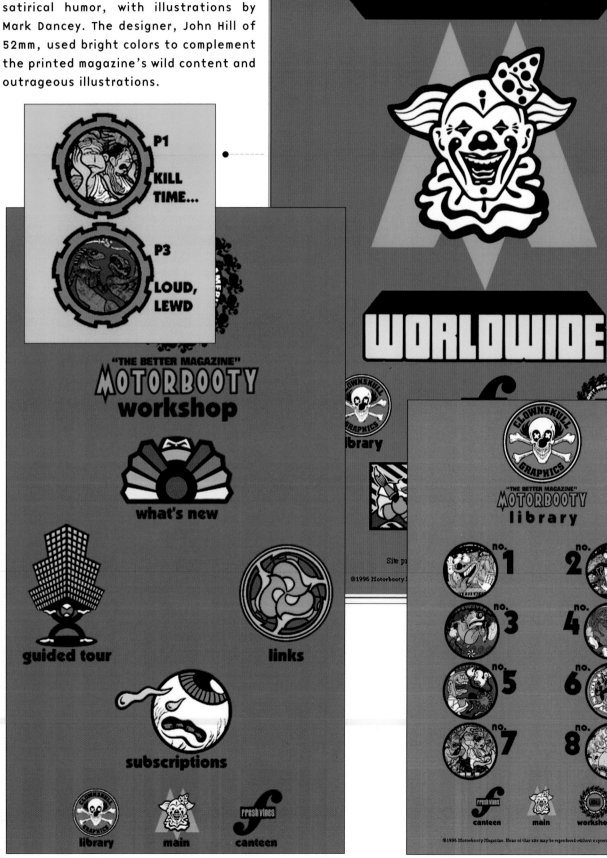

Netscape: MOTORBOOTY WORLDWIDE

Back | Forward | Home | Reload | Images | Open | Print | Find | Stop

Location: http://www.motorbooty.com/booty/

MOTORBOOTY

WORLDWIDE

P1 KILL TIME...

P3 LOUD, LEWD

"THE BETTER MAGAZINE"
MOTORBOOTY
workshop

what's new

guided tour

links

subscriptions

library main canteen

CLOWNSKULL GRAPHICS

"THE BETTER MAGAZINE"
MOTORBOOTY
library

no. 1 no. 2
no. 3 no. 4
no. 5 no. 6
no. 7 no. 8

canteen main workshop

©1996 Motorbooty Magazine. None of this site may be reproduced without expressed permission.

The bright, flat color scheme featured on each page makes it easier for the designer to optimize the pages for faster download. Using illustrations throughout the site rather than photos also helps to keep download times shorter.

Project: Motorbooty Worldwide

Design Firm: 52mm

Design: John J. Hill

Illustration: Mark Dancey

Photography: Mark Dancey

Programming: John J. Hill

PEPSI WORLD

COMMERCIAL

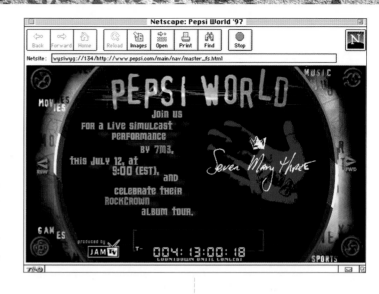

Pepsi World, designed by DDB Interactive, ranks as one of the most creative commercial Internet Websites. Pepsi World takes advantage of the latest advances in Web technology to present an interactive environment with cutting-edge design and navigation. The splash page of the Website opens a new Netscape window without toolbars and with borderless frames. In a new window the site is separated into five distinct frames that are joined together seamlessly as one design.

Each page features four main JavaScript buttons with sound. The main information frame features a new design for each upper-level page.

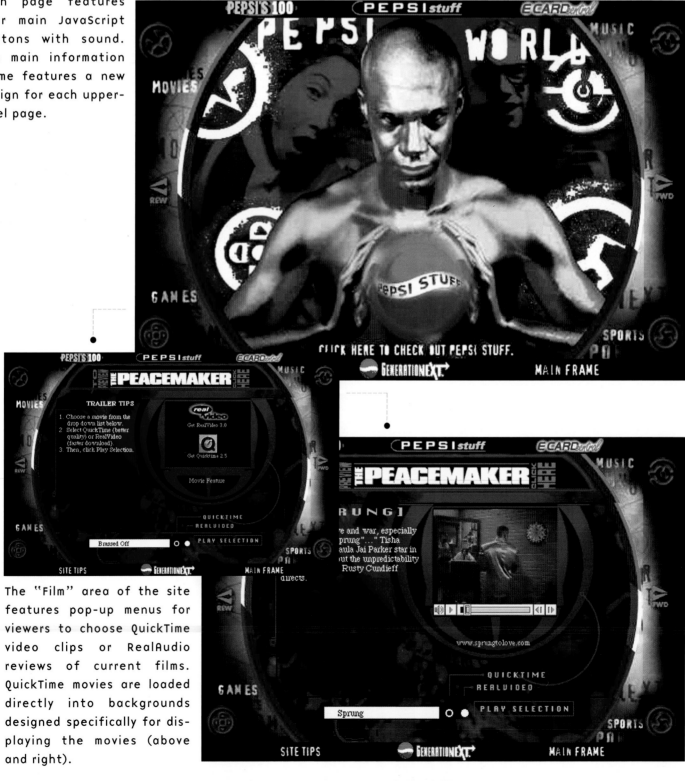

The "Film" area of the site features pop-up menus for viewers to choose QuickTime video clips or RealAudio reviews of current films. QuickTime movies are loaded directly into backgrounds designed specifically for displaying the movies (above and right).

TECHNIQUE: The designers wanted to create a very visually intensive, rather than text-intensive, Website. To achieve this, they present material in a non-scrolling environment, similar to a CD-ROM interface. The GIF89a animation of the slam-dunking basketball player links from the main sports area (below).

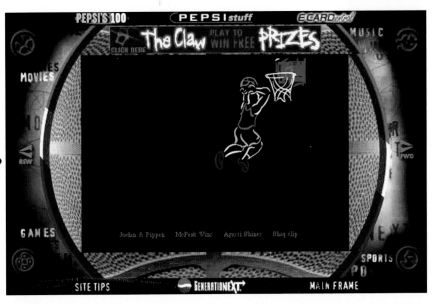

Project: Pepsi World
Client: Pepsi Co.
Design Firm: DDB Interactive
Design: Chris Hess, Frances Ko, Mike Gonzales, Tricia Elliot
Photography: Jill Green
Programming: Thomas Jeffry, Shelley Shay, Sal Torneo
Features: GIF89a animation, Shockwave Flash, JavaScript, Java, RealAudio, RealVideo, VRML, QuickTimeVR

FOUR COLOR IMAGES INC.

Four Color Images Inc. specializes in selling fine art from the field of comic books. The only store of its kind in New York City, Four Color Images put up a Website designed to highlight the store and the artists it represents, and to offer global access to the store's products. Garage fonts, rough borders, and splattered ink create a radical home page that complements the new style of comic art being created.

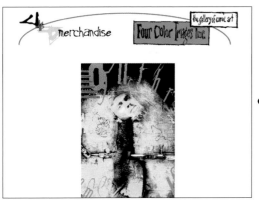

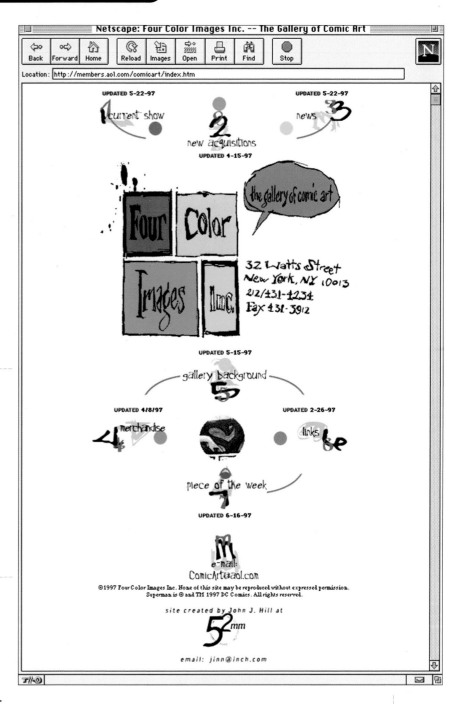

The rough design complements the illustration style of the featured artist's work (as with the Dave McKean calendar, above) but is still minimal enough to allow the artwork to stand out as the focus of the site.

Project: Four Color Images Inc.

Design Firm: 52mm

Design: John J. Hill

Photography: John J. Hill, Ken Sanzel, Laura Sanzel

Features: GIF89a animation

http://www.members.aol.com/comicart

Fabric8—a "virtual store"—features unique items created by urban designers. The graphic style of the site reflects the varied and individual styles of the designers showcased in this online shopping environment. Fabric8 designs each of the specific online areas for companies selling their products, trying to convey the look and feel of the company through the use of typography and Web technology such as JavaScript or GIF89a animations.

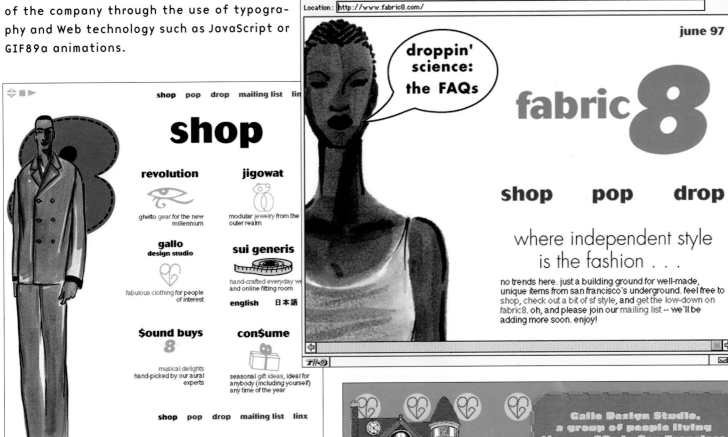

Project: Fabric8

Client: Fabric8 Online Boutique

Design Firm: Fabric8 Productions

Design: Olivia Ongpin, Antony Quintal

Programming: Antony Quintal, Olivia Ongpin, Joe Emenaker

Photography: Drea Donio, Keith Ross, Jackie Way

Features: GIF89a animation, Shockwave, JavaScript, Java, Beatnik

http://www.fabric8.com

D8 ANNEx

The d8 Annex is an online companion to *d8*, a print magazine about contemporary gaming. The site's designer, David DeCheser, wanted to create a promotional vehicle for the publication that would also showcase unpublished photography and artwork not used in *d8*. The d8 Annex contains contact information for staff, teasers for future issues, and gaming-related links from around the world. The Gothic and mystical icons and typography fit in well with the gaming theme of the site.

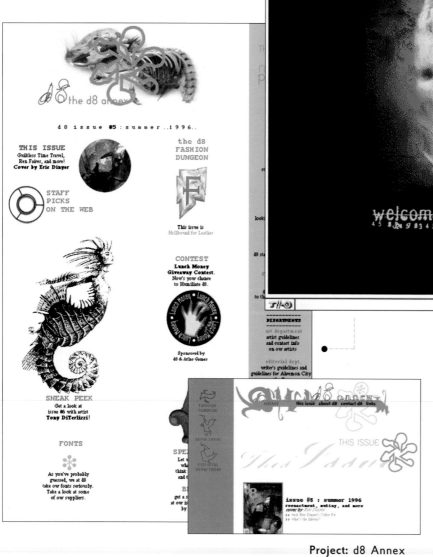

Project: d8 Annex

Design Firm: Dreamless Studios

Design: David DeCheser

Illustration: Eric Dinyer, David DeCheser, Joseph Hasenauer, Dave McKean

Programming: David DeCheser

Features: GIF89a animation

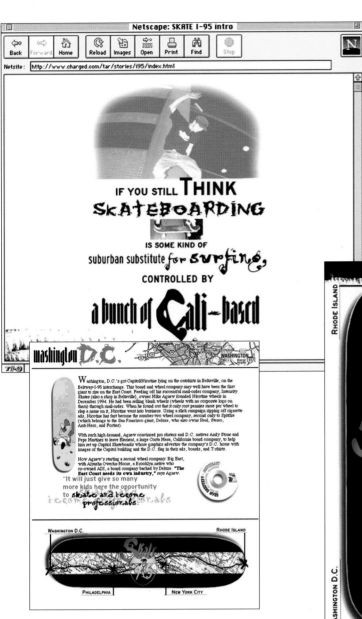

Skate I-95 was created as a promotional site for Charged—a skateboard manufacturer. Grunge typography and radical skateboarder images combine with HTML text and Web technology to let skateboarders everywhere know what is happening throughout the United States.

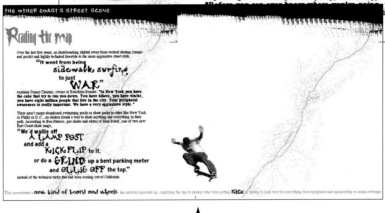

TECHNIQUE: The "Reading the Map" article (right) is featured in a long, horizontally scrolling page. To cue viewers that they need to scroll across the page to continue reading the article, a GIF89a animation of a skateboarder moves from left to right, crossing the page and disappearing.

Project: Skate I-95

Client: Charged

Design Firm: Entropy8 Digital Arts

Design: Auriea Harvey

Features: GIF89a animation

rSUB

The Razorfish Subnetwork is an online network of original content. It serves as a platform for highly idiosyncratic, well-executed personal artistic and political expression in the form of games ("Bunko!"), episodic fiction ("This Girl"), art and literature ("the blue dot"), cutting edge technology and futurology ("TheNvelope"), and others.

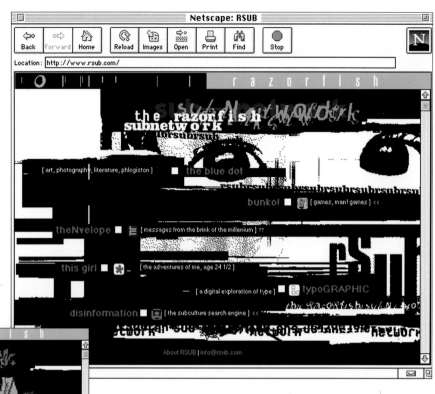

The home page features four different designs that load in random order, with different color schemes for both the background and text. The premise seems to be "Don't abandon the old, but accommodate the new."

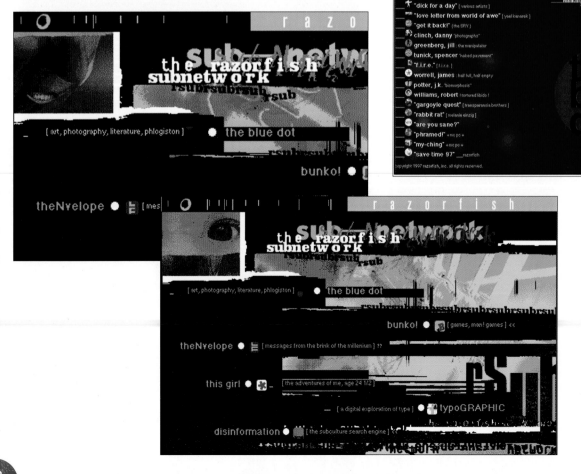

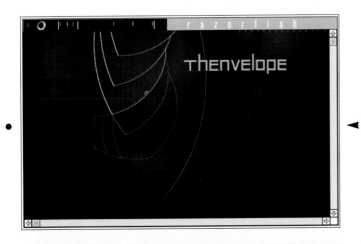

TECHNIQUE: "TheNvelope" area of the site features a background full of intriguing organic and linear elements, evoking a feeling of web-like deep sea architecture (left). The central ladder-like construction (below) contains JavaScript buttons that reveal hidden text in the open area to the right, and clicking on a button loads additional information into the frame.

Project: Razorfish Subnetwork

Design Firm: Razorfish Inc.

Main Interface Design: Thomas Mueller (see credit listings, page 160)

Programming: Oz Lubling, Mark Tinkler

Features: GIF89a animation, Shockwave, Java applets, RealAudio

Xcentrix, a quarterly entertainment Web magazine, features fashion, music, and film reviews. The magazine's design conveys a sense of urban decay interwoven with the technology of the Web. The home page (right) typifies this idea: A fractal-like image, collaged with rough textures and typography, is overlaid with sparkling GIF89a animations.

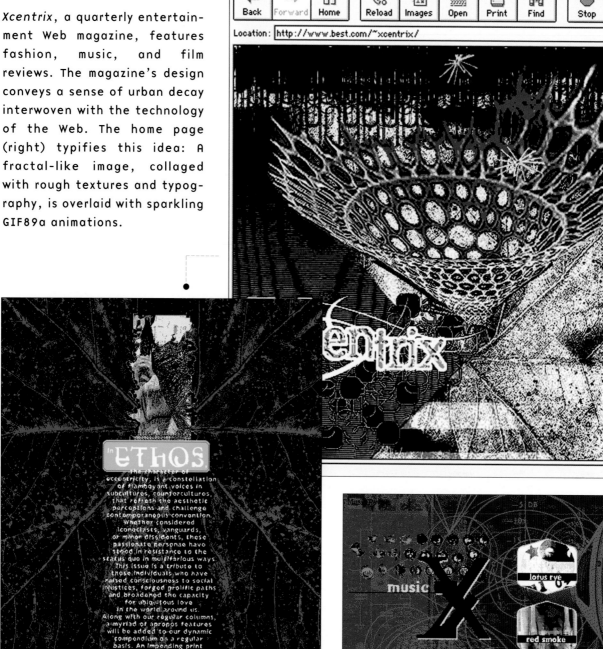

The music area of the *Xcentrix* Website features downloadable music clips that can be played using the RealAudio plug-in. To make downloading easier, the designers specify two modem speeds for audio clips (right).

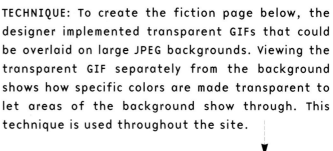

TECHNIQUE: To create the fiction page below, the designer implemented transparent GIFs that could be overlaid on large JPEG backgrounds. Viewing the transparent GIF separately from the background shows how specific colors are made transparent to let areas of the background show through. This technique is used throughout the site.

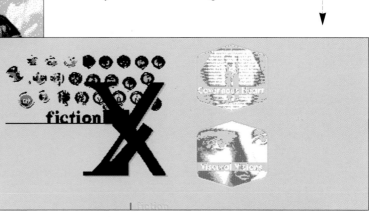

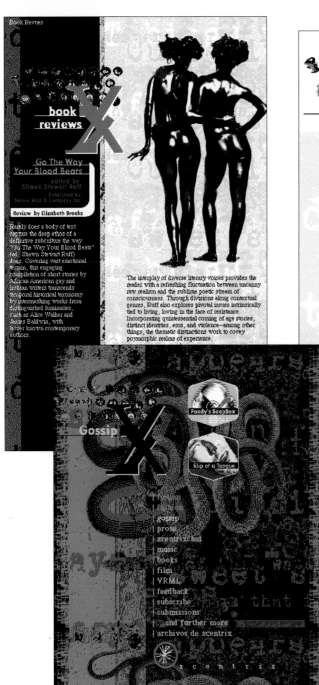

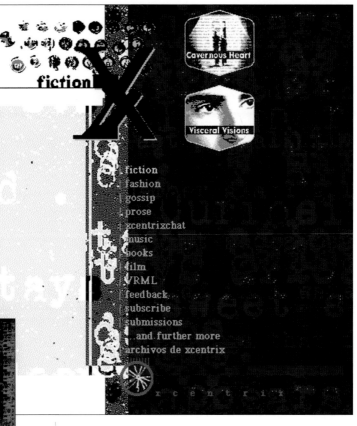

Project: *Xcentrix* Magazine

Design Firm: MK Advertising & Design

Design: Martin Kraus

Illustration: Eric Dinyer

Photography: Martin Kraus, Elizabeth Brooks

Programming: Peter Trapasso

Features: GIF89a animation, Shockwave, JavaScript, RealAudio, VivoActive

Cutting Edge
Self-Promotion

utting-edge is a highly individual concept-dependent on the background and interests of the definer. One person's attempt to define "cutting edge" might be: "an unpopular style on the verge of receiving public acceptance." of course, after a brief time in the spotlight, the "cutting edge" becomes "mainstream."

Too often, however, "cutting edge" is merely a design that everyone thinks sucks-until a person of notoriety says it is genius, which often happens in web magazines, design journals, "cool site of the day" lists and the like. Technology itself often becomes a part of the definition of cutting edge, especially to the technology-addicted web surfer, for whom a great plug-in or innovative java programming can be as important an element of the site as the graphics and layout.

The cutting-edge of web design evolves and changes more rapidly than in other media. This is due in part to the ability of web developers to affordably deliver content. The economic playing field of the web is more accessible for talented designers and students than for any other medium, such as magazines, video, film, or even direct mail. An innovative site doesn't necessarily have the same exposure to the world as Microsoft's or Netscape's site, but its presentation and content can outshine many high-budget sites. When you compare the cost of this presentation to the cost of printing a glossy promotional mailer or working with a film crew, you can see that detachment from major budgetary constraints shapes the future of the web. For one thing, the office is always open-designers can go to their regular day jobs, but can generate a lot of "night owl,"

part-time design-self-satisfying creations. For another thing, images for the web need only be 72-DPI resolution-easy to work with on an average or above-average machine. At the same time, it also accelerates the design process.

As with CD-ROM design and programming, the limitations of web design are related to the technical capabilities of the viewer's machine; unlike television, film, or print, where the finished products either play back on fully compatible, standardized machines, or require no equipment at all, the web is an experience entirely dependent on bandwidth, the viewer's monitor, and the software the viewer has installed, with bandwidth being the most important. It is safe to say that presently 14.4 Kbps modems form the largest base for web surfers. Those who have used these modems know that these devices are too slow to be the foundation for the future of the web-the lowest common denominator of bandwidth needs to be raised a bit higher, and it's happening now. Additionally, not many people are willing to find and download 2 MB plug-ins in order to view your latest piece of cutting-edge work. These factors, of course, narrow the potential audience. If the target audience uses high-speed connections, there is nothing to worry about. You must be not only a designer, but a programmer and a systems analyst in order to anticipate, evaluate, and solve these frustrations encountered on the cutting edge.

The first consideration is "how many people do you want to view your work?"; second is, "who are your clients?" Your site might actually attract a few clients who love cutting-edge design, but they also may have a different priority when choosing you as their designer-they have products to sell and information to provide to viewers. Inevitably your passion for new technology and design innovations will have to take a backseat to the client's needs, that is, if you're trying to make a living at being a web designer. At Dreamless Studios our experience is that cutting-edge design for our clients is limited almost exclusively to a graphical arrangement-our clients do not expect visitors to have a particular plug-in (or to go download one) to be able to view their sites.

Surprisingly, we have noticed that some print designers are hesitant to enter

the web scene-generally those who have had only limited exposure to or interest in the web-it seems that there is an underlying fear of new technology, similar to the fear of desktop publishing that swept through the design world (which we still encounter among designers, again to our surprise).

Designing interactive media requires a non-linear, highly experience-based approach that can challenge even the best print designers. Although the required programming skills lessen with each passing day, print designers still grapple with designing for the screen.

Cutting-edge web design will always remain on the fringes of the web. Corporations trying to sell products and services to a certain market group will dissect and extract palatable bits and pieces of cutting-edge design for ad campaigns-either to attract individuals from a desired demographic or to evoke a sense of "hipness."

What is the future of the cutting edge? Maybe by the year 2001 we will have been so inundated by interactivity, graphics, and sound that someone will capture the spotlight by returning to the "retro" web look of 1994 (i.e., gray backgrounds, left justified type, etc.) and be proclaimed a genius. As the future is designed, page by page, it's important to remember that as a cutting- edge designer it's easy become jaded with your own work, perhaps losing perspective on what cutting-edge means to the rest of the world-whether the rest of the world means clients or itinerant web surfers.

DAVID DECHESER
ERIC DINYER
DREAMLESS STUDIOS

IN EVERY WORK OF GENIUS WE RECOGNIZE OUR

OWN REJECTED THOUGHTS; THEY COME BACK TO

US WITH A CERTAIN ALIENATED MAJESTY.

≫ *RALPH WALDO EMERSON*

151

SELF-PROMOTION

The 151 Website shows a self-portrait of a six-month period in the life of designer/illustrator Joel Harris, as seen through his work, art, and music. The site uses typography, illustration, photography, and original music by the designer's brother, Erik Brown, to evoke a sense of individual experience and mood.

The "151" GIF89a animation at the left edge of the home page (below) continuously expands and contracts vertically as Shockwave music files load in.

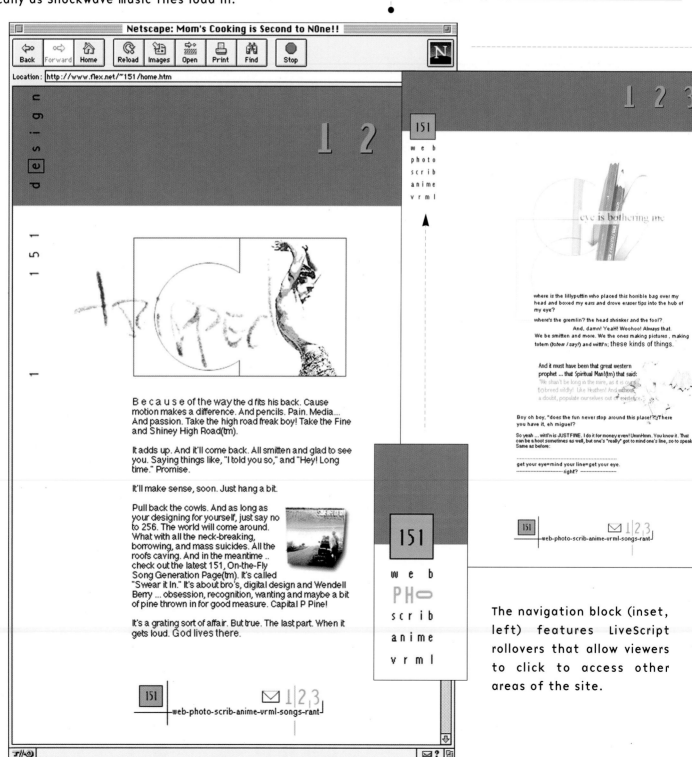

Because of the way the d fits his back. Cause motion makes a difference. And pencils. Pain. Media... And passion. Take the high road freak boy! Take the Fine and Shiney High Road(tm).

It adds up. And it'll come back. All smitten and glad to see you. Saying things like, "I told you so," and "Hey! Long time." Promise.

It'll make sense, soon. Just hang a bit.

Pull back the cowls. And as long as your designing for yourself, just say no to 256. The world will come around. What with all the neck-breaking, borrowing, and mass suicides. All the roofs caving. And in the meantime .. check out the latest 151, On-the-Fly Song Generation Page(tm). It's called "Swear it In." It's about bro's, digital design and Wendell Berry ... obsession, recognition, wanting and maybe a bit of pine thrown in for good measure. Capital P Pine!

It's a grating sort of affair. But true. The last part. When it gets loud. God lives there.

The navigation block (inset, left) features LiveScript rollovers that allow viewers to click to access other areas of the site.

This is a collection of homebrew recordings that my bro erik and I made not to long ago. The recordings I mean. This web page business is new. Anyway, they are available here in three of the most accessible audio formats on the net. You have no excuse to not listen.

TECHNIQUE: Streaming audio begins to play as viewers enter the site from the splash page (facing page, top). In the "Trouble on the Go" area viewers can select from three formats—Shockwave streaming audio, RealAudio, and AU files—to listen to as they view illustrations and photos that accompany the lyrics.

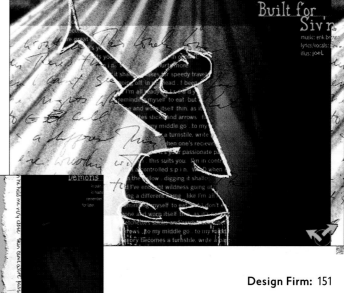

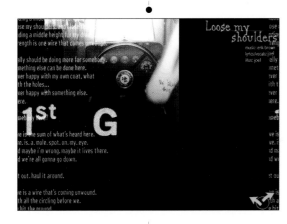

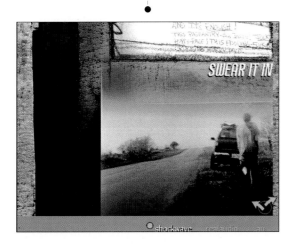

Design Firm: 151

Design: Joel Harris

Photography: Joel Harris, Erik Brown

Programming: Nick Heinle

Features: GIF89a animation, Shockwave, Shockwave Streaming Audio, LiveScript, RealAudio

26 & TEETH

SELF-PROMOTION

26 & Teeth, the personal Web site and portfolio of graphic design student Kevin Tamura-Murphy, features clean designs against plain backgrounds—a technique evoking a sense of spaciousness.

The site features spare, clean navigation in the form of a vertical list in the upper right corner. The current title is blurred, but as the cursor rolls over other titles, a JavaScript loads a clickable GIF89a animation that creates the effect of the text blurring.

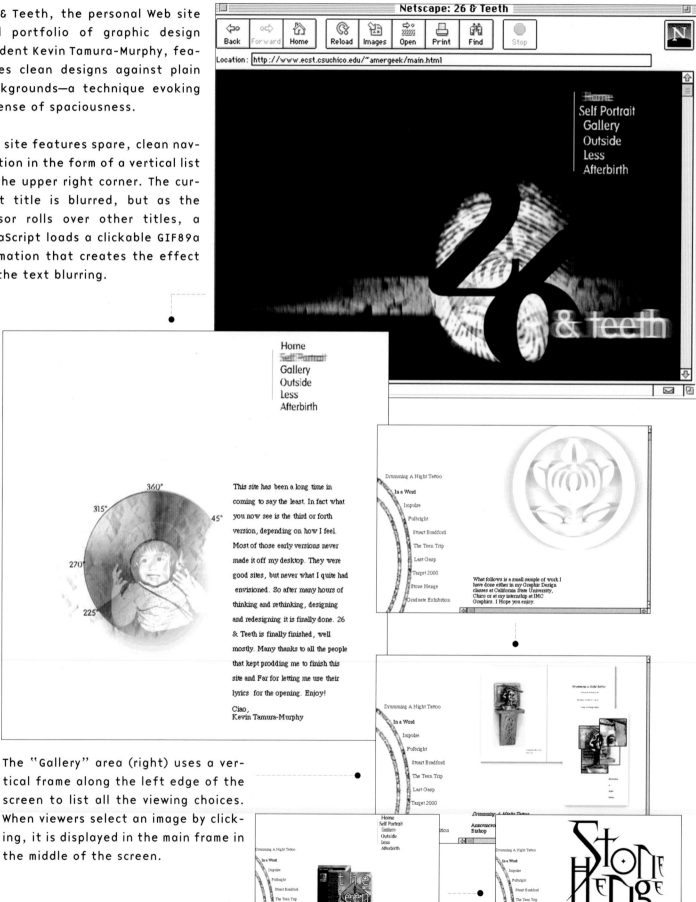

Netscape: 26 & Teeth

Back | Forward | Home | Reload | Images | Open | Print | Find | Stop

Location: http://www.ecst.csuchico.edu/~amergeek/main.html

Home
Self Portrait
Gallery
Outside
Less
Afterbirth

This site has been a long time in coming to say the least. In fact what you now see is the third or forth version, depending on how I feel. Most of those early versions never made it off my desktop. They were good sites, but never what I quite had envisioned. So after many hours of thinking and rethinking, designing and redesigning it is finally done. 26 & Teeth is finally finished, well mostly. Many thanks to all the people that kept prodding me to finish this site and Far for letting me use their lyrics for the opening. Enjoy!

Ciao,
Kevin Tamura-Murphy

What follows is a small sample of work I have done either in my Graphic Design classes at California State University, Chico or at my internship at IMC Graphics. I hope you enjoy.

The "Gallery" area (right) uses a vertical frame along the left edge of the screen to list all the viewing choices. When viewers select an image by clicking, it is displayed in the main frame in the middle of the screen.

Featuring clean layouts, simple typography, and intriguing illustrations, the "My Life" section recounts the designer's youth. The page at the left appears at the end of the sequence, allowing viewers to return to any page of the story at will.

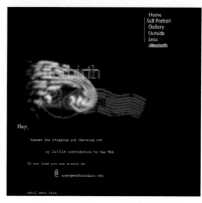

Project: 26 & Teeth

Design: Kevin Tamura-Murphy

Features: GIF89a animation

SELF-PROMOTION

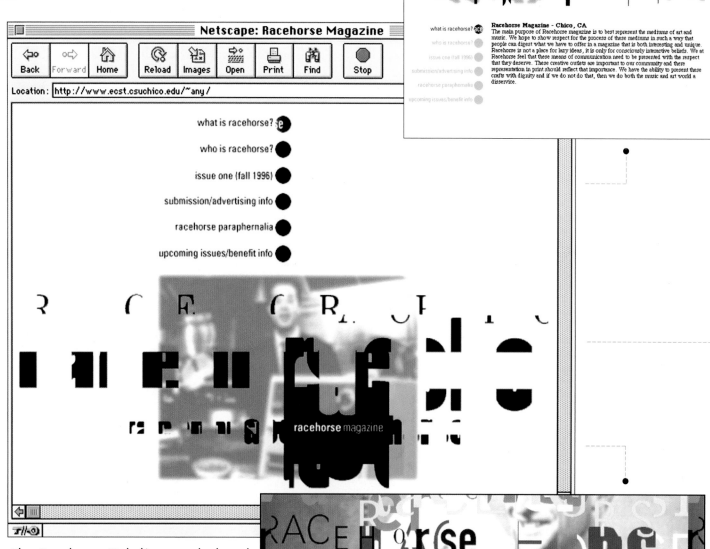

Netscape: Racehorse Magazine

Back | Forward | Home | Reload | Images | Open | Print | Find | Stop

Location: http://www.ecst.csuchico.edu/~any/

what is racehorse?
who is racehorse?
issue one (fall 1996)
submission/advertising info
racehorse paraphernalia
upcoming issues/benefit info

Racehorse Magazine - Chico, CA
The main purpose of Racehorse magazine is to best represent the mediums of art and music. We hope to show respect for the process of these mediums in such a way that people can digest what we have to offer in a magazine that is both interesting and unique. Racehorse is not a place for lazy ideas, it is only for consciously interactive beliefs. We at Racehorse feel that these means of communication need to be presented with the respect that they deserve. These creative outlets are important to our community and there representation in print should reflect that importance. We have the ability to present these crafts with dignity and if we do not do that, then we do both the music and art world a disservice.

racehorse magazine

The Racehorse Website was designed to provide an additional means of accessing original or updated material from *Racehorse* magazine, a local fiction, poetry, and music magazine.

The seven main sections of the site are grouped in a single frame that appears as an element on subsequent pages. The circle for the active section features a black and white GIF89a animation that cycles through the word "Racehorse."

The headers for each section feature the "Racehorse" name, but with a different color palette and a different typographic treatment—most viewers won't notice, but those who do will appreciate the designer's creativity.

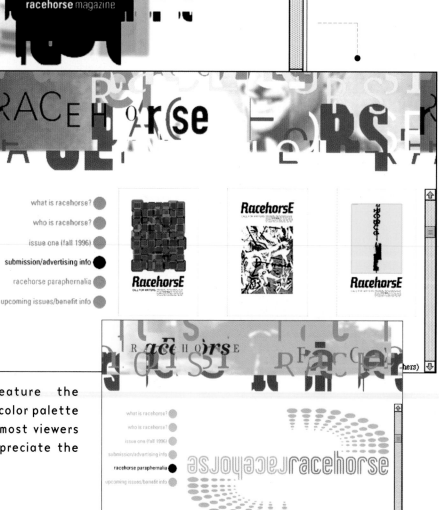

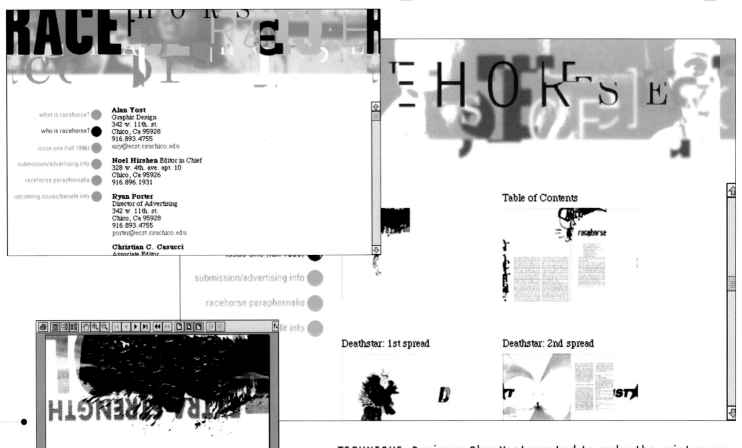

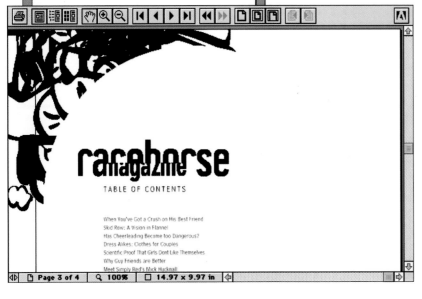

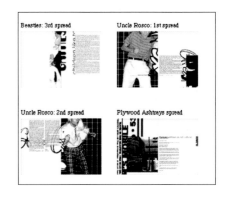

TECHNIQUE: Designer Alan Yost wanted to make the print maga-
zine experience accessible to Web viewers, so thumbnail images
of the entire magazine (above) link to and display fully down-
loadable electronic versions as PDF files. These can be viewed
onscreen if the viewer has the plug-in for Adobe Acrobat
installed (left and below).

Project: *Racehorse* magazine
Design Firm: Big Deal Design
Design: Alan Yost
Features: GIF89a animation

SOME CLUB

SELF-PROMOTION

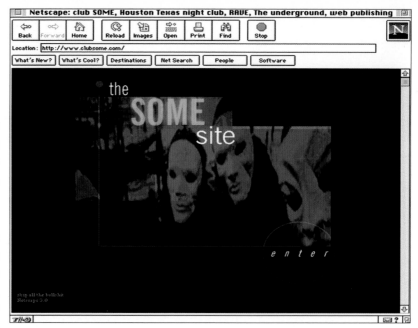

Project: SOME club

Client: SOME club

Design: Trevor Dodd

Features: GIF89a animation,
Shockwave Streaming Audio,
Shockwave, JavaScript

The SOME club site promotes SOME club, a music nightclub located in Dallas, Texas. SOME club's Web designer, Trevor Dodd, sums up his site by explaining it as being "fun and trippy with a touch of conscience."

The site's splash page features a dark, almost Mardi Gras-like image leading to a home page carrying on the dark design with a silver-gray palette and broken grunge typography. Viewers can check out links to various types of music, a schedule of SOME club events, and a number of fliers designed for the club. For the "touch of conscience," Dodd has included his thoughts on eating animals in the "Kill the Cow" area of the site.

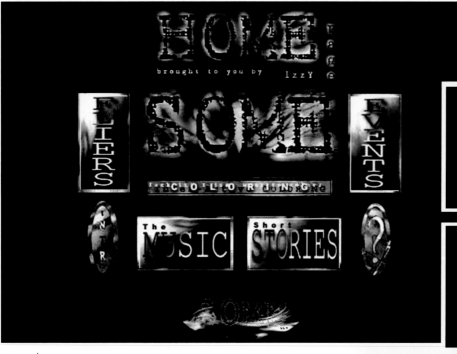

TECHNIQUE: The GIF89a animation at the bottom of the home page was created with the "Twirl" filter in Photoshop on several different layers, combining them to be imported into GifBuilder, and the exporting the images as a GIF89a animation.

http://www.clubsome.com

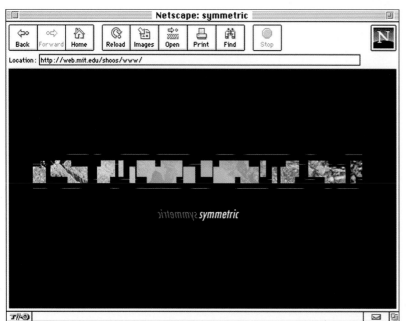

Andrew Hsu says that the original purpose of his Website was "mainly just to have one." Once the site was up and running, Hsu transformed it into an interactive resume to display his interests in graphic design.

The simple navigation scheme of the image-mapped home page (there are only three links branching off to other pages) draws the viewer's focus to the design and typography of the site. Quick downloads of each page make the site convenient for slower modems and viewers in a hurry to see Hsu's design work.

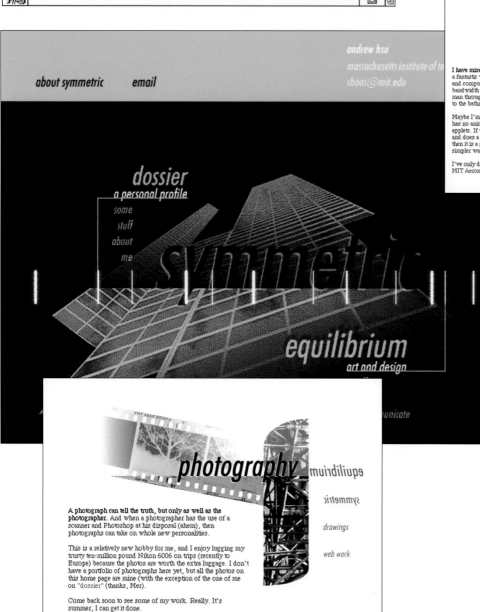

web work

equilibrium
symmetric
drawings
photography

I have mixed feelings about web design. On the one hand, it's a fantastic way to show off one's enthusiasm for art, design, and computers. However, the web has become an enormous bandwidth hog that tries to cram every type of media known to man through our puny phone lines. It disturbs me that I can go to the bathroom and come back while the weather page loads.

Maybe I'm a purist. Note that my page spawns no windows, has no animated gifs, and has no little roller-scroller Java applets. If the above is implemented well, for a clear reason, and does a better job of communicating than a simpler way, then it is a good design. But in the meantime, I'll do it the simpler way.

I've only done a few web pages for various organizations. The MIT Aeronautics and Astronautics web site, the MIT

photography

equilibrium
symmetric
drawings
web work

A photograph can tell the truth, but only as well as the photographer. And when a photographer has the use of a scanner and Photoshop at his disposal (ahem), then photographs can take on whole new personalities.

This is a relatively new hobby for me, and I enjoy lugging my trusty ten-million pound Nikon 6006 on trips (recently to Europe) because the photos are worth the extra luggage. I don't have a portfolio of photographs here yet, but all the photos on this home page are mine (with the exception of the one of me on "dossier" (thanks, Mer).

Come back soon to see some of my work. Really. It's summer, I can get it done.

Project: Andrew Hsu portfolio

Design: Andrew L. Hsu

BILL DOMONKOS

SELF-PROMOTION

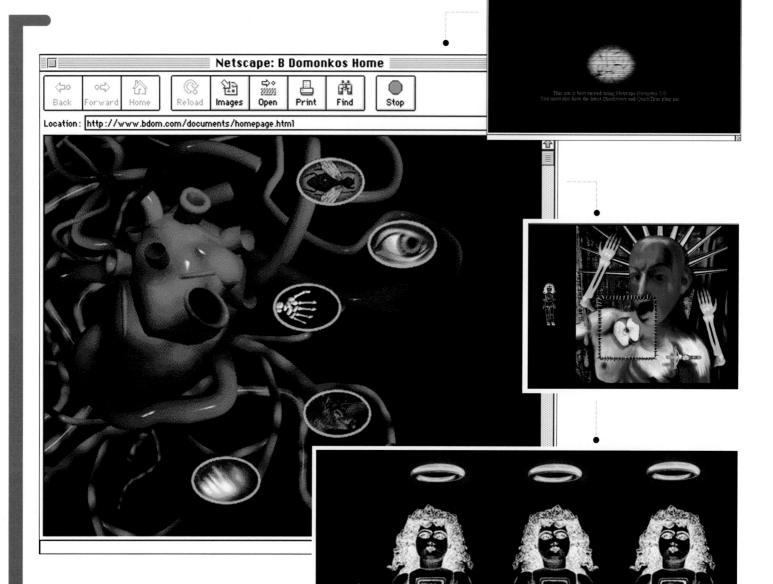

Netscape: Bill Domonkos

Location: http://www.bdom.com/

This site is best viewed using Netscape Navigator 3.0.
You must also have the latest Shockwave and QuickTime plug-ins.

Netscape: B Domonkos Home

Back Forward Home Reload Images Open Print Find Stop

Location: http://www.bdom.com/documents/homepage.html

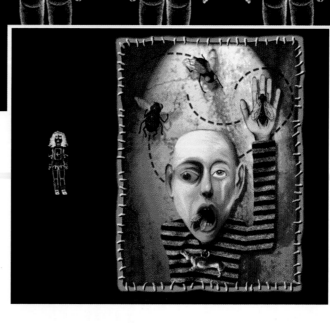

Bill Domonkos, a freelance designer and animator based in San Francisco, crafted this online portfolio of his work to surprise viewers, thereby also engaging them. The site is almost wholly image-based, text being restricted to the splash page (top right) and the designer's biography area. Viewers to the site are compelled to explore a language-less land with their sole reward being visual imagery. Clicking on one image leads to other surreal images, as well as to Shockwave interactive pieces.

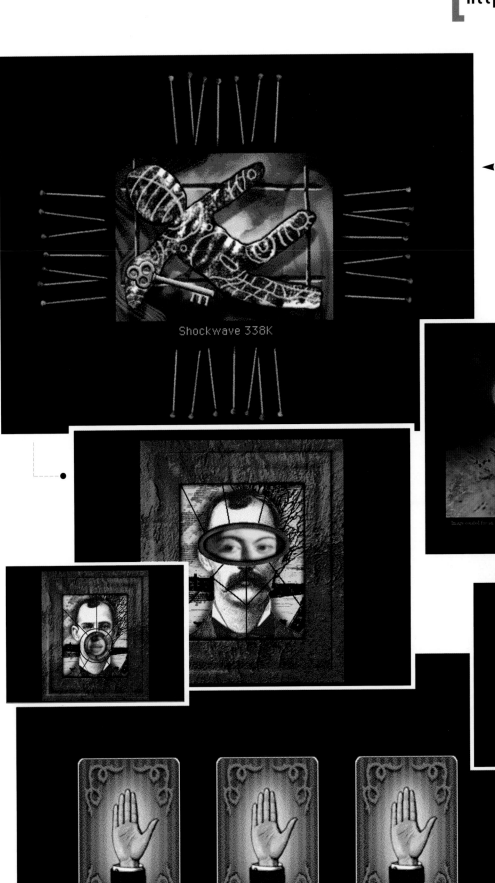

Shockwave 338K

TECHNIQUE: The designer uses Shockwave movies as gateways to video, illustration, or other Shockwave movies. In the Shockwave movie at left, rolling the cursor over the voodoo figure's arm generates a clickable key that takes the viewer to the three-card tarot spread (below left), in which each card is again a clickable object.

Design: Bill Domonkos

Programming: Vince Guarino,
Julie Cohen

Features: GIF89a animation,
Shockwave

52MM

SELF-PROMOTION

The 52mm Website contains all the basic elements of a conventional self-promotional site: portfolio, client list, employee portraits, and so on, but the site has a unique edginess and sharpness deriving from the use of grainy, dark images throughout, as well as unconventional typography.

The images on this page are from an earlier version of the 52mm site, whereas the images from the opposite page are from the updated version. A standard Netscape window was used on the earlier design, but for the later versions JavaScript programming removes the toolbar and produces a cleaner look and a smaller screen, and images load in very rapidly.

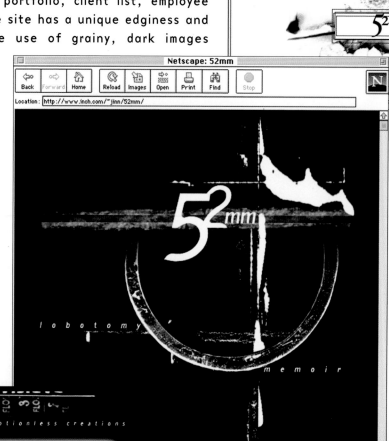

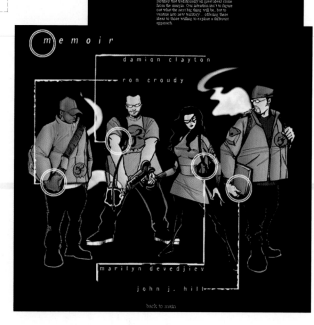

Instead of a traditional photographic treatment to feature the designers at 52mm, the firm opted for this playful comic book rendition of the designers.

TECHNIQUE: The "Movements" section of the updated site offers viewers playable QuickTime clips from the company's demo reel. Clicking on a screen shot from the image-mapped graphic (left) opens a new window and loads in a QuickTime movie.

The updated site also features an audible navigation bar. JavaScript rollovers cause percussion sounds to play for each icon (left and below).

Design Firm: 52mm

Design: John J. Hill, Ron Croudy,
Marilyn Devedjiev

Illustration: John J. Hill, Ron Croudy

Photography: John J. Hill

Programming: John J. Hill

Features: JavaScript, Shockwave

BrNr LABS

SELF-PROMOTION

The BRNR site features avant-garde Web experiments, delivering interactive entertainment, information, and other unique things to click through. Each circle on the home page grid (right) links to an area of the site; currently, the only active links are the circles with icons in them. Rolling over the icons causes the frame to the left to display a representation of the link's destination—game, experiment, or information.

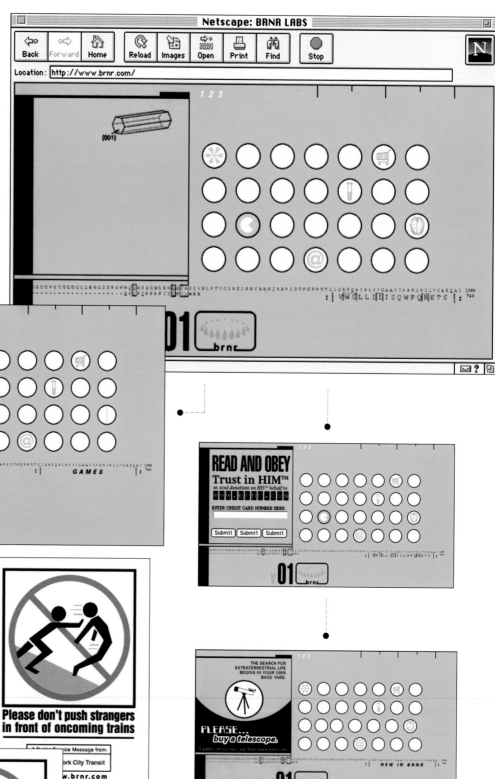

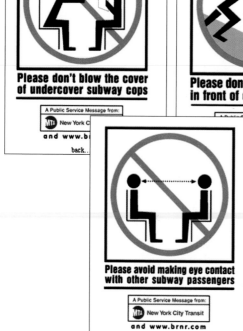

Personal humor and commentary are as essential to this site as fine design and JavaScript. The hypothetical signs (above left and left) are from the "Pure Culture" area of the site (opposite page).

TECHNIQUE: Programmer/designer Michael French has brought a Korean version of the classic game "Rock-Paper-Scissors" to the Web, complete with strategy and sound, using Shockwave programming. Clicking on the "play game" button initiates play against the computer.

The center images are from another Shockwave game featured on the site, "Bob's Plumbing Co."

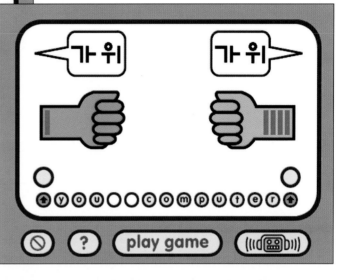

Project: BRNR Labs

Design: Michael French

Features: GIF89a animation, Shockwave, JavaScript

The link to the "United Users of Gaussian Glow" at the lower right of the page above, is a wry commentary on special interest design groups.

CIRCUMSTANCE DESIGN

SELF-PROMOTION

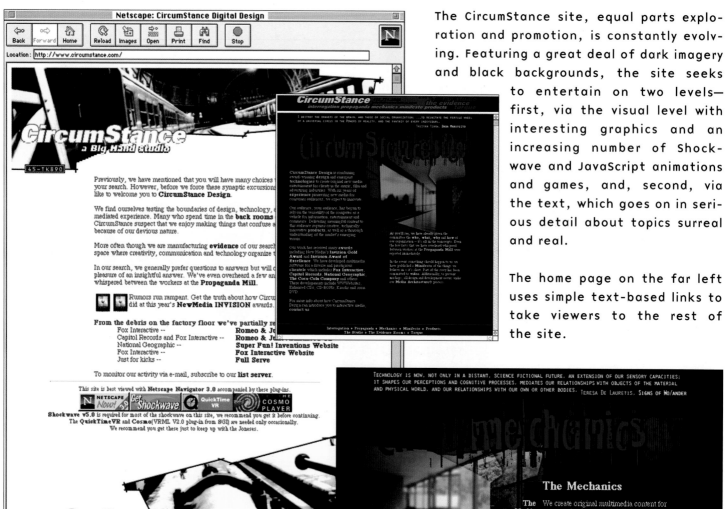

The CircumStance site, equal parts exploration and promotion, is constantly evolving. Featuring a great deal of dark imagery and black backgrounds, the site seeks to entertain on two levels—first, via the visual level with interesting graphics and an increasing number of Shockwave and JavaScript animations and games, and, second, via the text, which goes on in serious detail about topics surreal and real.

The home page on the far left uses simple text-based links to take viewers to the rest of the site.

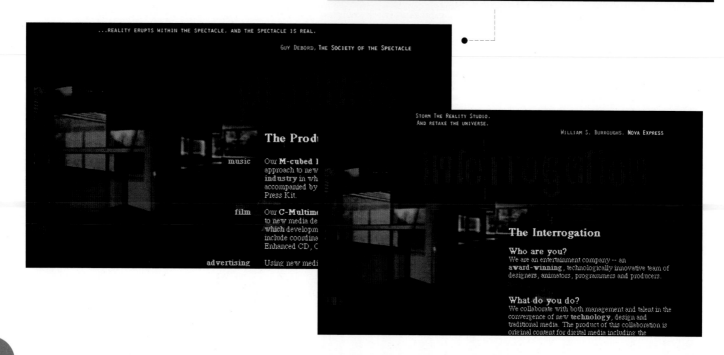

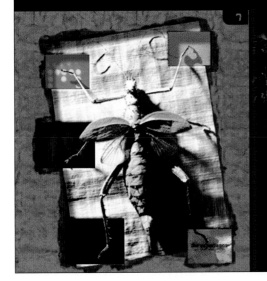

THE ART OF MAKING PICTORIAL STATEMENTS IN A PRECISE AND REPEATABLE FORM IS ONE THAT WE HAVE LONG TAKEN FOR GRANTED IN THE WEST. BUT IT IS USUALLY FORGOTTEN THAT WITHOUT PRINTS AND BLUEPRINTS, WITHOUT MAPS AND GEOMETRY, THE WORLD OF MODERN SCIENCES AND TECHNOLOGIES WOULD HARDLY EXIST. -MARSHALL MCLUHAN

Previously, I have mentioned the possible existence of a government agency of cartographers dedicated to the exploration and modeling of reality in both the physical world and cyberspace. The information they gather is far more extensive than what is generally available and, therefore, potentially harmful to the status quo of public perception. For this reason every conceivable effort is made by the Bureau to protect its trade and conceal it's own existence.

The cartographers are conditioned to monitor, direct, and analyze multiple real-time feeds, database sources, and physical information. They have an inhuman capacity to focus millions of data sources world wide in an effort to attain omniscience within 'emergent events.' The bureau's existence is attributed to the

The images to the left and below serve as examples of how animation and Shockwave animations can be used as page design elements. In the top image, the graphic of the insect is overlaid with six windows containing different GIF89a animations. The effect is of constant activity.

In the lower image, a complex interactive Shockwave animation plays in the left-hand frame. Several things happen at once: the viewer can manipulate the circles by clicking and dragging the mouse; the clicking action also changes the wording of the blue sentence and the numbering of the X, Y, and D coordinates; additionally, the black-and-white images within the circles constantly switch. The challenge is for viewers to unravel the effect of their actions versus the effects of underlying programming.

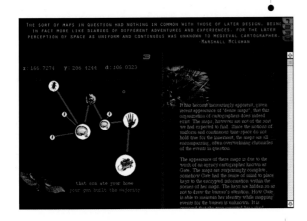

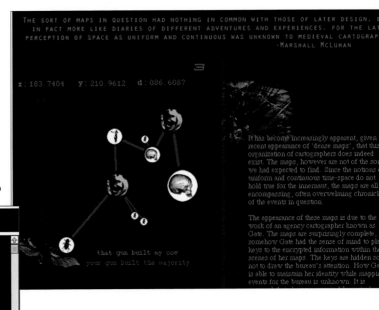

Design Firm: CircumStance Design

Design: Tim Barber, David Bliss

Illustration: Tim Barber, David Bliss

Programming: David Bliss

Features: GIF89a animation, Shockwave, JavaScript

CircumStance Design is combining award-winning design and emergent technologies to create original new media entertainment for clients in the music, film and advertising industries. With six years of experience pioneering new media for consumer audiences, we expect to innovate.

Our audience, your audience, has begun to rely on the versatility of the computer as a vehicle for information, entertainment and commerce. Delivering meaningful content to this audience requires creative, technically innovative products, as well as a thorough understanding of the market's emerging terrain.

Our work has received many awards including New Media's Invision Gold Award and Invision Award of Excellence. We have developed multimedia software for a diverse and prestigious clientele which includes Fox Interactive, Capitol Records, National Geographic, The Coca-Cola Company and others. These developments include WWWebsites, Enhanced CDs, CD-ROMs, Kiosks and soon DVD.

For more info about how CircumStance Design can introduce you to interactive media, contact us.

SMARTBOMB

SELF-PROMOTION

The Smartbomb Website is an online portfolio and experimental area where illustrator Ron Croudy showcases current and past projects. The home page illustrations (below and left) are the main focus of the navigation structure, which is woven around and through a robot reminiscent of Japanese techno-animation. Icons mapped to specific areas of the robot's suit link viewers to other pages within the Website.

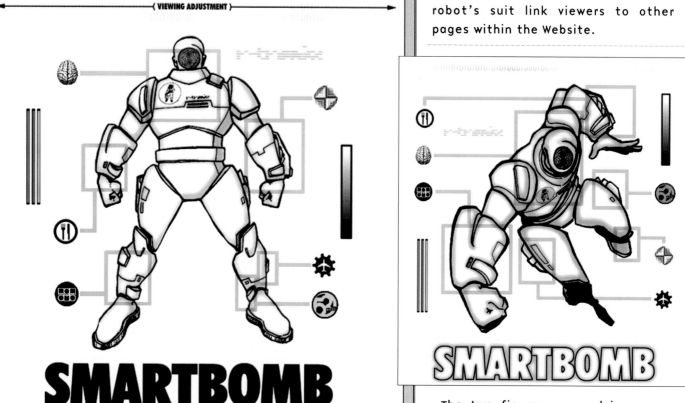

Netscape: SMARTBOMB

Back | Forward | Home | Reload | Images | Open | Print | Find | Stop

Location: http://www.inch.com/~r-tronix/

(VIEWING ADJUSTMENT)

SMARTBOMB

SMARTBOMB

The two figures encased in space suits link viewers to two "Gallery" areas. The left image features design-oriented projects, while the right image (below) links to more organic, painterly artwork. Clicking on a small image loads a larger version of specific images.

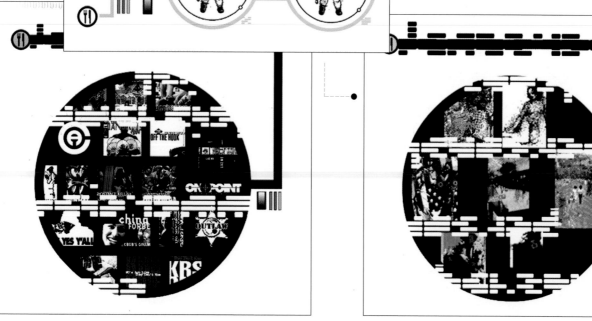

r-tronix@inch.com

TECHNIQUE: The "Links" area (left) features other sites that the designer found relevant to his own site and interests. Traditional buttons and hypertext links were discarded for a more visual interface. Rolling over a linked area of the image sets an HTML script into play that displays a descriptive phrase at the bottom of the browser window.

Clicking a small image on the navigation bar (above) loads a larger image of a cover from *Third I*, a print 'zine that the designer is changing over to a Web-based 'zine.

Project: Smartbomb

Design: Ron Croudy

Features: GIF89a animation

DISAPPEARING INC.

SELF-PROMOTION

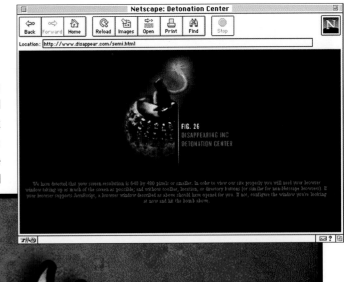

Red#40 designed this commercial site for Disappearing Inc., a young type foundry based in New York City. Imbued with a sense of darkness evoked by fiery red-and-black backgrounds, the site's iconography amplifies the mood: type element "bombs" on the opening screens, vise "bombs" on the Font Arsenal page (below right), and toxic waste drums in the "Serum" section (facing page). On the splash page, the company's initials seem to flare and burn against a background of embers (right).

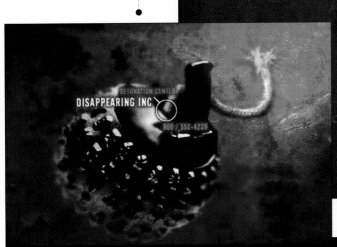

TECHNIQUE: A Java applet runs the Font Dialer, which allows viewers to see fonts and then order them. Rolling the cursor over the up and down arrows plays a squeaking sound as the font names scroll through. Clicking on a font name displays the font in the large frame to the right.

The Disappearing Discourse screen (far right) uses a CGI script to display random nonsensical thoughts about typography using Disappearing Inc. fonts.

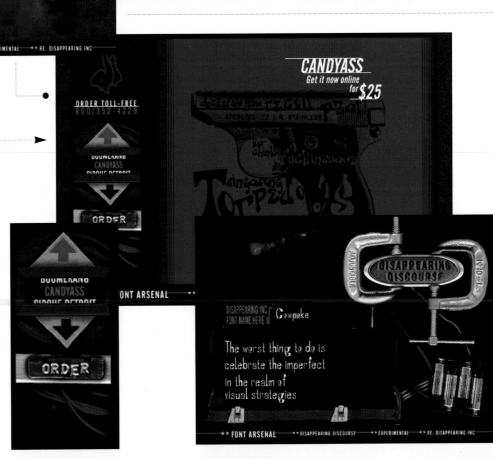

Netscape: Serum

Forward Home Reload Images Open Print Find Stop

tp://www.disappear.com/serum/

The use of frames as art elements and highly-textured background images give the site a full-screen, dramatic feeling regardless of the viewer's monitor size. The opening splash screen (opposite page, top) runs a Java applet that detects screen size to properly display the graphics.

Project: Disappearing Inc.'s Font Arsenal

Design Firm: Red#40

Design: Jeff Prybolsky, Jason Lucas

Illustration: Jeff Prybolsky, Jason Lucas

Photography: Jason Lucas

Programming: Al McElrath, Jeff Prybolsky

Features: JavaScript

DREAMSTATE

SELF-PROMOTION

The Dreamstate site shows an experiment in typography and drama by designer Josh Feldman of Prophet Communications. The premise of the piece was to create a film without actors, sets, or sound, using only animated type to convey action, emotion, and intelligence. For instance, where sound and music are used to evoke emotions in film, in Dreamstate this is accomplished by subtle overtones of moving color.

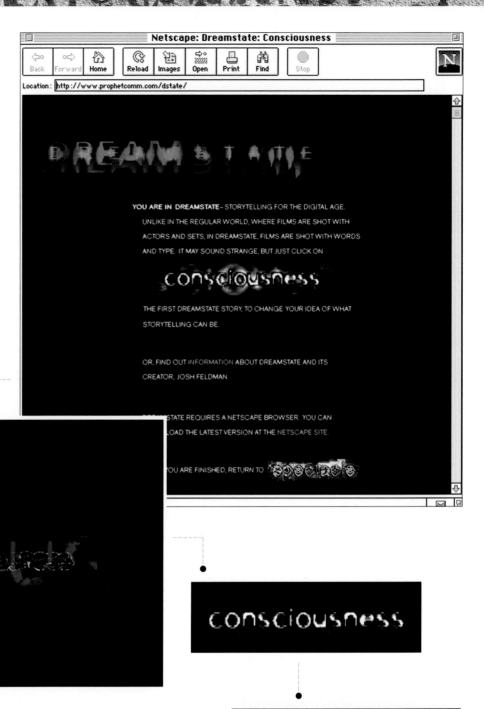

DREAMSTATE IS THE BRAINCHILD OF JOSH FELDMAN, A DESIGNER
LIVING IN SAN FRANCISCO. WITH A DEGREE IN GRAPHIC DESIGN
FROM THE RHODE ISLAND SCHOOL OF DESIGN, JOSH QUICKLY

I believe the
definition for
child
fits me

MOVED AWAY FROM THE STATIC PRINTED PAGE AND STARTED
EXPLORING DESIGN OVER TIME. *CONSCIOUSNESS* BEGAN AS AN
EXPERIMENT–COULD ONE "SHOOT" A MOVIE WITHOUT ACTORS
OR SETS, BUT INSTEAD ONLY WITH TYPE? THE RESULT WAS SO
SUCCESSFUL THAT IT WAS ONE OF THE WINNERS IN WIRED
MAGAZINE AND INTERVAL RESEARCH'S *NEW VOICES, NEW VISIONS*
CONTEST. IF YOU LIKE CONSCIOUSNESS, YOU CAN ACTUALLY
PURCHASE THE 30FPS ANIMATED VERSION OF IT FROM VOYAGER
ON THE NVNV COMPILATION CD-ROM.

Management
isn't going to
go for
this
though

TECHNIQUE: A continuous stream of typographic imagery created with Adobe Premiere conveys the "action" in the Dreamstate story. Server-push technology, then enhances throughput by allowing each "scene," or sentence, to sinuously blend into the next. In the frame below, phrases appear to randomly merge and separate, creating new meaning before transforming into the next scene.

I believe the
definition for
child
fits me

There are
two shapes
two shapes
have
with man
shapes
to them move
and
attached
they
that along
the shape
auxiliary

DREAMSTATE
consciousness
CHAPTER 3
questions

CONTINUE
REWIND A CHAPTER
MAIN
TO SAVE YOUR PLACE, BOOKMARK THIS PAGE

•facts
I know figur.es
da/t/es and
FOR MU/LA(S)

Project: Dreamstate

Design Firm: Prophet Communications

Design: Josh Feldman

Features: GIF89a animation, Shockwave

They said they didnt have
any ideas
but that they would look into-

THE ECLECTICA

SELF-PROMOTION

Large, artfully illustrated background images make up many of the areas in "The Eclectica," an experimental portfolio piece for designer Jonathan Leong. Leong created the site to present his work, along with his own ideas and concepts of the aesthetics of design for the Internet. His grasp of the tools used to create high-quality design for this medium is evident in each of the beautifully rendered pages throughout the site.

To keep download times as short as possible with such large images, Leong chose to rely on imagery to carry viewers through the site, rather than implementing interactive bells and whistles that would have slowed downloads and distracted from the overall design.

TECHNIQUE: The image at left, when viewed with the "open as" command—available by holding the mouse button down on an image in a Netscape window—shows that a transparent GIF was used to place the "Berkeley Scientific" image in the white box on top of the large background photo (below left).

Project: The Eclectica
Design Firm: Drawbridge Productions
Design: Jonathan Leong

HAUS OF JINN

SELF-PROMOTION

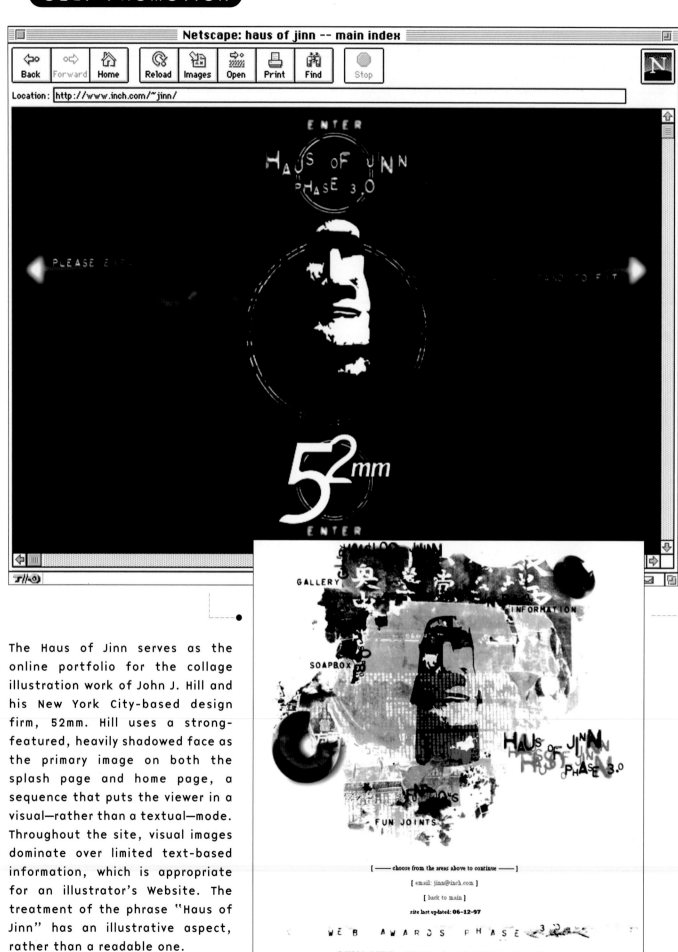

Netscape: haus of jinn -- main index

| Back | Forward | Home | Reload | Images | Open | Print | Find | Stop |

Location: http://www.inch.com/~jinn/

The Haus of Jinn serves as the online portfolio for the collage illustration work of John J. Hill and his New York City-based design firm, 52mm. Hill uses a strong-featured, heavily shadowed face as the primary image on both the splash page and home page, a sequence that puts the viewer in a visual—rather than a textual—mode. Throughout the site, visual images dominate over limited text-based information, which is appropriate for an illustrator's Website. The treatment of the phrase "Haus of Jinn" has an illustrative aspect, rather than a readable one.

TECHNIQUE: The image-mapped graphic in the digital illustration gallery (below) links to full-page examples of digital illustrations by Hill. Once in the gallery, framed navigation bars allow the viewer to go forward, go back, or return to the gallery.

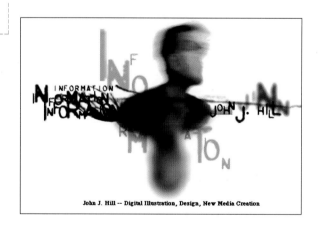

Project: Haus of Jinn

Design Firm: 52mm

Design: John J. Hill

HYPNAGOGUE

SELF-PROMOTION

The Hypnagogue site shows still images, QTVR, sounds and text from the Hypnagogue interactive CD-ROM. Designed by Ocurix Films as a trailer for the CD-ROM, the site features images and text with a gauzy, dreamlike quality that fosters a desire to linger and gaze. Though the home page graphic is very large (117K), it is a well-optimized JPEG that both loads in and scrolls very quickly.

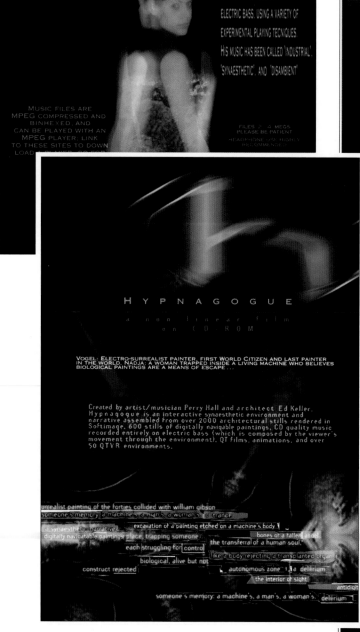

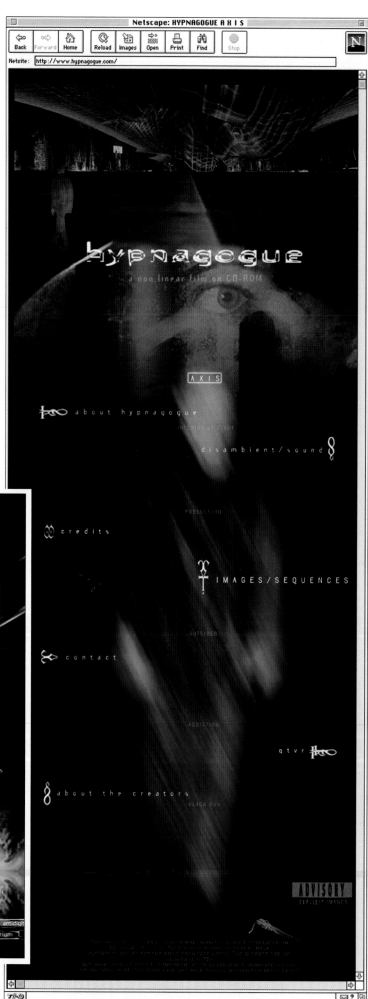

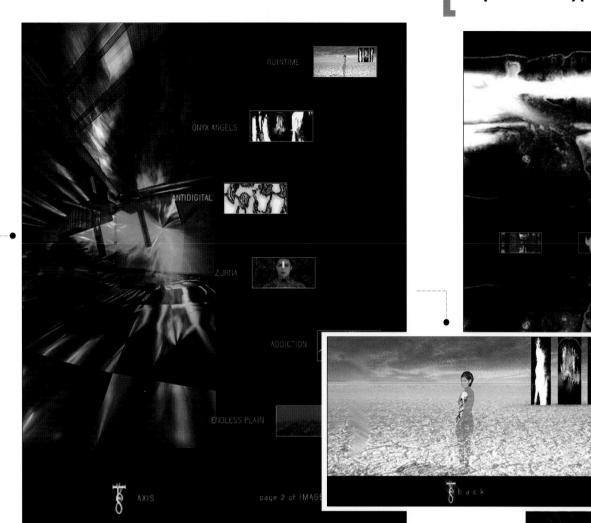

TECHNIQUE: The sequence below demonstrates text fading in over a blurry black-and-white background—the text is readable, yet demanding in its own way (much like trying to read a book in a dream). It is difficult for the eye to grasp the letters because the type is not set along a straight baseline, and the reversed-out white type threatens to disappear against the white patches in the background. This sequence is an excellent example of highly creative screen-based typography that would probably be unsuccessful in any other medium save the Web or CD-ROM.

Project: Hypnagogue
Design Firm: Ocurix Films
Design: Perry Hall, Ed Keller
Photography: Dave Joseph
Programming: Perry Hall, Ed Keller
Features: QuickTime VR, MPEG audio

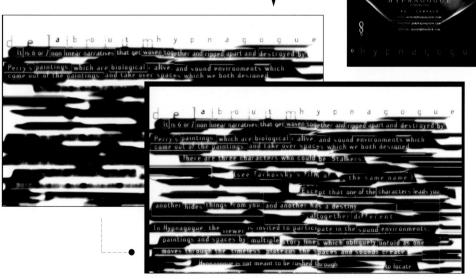

Designer Josh Feldman created the Iconoclast Website to prove to the design industry that revolutionary design doesn't have to be on paper. To prove this point, he combines contemporary typography and layouts found in many cutting-edge print pieces with beautifully rendered organic and high-tech backgrounds. This site satisfies viewers searching for this type of design, offering links to other sites of similar quality.

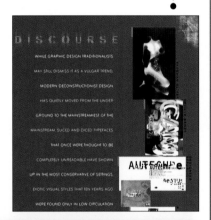

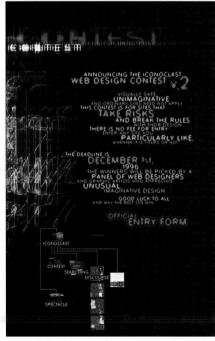

Project: Iconoclast

Design Firm: Prophet Communications

Design: Josh Feldman

http://www.prophetcomm.com/iconoclast

SELF-PROMOTION

The Web Page Explosion is a portfolio piece for designer and font creator Jay David. David created the site after taking a graphic design course that introduced him to Web design. The site offers viewers an exhibition of his student work, personal interests, and links to other designers from the "Design Posse" area. Creative typography and illustration balance nicely with the black background used throughout the site. Viewers also get a chance to download some of David's font creations for free, as well links to other free fonts on the Web.

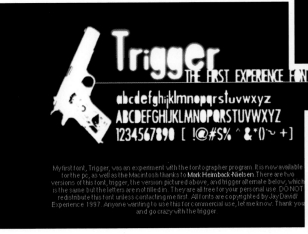

Project: Web Page Explosion

Design: Jay David

Features: GIF89a animation,
JavaScript

LUMINArIA

SELF-PROMOTION

Dreamless Studios' designer David DeCheser and illustrator Eric Dinyer collaborated to create this web site to promote an upcoming book entitled *Luminaria*. The book essentially tries to capture the dream state in a book+enhanced CD format using text, images, and music. An excerpt from the book, "While the Body Slept," hints at the feelings the book will evoke in its readers.

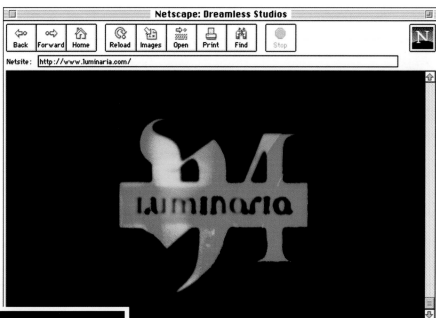

Netscape: Dreamless Studios

Back | Forward | Home | Reload | Images | Open | Print | Find | Stop

Netsite: http://www.luminaria.com/

home.htm

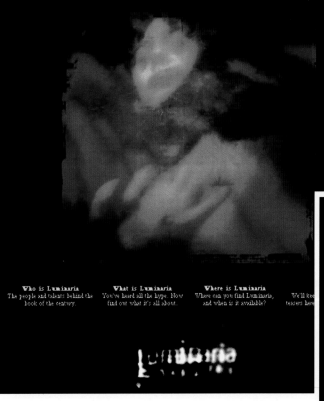

Who is Luminaria
The people and talents behind the book of the century.

What is Luminaria
You've heard all the hype. Now find out what it's all about.

Where is Luminaria
Where can you find Luminaria, and when is it available?

We'll keep teasers here

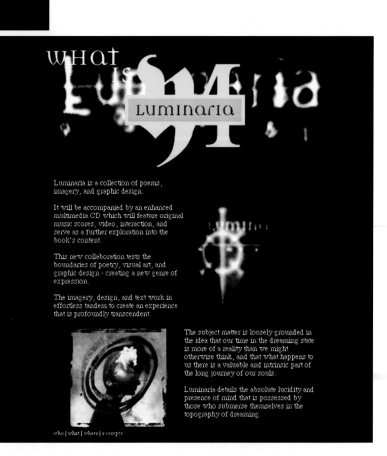

Luminaria is a collection of poems, imagery, and graphic design.

It will be accompanied by an enhanced multimedia CD which will feature original music scores, video, interaction, and serve as a further exploration into the book's content.

This new collaboration tests the boundaries of poetry, visual art, and graphic design - creating a new genre of expression.

The imagery, design, and text work in effortless tandem to create an experience that is profoundly transcendent.

The subject matter is loosely grounded in the idea that our time in the dreaming state is more of a reality than we might otherwise think, and that what happens to us there is a valuable and intrinsic part of the long journey of our souls.

Luminaria details the absolute lucidity and presence of mind that is possessed by those who submerse themselves in the topography of dreaming.

who | what | where | excerpts

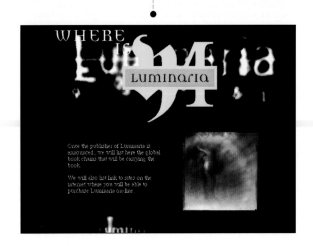

Once the publisher of Luminaria is announced, we will list here the global book chains that will be carrying the book.

We will also list link to sites on the internet where you will be able to purchase Luminaria on-line.

while
the
slept

I.

BODY STILL; I, MOVING.

BREATH FILLING CORNERS OF light.

FILLING SPACES OF BONES

WHICH RISE, SOMEHOW,

IN GREETING.

II.

a BURIAL GROUND.

STRANDS OF HAIR; RICH EARTH; MOSS.

NO WIND REVEALS ITSELF WITHOUT CARE.

VESSELS OF FOOD BECOME EMPTY, UNSEEN, OVER TIME.

RIVERS WASH THEMSELVES CLEAN.

IV.

statues of OLD GODS ARE STILL,

HEAVY WITH NOT-BREATHING.

WHEN WE SEE THEM,

THEIR EYES SHOW US

AN OCHRE LANDSCAPE OF STONE.

THEY ARE INVISIBLE.

I.

BODY STILL; I, MOVING.

BREATH FILLING CORNERS OF light.

FILLING SPACES OF BONES

WHICH RISE, SOMEHOW,

IN GREETING.

TECHNIQUE: The essence of the site is conveyed by David DeCheser's skillful collage of original illustrations by Eric Dinyer. In the illustration below several translucent images are layered on top of each other like voices in a chorus. A rough border is also applied to this image and the one on the opposite page, accentuating the passing nature of the scene depicted—the essence of a dream.

Project: Luminaria

Design Firm: Dreamless Studios

Design: David DeCheser

Illustration: Eric Dinyer

Photography: Eric Dinyer

Programming: David DeCheser

MIND CANDY

SELF-PROMOTION

This site for the MindCandy studio features a strong, unified color palette of electric blues and reds balanced by a few warm earth tones. Using the image of a nautilus shell and fractals, the design of both the home page (left) and the index page (below) show an admirable balance between the artificial and organic. This type of balanced color scheme is also evident in the studio's work for clients, as seen in the gallery of T-shirt animal images on the facing page.

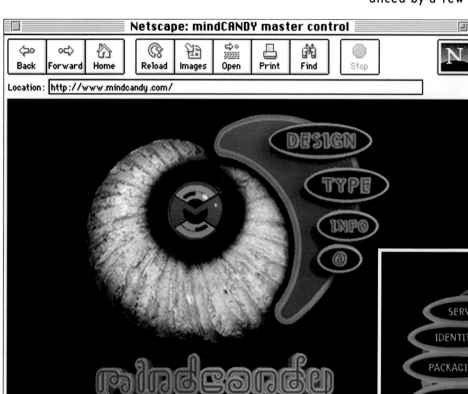

Netscape: mindCANDY master control

Back | Forward | Home | Reload | Images | Open | Print | Find | Stop

Location: http://www.mindcandy.com/

DESIGN
TYPE
INFO
@

mindcandy

Document: Done.

SERVICES
IDENTITY
PACKAGING
ILLUSTRATION

mindcandy
SERVICES

your creative resource for any medium
print. cd-rom. video. internet. silk screen
we proudly offer the following services:

2D & 3D ANIMATION
DIGITAL NON-LINEAR EDITING
CUSTOM TYPEFACE DESIGN
GRAPHIC DESIGN
ILLUSTRATION

FILM/VIDEO SPECIAL E/X
COMPUTER TO BETA-SP TRANSFERS
(COMPONENT SIGNAL BROADCAST QUALITY)

INTERNET SITE DEVELOPMENT
WEB PAGE DESIGN
CUSTOM CGI & JAVA SCRIPTING

to disuss your personal creative needs
please contact your mindcandy fulfillment
representative by phone (512-448-3955)
or e-mail type@austin.mindcandy.com

mindcandy

BACK

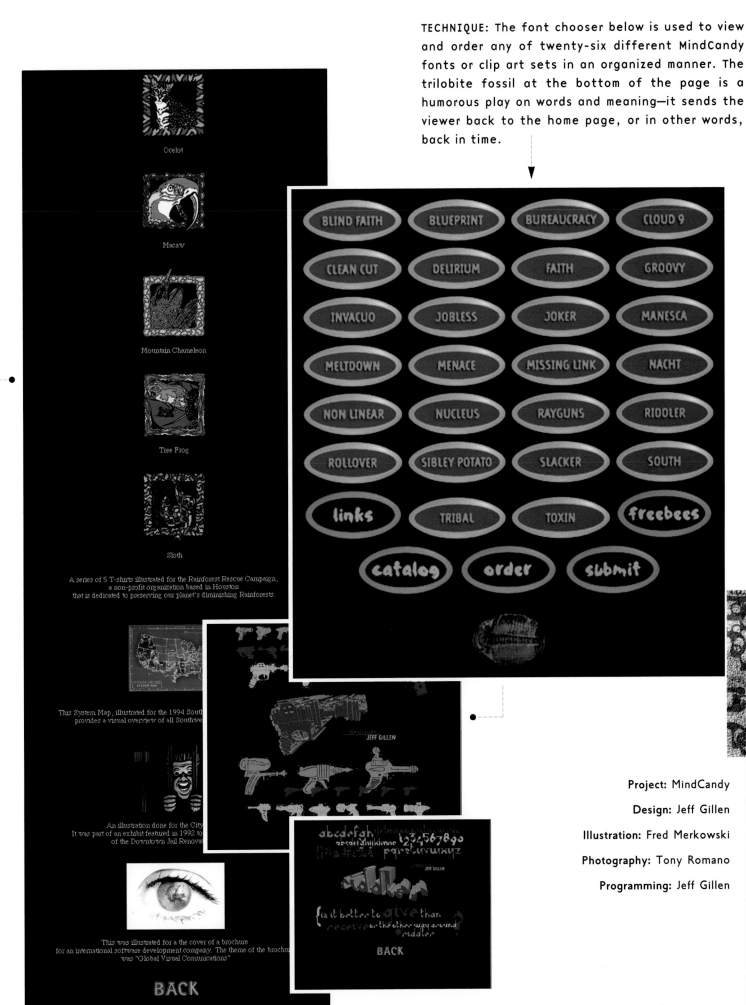

TECHNIQUE: The font chooser below is used to view and order any of twenty-six different MindCandy fonts or clip art sets in an organized manner. The trilobite fossil at the bottom of the page is a humorous play on words and meaning—it sends the viewer back to the home page, or in other words, back in time.

Ocelot

Macaw

Mountain Chameleon

Tree Frog

Sloth

A series of 5 T-shirts illustrated for the Rainforest Rescue Campaign, a non-profit organization based in Houston that is dedicated to preserving our planet's diminishing Rainforests.

This System Map, illustrated for the 1994 South provides a visual overview of all Southwe

An illustration done for the City It was part of an exhibit featured in 1992 to of the Downtown Jail Renova

This was illustrated for a the cover of a brochure for an international software development company. The theme of the brochu was "Global Visual Comunications"

BACK

BLIND FAITH · BLUEPRINT · BUREAUCRACY · CLOUD 9
CLEAN CUT · DELIRIUM · FAITH · GROOVY
INVACUO · JOBLESS · JOKER · MANESCA
MELTDOWN · MENACE · MISSING LINK · NACHT
NON LINEAR · NUCLEUS · RAYGUNS · RIDDLER
ROLLOVER · SIBLEY POTATO · SLACKER · SOUTH
links · TRIBAL · TOXIN · freebees
catalog · order · submit

BACK

Project: MindCandy
Design: Jeff Gillen
Illustration: Fred Merkowski
Photography: Tony Romano
Programming: Jeff Gillen

QASWA

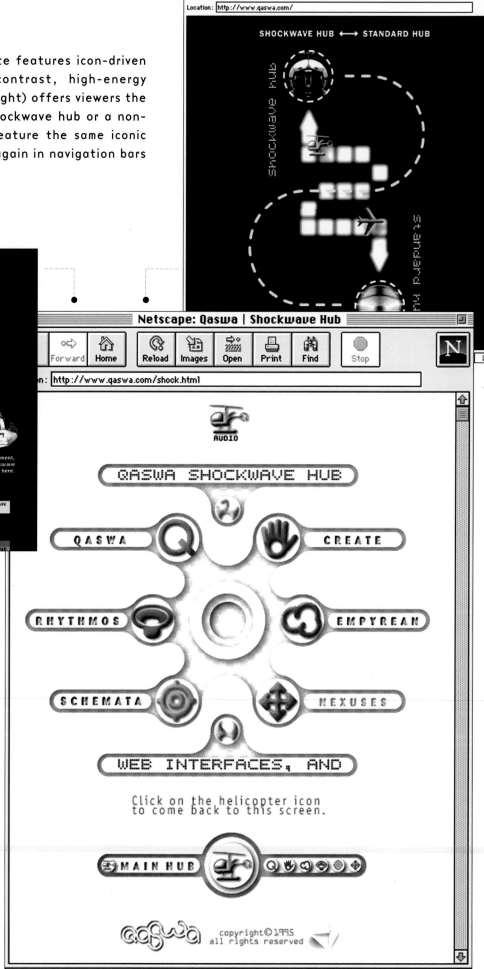

The Qaswa Communications site features icon-driven navigation and very high-contrast, high-energy design. The opening screen (right) offers viewers the option of navigating via a Shockwave hub or a non-Shockwave hub. Both hubs feature the same iconic section heads that are used again in navigation bars on every page.

Clicking on the helicopter audio icon at the top of the Shockwave hub (right) plays a looping music clip, and the icon switches to the schematic above. Clicking in the small circles turns the sound on and off and controls the volume level.

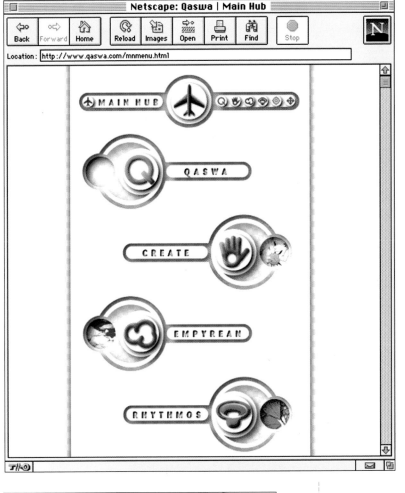

TECHNIQUE: Often the "lite" version of a site features an inferior design, but the Qaswa site has two equally satisfying versions of the main navigation hub. The simple version (left) features an airplane icon, whereas the Shockwave version (facing page) features a helicopter icon, but all the remaining icons and color schemes are the same. The Shockwave version features rollover section icons that display the section title in the horizontal bar at the top of the hub, a small image that appears in the center of the hub, and a longer description of the section that scrolls through the horizontal bar at the lower edge of the hub.

Project: Qaswa

Design Firm: Qaswa Communications

Design: Ammon Haggerty

Features: Shockwave

STUDIO CD

SELF-PROMOTION

The Studio CD Website employs a highly consistent pattern of frames: navigation information always resides in the top frame while beautiful illustrations provide a background for listings of subtopics listed in the frame on the left. The main frame on the lower right holds portfolio images and text.

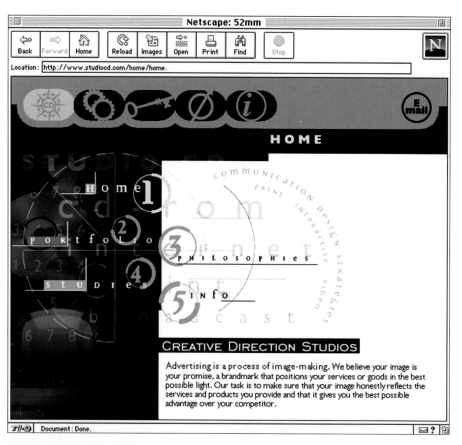

CREATIVE DIRECTION STUDIOS

Advertising is a process of image-making. We believe your image is your promise, a brandmark that positions your services or goods in the best possible light. Our task is to make sure that your image honestly reflects the services and products you provide and that it gives you the best possible advantage over your competitor.

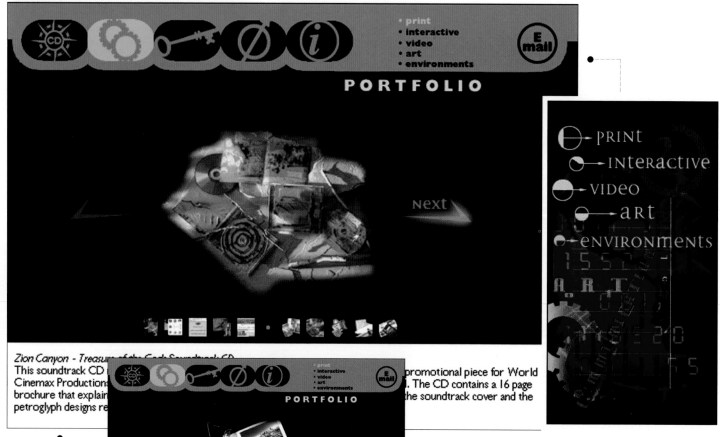

Zion Canyon - Treasure of the Gods Soundtrack CD
This soundtrack CD ... promotional piece for World Cinemax Productions ... The CD contains a 16 page brochure that explain ... the soundtrack cover and the petroglyph designs re ...

Pier 39 Offering Summary
Creative Direction Studios has been contracted by many companies to design corporate, annual, and financial reports. This 24-page report summarizes a general offering opportunity for potential investors. The design is clean and straight forward to be sure to highlight the important financial information but the bright colors and pristine photography speak to readers and convey a sense of fun and excitement for Pier 39, San Francisco.

In the "Portfolio" section of the site, users can click through to show all the images sequentially or click on a small thumbnail image to immediately go to the image they want to see.

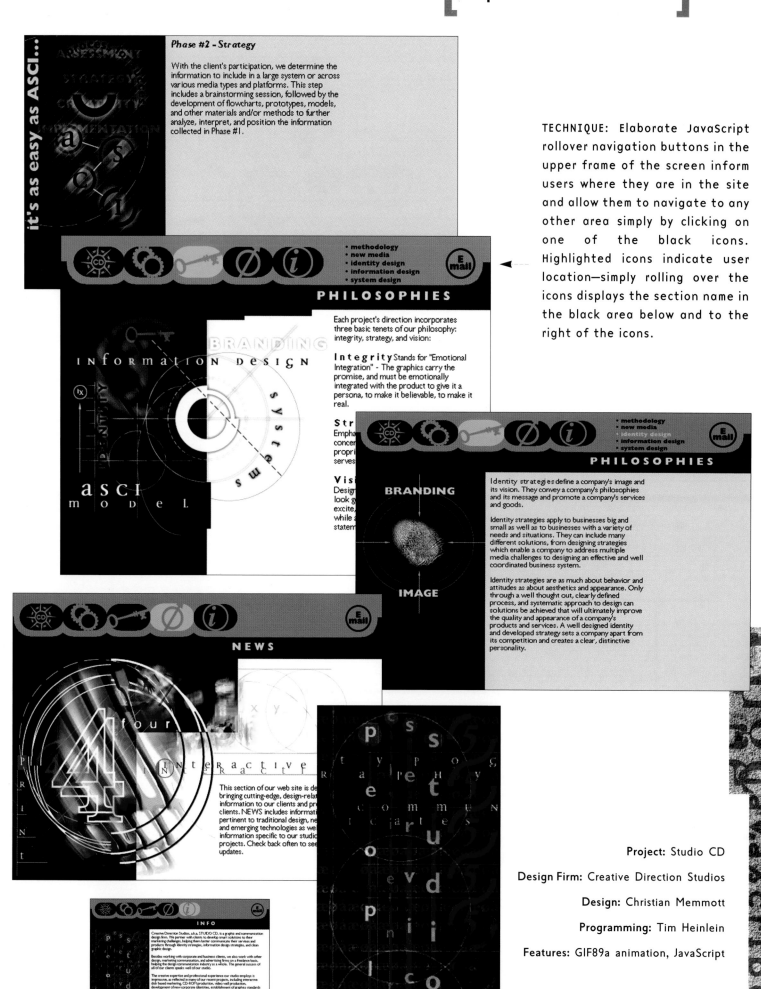

Phase #2 - Strategy

With the client's participation, we determine the information to include in a large system or across various media types and platforms. This step includes a brainstorming session, followed by the development of flowcharts, prototypes, models, and other materials and/or methods to further analyze, interpret, and position the information collected in Phase #1.

TECHNIQUE: Elaborate JavaScript rollover navigation buttons in the upper frame of the screen inform users where they are in the site and allow them to navigate to any other area simply by clicking on one of the black icons. Highlighted icons indicate user location—simply rolling over the icons displays the section name in the black area below and to the right of the icons.

- methodology
- new media
- identity design
- information design
- system design

PHILOSOPHIES

Each project's direction incorporates three basic tenets of our philosophy: integrity, strategy, and vision:

Integrity Stands for "Emotional Integration" - The graphics carry the promise, and must be emotionally integrated with the product to give it a persona, to make it believable, to make it real.

Str
Empha
concer
propri
serves

Vis
Desig
look g
excite,
while
statem

- methodology
- new media
- identity design
- information design
- system design

PHILOSOPHIES

Identity strategies define a company's image and its vision. They convey a company's philosophies and its message and promote a company's services and goods.

Identity strategies apply to businesses big and small as well as to businesses with a variety of needs and situations. They can include many different solutions, from designing strategies which enable a company to address multiple media challenges to designing an effective and well coordinated business system.

Identity strategies are as much about behavior and attitudes as about aesthetics and appearance. Only through a well thought out, clearly defined process, and systematic approach to design can solutions be achieved that will ultimately improve the quality and appearance of a company's products and services. A well designed identity and developed strategy sets a company apart from its competition and creates a clear, distinctive personality.

NEWS

This section of our web site is de bringing cutting-edge, design-rela information to our clients and pr clients. NEWS includes informati pertinent to traditional design, ne and emerging technologies as we information specific to our studio projects. Check back often to see updates.

INFO

Creative Direction Studios, a.k.a. STUDIO CD, is a graphic and communication design firm. We partner with clients to develop smart solutions to their marketing challenges, helping them better communicate their services and products through identity strategies, information design strategies, and clean graphic design.

Besides working with corporate and business clients, we also work with other design, marketing communication, and advertising firms on a freelance basis, helping the design communication industry as a whole. The general success of all of our clients speaks well of our studio.

The creative expertise and professional experience our studio employs is impressive, as reflected in many of our recent projects, including interactive disk-based marketing, CD-ROM production, video wall production, development of new corporate identities, establishment of graphics standards and information models, and promotional print and web interactive campaigns. We have a holistic view of the graphic and communication design industry. We are problem solvers, strategic information organizers, identity and branding specialists, and project orchestrators.

We bring together teams equipped to best tackle a client's unique communication problem, whether it is a full blown identity overhaul, or the challenge of creating an annual report, brochure, or interactive CD.

Project: Studio CD
Design Firm: Creative Direction Studios
Design: Christian Memmott
Programming: Tim Heinlein
Features: GIF89a animation, JavaScript

CORE77

SELF-PROMOTION

The Core77 Website brings together the industrial design community and serves as a focal point for ID-related information on the Web. The home page (right) features links to design firms, projects, jobs, schools, and products related to industrial design. The site also features a bulletin board for viewers to discuss design-related topics.

Netscape: CORE- Industrial Design Network

Back | Forward | Home | Reload | Images | Open | Print | Find | Stop

Location: http://www.core77.com/

CORE INDUSTRIAL DESIGN NETWORK

May 1997

Making Space in Milan — three exhibits at the international furniture fair ▶go!

CORE STORE

EMPLOYMENT

CONTRAPTION- PRODUCT REVIEWS

FIRM LIST

REACTOR
ARTICLES, PROJECTS

DESIGN.EDU
SCHOOLS, WHAT IS ID?

CHIT-CHAT
BULLETIN BOARD, DESIGN FORUM

RESOURCES
FIRM LIST, EMPLOYMENT, CALENDAR

SOFT CORE
GAMES, O' THE MONTH

What's new?

CORE Industrial Design Network-Reactor | Design.edu | Chit-Chat | Resources | SoftCORE

Would you like to receive an e-mail update when CORE posts new material, i.e. jobs, events, articles?

CORE is produced by Core77, Inc.

Welcome to the new and improved CORE memorabilia store; take a look at our merchandise and make sure to go and visit the online CORE Bookstore if you feel like browsing and buying some great design books.

Contact us (info@core77.com) if you any questions about our merchandise.

core-e-spondent
LINO WIEHEN
reports from the 1997
Milan Furniture Fair

making. space. in milan

ingo maurer
ron arad

loungecore

aqua creations

From: leonbenn@dom.de
Date: Mon, 26 April 1997 15:29:57 +0100
To: ludlum@core77.com
Status: priority
Subject: Milan Furniture Fair;

The focus of my trip to this year's Milano Salone (Furniture Trade Show) were the evening shows and openings. These shows, sometimes off the beaten path in very temporary settings, were part furniture and part experience, combined to create an atmosphere unique to each group. The semi-comprehensible guide and map, to both the showrooms and the parties, was all I had to guide me on how to get there (not always so easy).

I worked at the Ron Arad and Ingo Maurer opening showing my cd-rom catalog for Ingo Maurer. I had a chance to visit several other showrooms during my stay and have included images from 2 others I found interesting, Loungecore and Aqua Creations.

making. space. in milan

ingo maurer
ron arad

loungecore

aqua creations

aqua gallery

Walking into the Aqua Creations showroom gives the impression of a scuba dive on a fantastic reef 30 meters down. The lights and furniture were incredible. The showroom lived up to its namesake, in spirit and atmosphere.

Aqua Creations Ayala Sperling - Serfaty
69 Maze'h Street
Tel Aviv 65789
Israel

TECHNIQUE: The home page features a beautifully designed navigation interface with multiple drop shadows that give the design both a layered look and an illusion of depth.

CORE encourages readers to communicate directly, with us and with each other. We will publish notices for available positions, and provide contact information as well. If you would like to advertise a position here, e-mail corejr@core77.com, or give us a call at 212-965-1998.

Features:

NEW!! Positions Wanted
This forum is for under-employed designers looking for work. Add your name to the board and watch the calls start pouring in!

This is CORE's experimental section, featuring conceptual projects, articles, design on the Web and anything else we can find. If you would like to contribute, contact us and we'll make it happen.

Regulars:

Contraption
Product commentary and reviews

Project: Core77

Design: Eric Ludlum, Stuart Constantine

Features: GIF89a animation, Shockwave, JavaScript, Java, VRML

SELF-PROMOTION

The Airwalk Sno-Core Tour is a sub-site of the Airwalk Snowboard Website; it promotes the Sno-Core winter concert tour of alternative bands, as well as promoting the company's snowboard line. The home page sets the tone of the site's design by using cool colors, an icy logo, and interesting shapes to display the various headings (such as the orange snowboards for navigating the three main areas of the site).

TECHNIQUE: A GIF89a animation creates the dynamic effect of a snowboarder gliding through the three rounded boxes on the home page (above). The snowboarder is visible only when he is within the blue area of the boxes, which creates the effect of looking through windows cut out of the page.

Headings on each of the main pages continue the look and feel of the home page by including related icons and text box shapes.

Project: Airwalk Sno-Core Tour

Client: Airwalk Snowboard

Design Firm: Cyberg8t

Design: Mike Lin

Programming: Mike Lin

Features: GIF89a animation, browser recognition

THE FRAY

SELF-PROMOTION

The Fray is a Web-zine focusing on San Francisco culture. Each issue features articles and stories relating to different elements of city life. The four main areas of the site are highlighted by the typographic icons of the Thorn Forms font by Emigre. The basic color palette of blues plus black make the site a relatively quick download for any speed modem.

Netscape: {fray} welcome

Back Forward Home Reload Images Open Print Find Stop

Location: http://www.fray.com/

{ join the fray mailing list }

The 24 line mixes the best and worst of San Francisco. I'd forgotten how unsettling it can be.

reality check

Meeting Peter

I'm meeting Peter for lunch. He apologizes for the fact that he's late and then launches into a long explanation of why he hates his job.

It is the second time that we've met for lunch, the continuous nature of our email correspondance has lent a sort of familiarity to the conversation. I already know, for example, that he likes having strange animals as pets, tarantulas, llamas. I know that he spends too much time thinking about work. He habitually stares at walls as if they hide the secrets of the universe. Maybe they

And he stares out the window often, as we eat and talk about the inevitable death of the WIMP interface and how much he would like to own a blue macaw. His eye-brows bunch up. He concentrates with such intensity that you can perceive your presence being zoned out, ceasing to matter or even to exist.

TECHNIQUE: A unique use of frames is featured in the "Hope" section of the Fray. Three frames are used to create a hidden area where a story is located. Removing the borders on the two outer frames and making the inner frame borders movable, the designer makes it possible for the middle frame to be closed and reopened to reveal the content inside.

Project: The Fray

Design Firm: Powazek's Productions

Design: Derek M. Powazek

Programming: Derek M. Powazek, Matt Wright, Jeff Burchell

Features: GIF89a animation

http://www.fray.com

DUNCAN HOPKINS

SELF-PROMOTION

Duncan Hopkins' online portfolio features a reaching hand and a GIF89a animation of an eye embedded in the palm slowly gazing from left to right (right). The splash page features a grayscale eye that loads first, replaced by a blue-tinted eye (below).

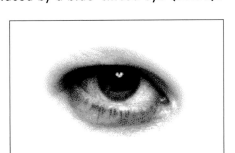

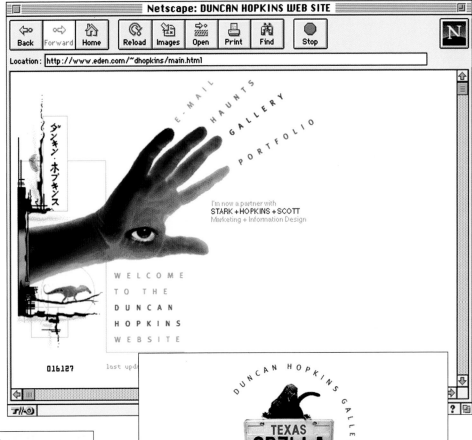

Netscape: DUNCAN HOPKINS WEB SITE

Back | Forward | Home | Reload | Images | Open | Print | Find | Stop

Location: http://www.eden.com/~dhopkins/main.html

E-MAIL · HAUNTS · GALLERY · PORTFOLIO

I'm now a partner with
STARK + HOPKINS + SCOTT
Marketing + Information Design

WELCOME TO THE DUNCAN HOPKINS WEBSITE

016127 last upd

BACK TO GALLERY

Monstrosium

ORIGINAL CONCEPTUAL SKETCHES BY DUNCAN HOPKINS

ALL ARTWORK © COPYRIGHT 1996 DUNCAN HOPKINS

DUNCAN HOPKINS GALLERY

TEXAS
GDZLLA

OBSESSION & DIVERSION

GARAGE KIT

MONSTROSIUM

HOUSE DEAMONS

MANTISIPATION

LUCKY 13

LOST WORLDS

THEATRE

TECHNIQUE: The "Theatre" area of Hopkins' Website features QuickTime movies of Bryce animations that can be downloaded and viewed in the browser window (right and below).

Project: Duncan Hopkins
Design Firm: Syndetic Design
Design: Duncan Hopkins
Features: GIF89a animation, QuickTime

http://www.syndeticdesign.com

117

Cutting Edge
Global Websites

WEBSITES AND THE DESIGN FOR THE INTERNET ARE OFTEN APPROACHED IN A NEGATIVE MANNER, WITH CONSTANT DWELLING ON THE LIMITATIONS WITHIN WHICH THE DESIGN PROCESS TAKES PLACE.

ACTIVATE

<<<<<<<< TRANSMIT NARROW SIZE LIMITATIONS BOUNDARIES PRIMITIVE IMPERSONAL IMPERFECT DEFICIENT AUSTERE DIFFICULT INCOMPATIBLE CONFUSED PARAMETERS CONTAIN RETAIN SPEED DATA DRAG SCROLL REDRAW SLOW LABORIOUS LINEAR COMMUNICATION INFRASTRUCTURE DOWNLOAD RAW INDIRECT SLUGGISH DULL HINDERED LOW SIMPLIFIED SMALL COMPRESS DE-SCALE INDEX PIXELLATE REDUCE SQUEEZE UNREFINED COMPROMISE AWKWARD TRANS-FER STREAM IMPETUS NAVIGATE DISTRIBUTE COHERENT RANDOM BROWSE REDRAW CONNECT ON-LINE NETWORK AUDIENCE INTERCONNECT CONVERT CRE-ATE TECHNIQUE ADAPT REACT RESPOND UNHINDERED INFORM EDUCATE PUBLISH INSPIRE MOTIVATE PROGRESS REACT DIRECT INTERPRET REVOLUTIONIZE STIMULATE DISCIPLINE DEVELOP AGITATE PERVERT DECONSTRUCT RECONNECT UNHINDERED ENTHUSIASTIC UNLEASH FREEFLOW MORPHING EXPANDING BLENDING COLLABORATE MOLDING BINDING CHANGE FORWARD PACE INTERACT PUSH CHALLENGE INNOVATE PROCESS EXCITE REVOLUTIONIZE ANSWER SOLU-TION >>>>>>>>

END?

THE CREATIVE MINDS IN THIS BOOK SHOW THAT THIS IS NEITHER AN INFERIOR OR SUPERIOR NEW MEDIA JUST ONE THAT NEEDS EXPLORING WITH IMAGINATION AND DETERMINATION TO STIMULATE AND DEVELOP THE MEDIA AS A WHOLE.

end

0 791

0791—designed by Shimizu Masayuki—features a simple navigation concept that belies the high-end Web design tools used in its creation. GIF89a animation, RealAudio, frames, and JavaScript rollovers are used throughout the site. The main navigation buttons on the home page and all subsequent pages are JavaScript buttons that highlight when the cursor rolls over them.

Macromedia's Shockwave animation is used frequently within the site, such as on the street light image with its Shocked, colored lights (left).

The "Gallery" (right) features an image-mapped graphic of a realistic gallery. Clicking on an art piece hanging on the walls loads a larger version of the image.

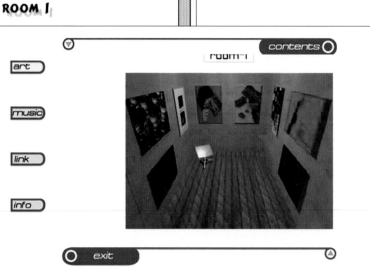

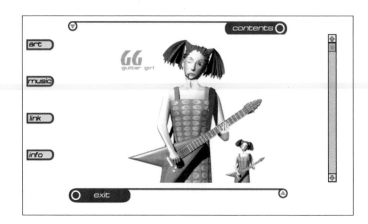

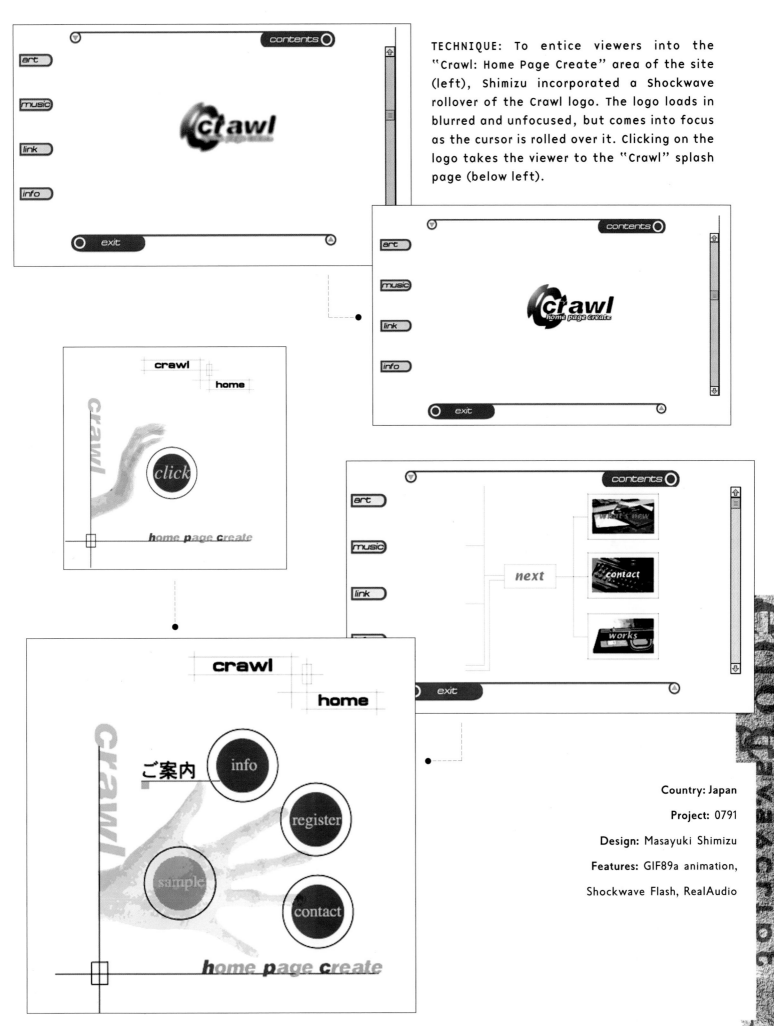

TECHNIQUE: To entice viewers into the "Crawl: Home Page Create" area of the site (left), Shimizu incorporated a Shockwave rollover of the Crawl logo. The logo loads in blurred and unfocused, but comes into focus as the cursor is rolled over it. Clicking on the logo takes the viewer to the "Crawl" splash page (below left).

Country: Japan
Project: 0791
Design: Masayuki Shimizu
Features: GIF89a animation,
Shockwave Flash, RealAudio

ANTArt
SELF-PROMOTION

The Antart designers refer to their Website as a "Web identity with a sense of humor." Besides featuring the standard portfolio and background information that accompany most Websites, Antart gives viewers background on past and present feline design assistants. The home page (right) features links to areas within the site, as well as a cat in a compromising position.

welcome to antart

A SMALL BUT EXQUISITELY FORMED
SYDNEY GRAPHIC DESIGN
COMPANY SPECIALISING IN
FILM AND TELEVISION PROMOTION.

portfolio

Netscape: antart animation

Back | Forward | Home | Reload | Images | Open | Print | Find | Stop

Location: http://www.antart.com.au/

ANTART

intro background portfolio clients

catwalk

e.mail anthony@antar

background

The long vertical page at right features a history of the Antart design firm, with humorous references to the design cats that have followed the firm's career.

Country: Australia
Project: Antart
Design Firm: Seven Iron, Antart
Design: Josh Logue, Rebecca Shanahan
Photography: Rebecca Shanahan
Programming: Josh Logue
Features: GIF89a animation

http://www.antart.com.au

ELECTRIC OCEAN

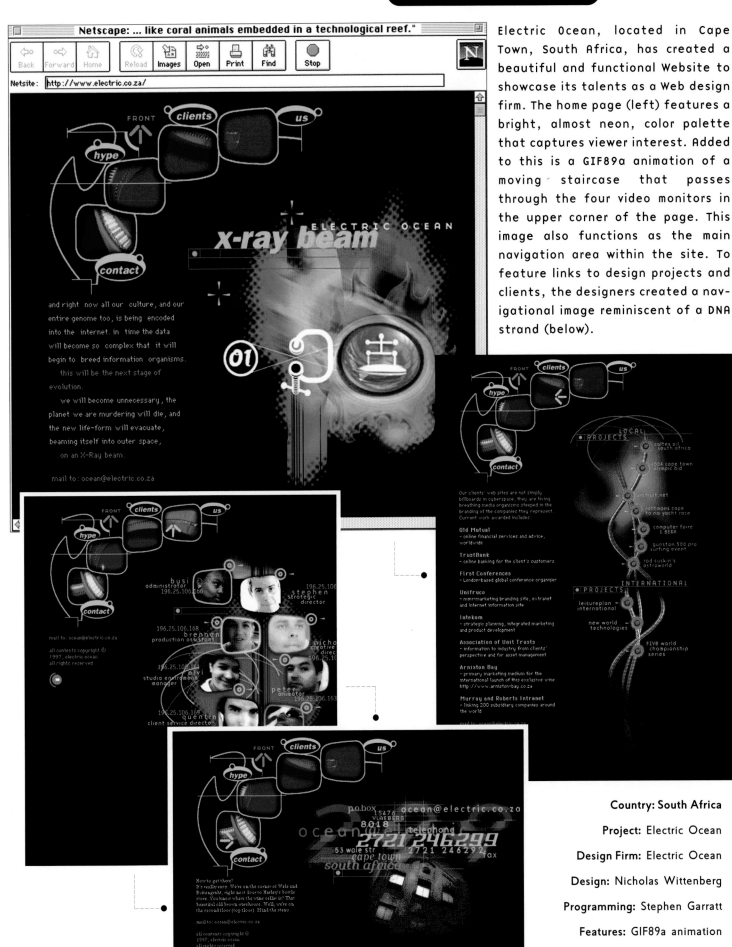

Electric Ocean, located in Cape Town, South Africa, has created a beautiful and functional Website to showcase its talents as a Web design firm. The home page (left) features a bright, almost neon, color palette that captures viewer interest. Added to this is a GIF89a animation of a moving staircase that passes through the four video monitors in the upper corner of the page. This image also functions as the main navigation area within the site. To feature links to design projects and clients, the designers created a navigational image reminiscent of a DNA strand (below).

Country: South Africa

Project: Electric Ocean

Design Firm: Electric Ocean

Design: Nicholas Wittenberg

Programming: Stephen Garratt

Features: GIF89a animation

JETSET

Layered and ragged grunge typography sets the tone of the Jetset Website site when it shows up on the splash page. A GIF89a animation of the title fades from the opening quote (right) to the "Enter" title (below right). Clicking "enter" links viewers to the home page (below). Tjer Geerts, the designer, tries to break the barriers that might hold his design back. The Jetset Website allows him to experiment with various techniques and showcase his portfolio as well.

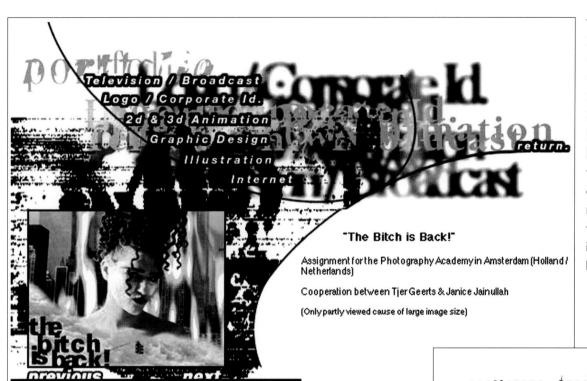

"The Bitch is Back!"

Assignment for the Photography Academy in Amsterdam (Holland / Netherlands)

Cooperation between Tjer Geerts & Janice Jainullah

(Only partly viewed cause of large image size)

TECHNIQUE: To showcase his design, Geerts uses frames. Frames separate the top and bottom halves of the pages; keeping the portfolio links in the top frame lets the designer change the bottom graphic and descriptive text without refreshing the links each time a new portfolio image appears in the lower frame.

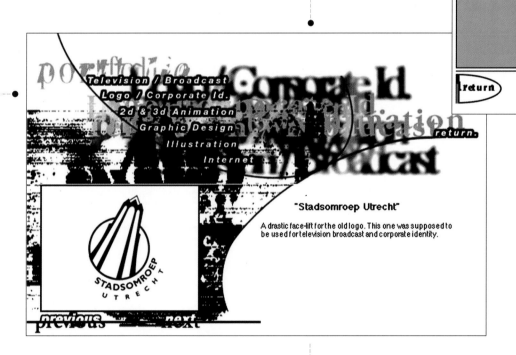

"Stadsomroep Utrecht"

A drastic face-lift for the old logo. This one was supposed to be used for television broadcast and corporate identity.

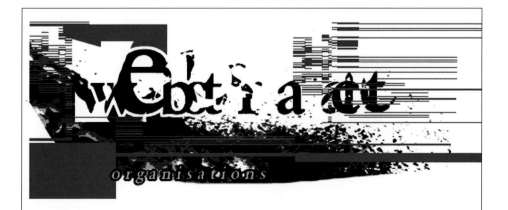

Country: Netherlands

Project: Jetset

Design Firm: Jetset Design

Design: Tjer Geerts

Features: GIF89a animation, ProJPEG

ARTEMISIA

SELF-PROMOTION

The Artemisia Website appears in a regular version (right) and a Shockwave version (middle left). The regular home page features four GIF89a animations as part of the navigation icons (below), keeping the page active as well as linking to other parts of the site.

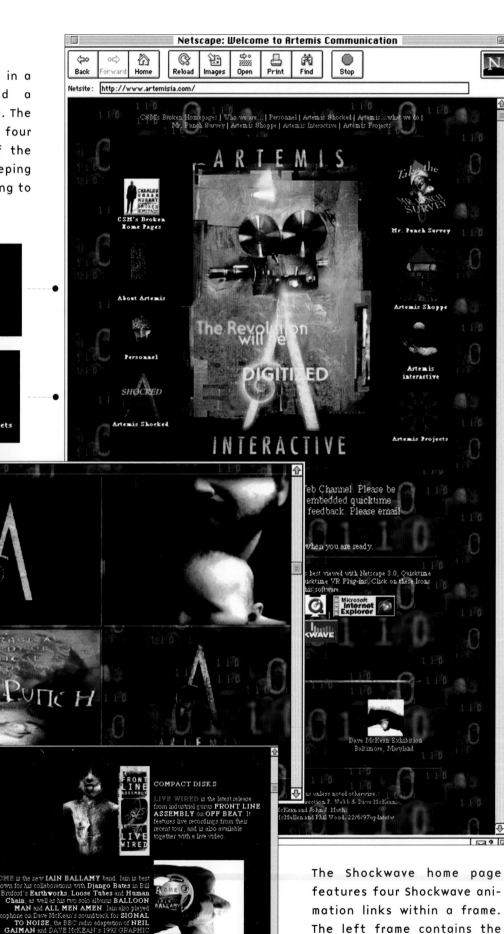

The Shockwave home page features four Shockwave animation links within a frame. The left frame contains the same GIF89a animation links from the home page.

TECHNIQUE: The "Hourglass" page pro-
motes the work of Artemis Art Director
Dave McKean. The images below are part
of a GIF89a animation sequence. Clicking
on the image links the viewer to Allen
Spiegel Fine Arts.

The "Artemis Interactive"
page features two QuickTime
movies promoting upcoming
products. Clicking on the
image from the page (left)
opens a new window to play
the movie (below left).

Country: United Kingdom
Project: Artemisia
Design Firm: Artemis Communications Ltd.
Design: Dave McKean, Phil Woods, Floyd Webb
Art Director: Dave McKean
Producer: Igor Goldkin
Video Producer/Production Manager: Simon Moorhead
Illustration: Dave McKean, Max McMullin,
Tom Hamlyn, Phil Woods
Photography: Phil Woods
Programming: Floyd Web
Features: GIF89a animation, Shockwave, QuickTime VR

CAPE TOWN 2004

SELF-PROMOTION

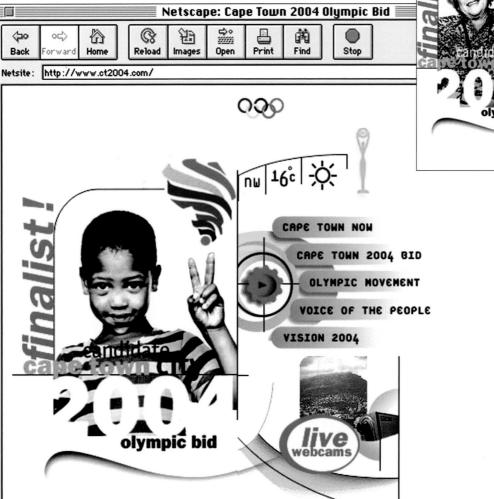

Netscape: Cape Town 2004 Olympic Bid

Back | Forward | Home | Reload | Images | Open | Print | Find | Stop

Netsite: http://www.ct2004.com/

The Cape Town 2004 Website served as part of the promotional effort behind the Cape Town Olympic Bid Company's bid to host the Olympics in 2004. The Website showcases Cape Town, its local happenings (with two Webcams sending live still images to the Website), Cape Town 2004 merchandise, and other information, all displayed in a clear colorful manner.

The home page image (right) cycles through four different black-and-white photographs of Cape Town residents, accented with the bright primary colors used in the Olympic logo and the Africa Olympic logo.

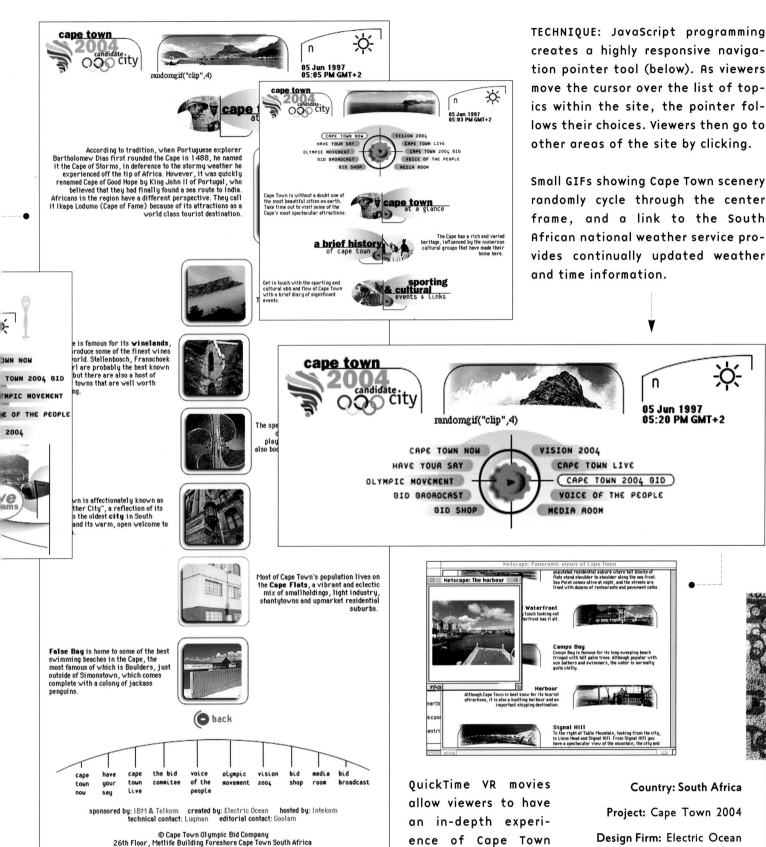

TECHNIQUE: JavaScript programming creates a highly responsive navigation pointer tool (below). As viewers move the cursor over the list of topics within the site, the pointer follows their choices. Viewers then go to other areas of the site by clicking.

Small GIFs showing Cape Town scenery randomly cycle through the center frame, and a link to the South African national weather service provides continually updated weather and time information.

QuickTime VR movies allow viewers to have an in-depth experience of Cape Town (above).

"Cape Town at a Glance" displays highlights of the city in a tall scrolling window (above). Because the central images are small, they load quickly. The bottom of all the sub-pages features the arcing navigation.

Country: South Africa

Project: Cape Town 2004

Design Firm: Electric Ocean

Design: Nicholas Wittenberg

Illustration: Nicholas Wittenberg

Programming: Stephen Garratt

Features: GIF89a animation, JavaScript, Shockwave, QuickTime VR

COSMOSMAG

COMMERCIAL

Cosmos magazine's Website coincides with the popular print counterpart to this Finnish entertainment magazine. The Website is unique in its contemporary design, compared to many other magazines, which often follow a conservative approach to the Web when repurposing print materials.

The *Cosmos* home page (right) showcases the main navigation links by surrounding them within a rough border graphic and highlighting title headings with ragged typographic treatments. This same treatment is used throughout the Website.

After the home page, a new navigation bar is used (below). This bar incorporates background art to help viewers recognize where they are within the site, such as the sports figures (bottom right) that relate to the sports section of the site.

TECHNIQUE: JavaScript opens a new Netscape window—minus the toolbars and location information—which is used as a navigation palette. The palette links viewers to specific areas within the site.

business

ILMIÖT
HENKILÖT
URHEILU
BUSINESS
POLITIIKKA
TOYS4BOYS
VIIHDE & VAPAA
INTERNET

TILAUS
KILPAILU
HUUTOKAUPPA
KUSTANTAJA

xLA230

BUSINESS]

Tuhannen peninkulman hyppy
Työkeikka ulkomailla, mikä on muu
muuttoa suunnittelevan kannattaa ot
Hyödylliset Internet-osoitteet.

Tilaa ja lue lisää Cosmoksesta

Suomalaisen know hown.
pako ulkomaille, lähtijän profiili, mi
kaksi pari vuotta ulkomailla työsk
tarinansa.

Luontaisedut syynissä.
Miksi kannattaa ja milloin? Autoetu,
kännykkäetu, matkustusetu, jne. Se
esimerkkitapaukset.

Talkoot toimistossa.
Miten työntekijä ja -antaja motivoidu
ja tuotto.

Neuvottelutaidot remonttiin.
Erään tutkimuksen mukaan suomalaisten liikemiesten
kielitaito on vain tyydyttävä. Kielitaidon merkitys kaupan
solmimisessa.

Cyberjohtaja hajoaa osiksi.
Esimiehenä olemisen uudet haasteet. Minkälaisia ovat
tulevaisuuden johtajat ja organisaatiot?

Success story:
Lohjalainen Antti Kuusisto törmäsi sattumalta loistavaan
ideaan. Nyt hän pyörittää miljoonia vuosittain.
Onnistumisen hinta.

Matka tulevaisuuteen alkaa jo nyt.
Yksityinen eläkevakuutus-kolmikymppiset säästävät jo.
Miten se otetaan, maksusuunnitelmia

Nykypäivän keksijät.
Miten keksinnöt ovat muuttuneet aikojen kuluessa? Tuire
Mäkelä saa leipänsä miesten jääkiekkovarustuksista.

Miten firma perustetaan ?
Käytännön vinkkejä esim. osakeyhtiön tai
kommandiittiyhtiön perustamiselle. Pikakurssi
yritysmaailman juridiikkaan.

Brändin luomisen abc.
Calvin Kleinin tuoteperheen syntyminen ja hoitaminen.
Mikä merkitys brändimarkkinoinnilla on?

Paheet ovat elämän suola.
Pako hyväksyttäviin ja paheksuttaviin paheisiin. Pimeät
työt, elastomuus, pettäminen, lääkkeet, alkoholi.
Suomalaisten paheet top ten.

internet

ILMIÖT
HENKILÖT
URHEILU
BUSINESS
POLITIIKKA
TOYS4BOYS
VIIHDE & VAPAA
INTERNET

TILAUS
KILPAILU
HUUTOKAUPPA
KUSTANTAJA

verkkojen tulevaisuus

Business rytisee 2000-luvulle. Kolme Internet-yrittäjää
kertoo kaupankäynnistä nettimaailmassa. Miten Internetin
sudenkuopat on arvioitavissa ja miten kotisivuja
rakennetaan ?

Tilaa ja lue lisää Cosmoksesta

kuurojen keskustelu

Parhaimmat nettikeskusteluosoitteet, miten niihin pääsee
mukaan, kokemuksia keskusteluista.

virtual dreams

Huutokauppa!

ILMIÖT
HENKILÖT
URHEILU
BUSINESS
POLITIIKKA
TOYS4BOYS
VIIHDE & VAPAA
INTERNET

PALJONKO TARJOTAAN?
MIRATEL DATAPHONE
KOTIMAINEN TUOTE!

ARVO 3000mk

LISÄTIETOJA: http://www.teleste.fi/comm/

TOYS 4 BOYS

ILMIÖT
HENKILÖT
URHEILU
BUSINESS
POLITIIKKA
TOYS4BOYS
VIIHDE & VAPAA
INTERNET

TILAUS
KILPAILU
HUUTOKAUPPA
KUSTANTAJA

Seikon uusin

Presage Chronograph-kello vaatii hiukan karvaisen ranteen ja
paljon asennetta. 2 350 markalla irtoaa herkitys ja ajanotto sekä
todennäköisesti paljon katseita.

Tilaa ja lue lisää Cosmoksesta

isälle, jolla on jo kaikkea

COSMOS KILPAILU)

MITÄ HALUAT?

ILMIÖT
HENKILÖT
URHEILU
BUSINESS
POLITIIKKA
TOYS4BOYS
VIIHDE & VAPAA
INTERNET

TILAUS
KILPAILU
HUUTOKAUPPA
KUSTANTAJA

-Halu...
Mitä haluat? Mitä himoitset? Mitä
tahdot yli kaiken?

Voita tonnilla laadukasta Netlife
Internet-aikaa ja kellut kevyesti
netissä...

5 vaimoa, uudet sukat, isomman
hauiksen, Karjalan takaisin, Naomi
Campbellin, miljoonan rahaa, ikuisen
elämän...
Kerro Cosmokselle, mitä himoitset yli
kaiken.

10 himotuinta asiaa ja ilmiötä
julkaistaan Cosmos 2/97:ssä. Muista
myös tilata Cosmos kotiisi.

Arvonta suoritetaan 30.6.1997.
Voittajat julkaistaan Cosmoksen
nettisivuilla.

VOITA LAADUKASTA
NETLIFE
INTERNET-AIKAA

NETLIFE

Country: Finland

Project: Cosmosmag

Design Firm: Stereomedia

Design: Miika Saksi

DELA TYPOGRAPHIE AU GRAPHISME

SELF-PROMOTION

The Dela Typographie au Graphisme Website—created by Frédéric della Faille as a practical application of the design theory he is learning at La Cambre design school in Brussels—reflects his theory that HTML should neither restrict nor limit the design process. His use of typography, layout, and imagery show his grasp of the tools and techniques needed to create beautiful, cutting-edge Web experiences.

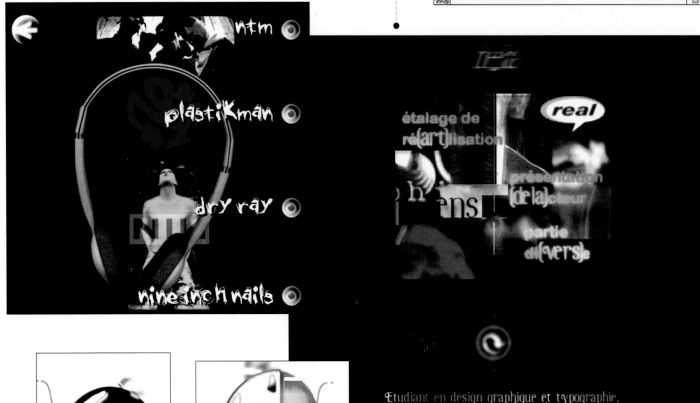

One dynamic element the designer added to the Website is downloadable audio and music (above and above left) using the RealAudio plug-in.

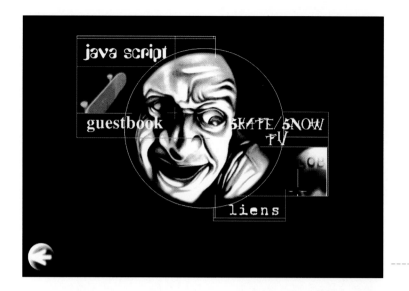

TECHNIQUE: A fun and engaging element implemented in the Website is a JavaScript memory game in which viewers try to duplicate a sequence of four colors as they flash around the game unit display. Viewers can choose speed of play: slow, medium, or fast (below).

A JavaScript opens a new window (below left) that offers viewers a "remote control" navigation palette for easier navigation of the "Skate/Snow TV" area of the site.

Country: Belgium

Project: Dela Typographie au Graphisme

Design Firm: Dust.net

Design: Frederic della Faille

Features: GIF89a animation, Shockwave, JavaScript

Looking at the mature and profession-al design of the Index 4 Website, one would imagine that the designer grad-uated from a prestigious art school. The fact is, however, that the Website belongs to Miika Saksi, a sixteen-year-old designer living in Espoo, Finland. Saksi's unique style can be seen in several of the spreads in this book. Flat, bold colors, interesting layouts composed of rounded boxes, and a firm grasp of Web technology work together to showcase the young designer's portfolio and interests.

TECHNIQUE: JavaScript rollovers frequently showcase specific images and areas within the site. The portfolio areas (below and right) feature rollovers that change graphics when the viewer moves the cursor over one of the three hypertext links or five numerical icons.

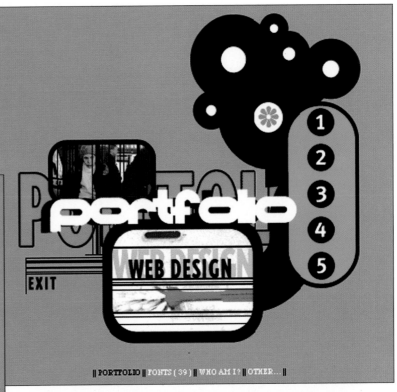

The designer searched the Web for fonts that he feels are worthwhile and now offers his findings to visitors in the font "rooms" (above and right).

Country: Finland

Project: Index 4

Design: Miika Saksi

Features: GIF89a animation, JavaScript

FISCHER WEST DESIGN

SELF-PROMOTION

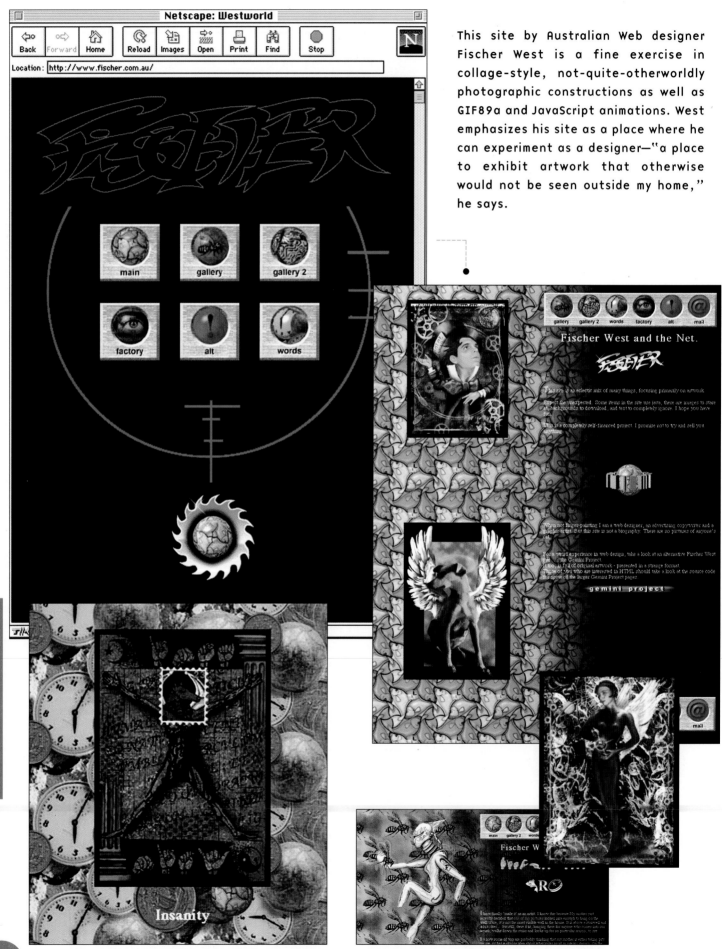

Netscape: Westworld

Back | Forward | Home | Reload | Images | Open | Print | Find | Stop

Location: http://www.fischer.com.au/

main

gallery

gallery 2

factory

alt

words

Insanity

This site by Australian Web designer Fischer West is a fine exercise in collage-style, not-quite-otherworldly photographic constructions as well as GIF89a and JavaScript animations. West emphasizes his site as a place where he can experiment as a designer—"a place to exhibit artwork that otherwise would not be seen outside my home," he says.

Fischer West and the Net.

gemini project

TECHNIQUE: The "Background Factory" page features an GIF89a animation of an eye blinking, which links to a background chooser, below. Clicking on one of the background GIFs loads a sample page so viewers can see the background in use. The viewer can then download the background GIF, with permission to use it in non-commercial applications.

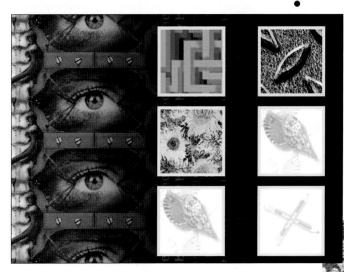

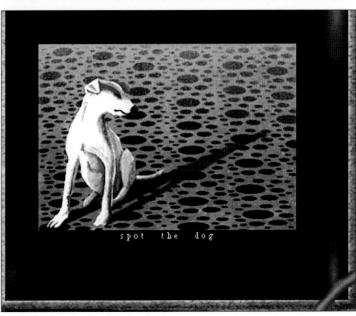

Country: Australia

Design Firm: Fischer West Design

Design: Fischer West

Features: GIF89a animation, JavaScript

This clean and simple site by Kjetil Vatne, a Norwegian Website designer, uses an airy, colorful layout for the splash page and table of contents. The spiky organic shape featured on the splash page reappears in other areas of the site.

Netscape: Kjetil Vatne Graphics+Design

Back | Forward | Home | Reload | Images | Open | Print | Find | Stop

Netsite: http://www.prodat.no/personer/kjetil_vatne/

kjetil vatne
graphics+design

kjetil vatne
graphics+design

table of contents

TABLE OF CONTENTS

art gallery
contact info
services
comments
about me
awards
www links
viewing tips

about the site

Welcome to my graphic and design site. The site includes my gallery of 3D art, animation and graphics design. Information about which services I can provide you with, as well as some personal info about myself. The site is not quite finished yet so bear with me. I decided to put up this site now as my old site was beginning to fall apart. This is the 4th complete makeover of the site. Enjoy and don't hestitate to drop me a note about what you think.

22nd of March 1997

gallery

architecture

nature

space

TECHNIQUE: The schematic to the left is the navigational map for a series of computer-rendered architectural images. The linear schematic balances with an organic circular motif in the background. This site is an exercise in simplicity—a technique in itself.

Country: Norway

Design Firm: Kjetil Vatne Graphics+Design

Design: Kjetil Vatne

PALVELU 2000

SELF-PROMOTION

Palvelu 2000 (Service 2000), a Finnish site, sells products directly to consumers or through school organizations. Designed by Miika Saksi, a designer with the Stereomedia design firm, the site conveys a sense of lightness and well-being by using white backgrounds, bright colors, and happy images; the site also conveys a sense of confidence with bold typography and unconventional borders around images.

TECHNIQUE: Before the full-color image below loads, the black-and-white image to the left loads. This common technique keeps viewers from clicking away while a large color file loads. In this site the black-and-white images carry as much interest as the color image—the strawberry, in particular, takes on the quality of an etching.

HYVÄT KAUPANHIERONTAEHDOT

Masse-peruspakkaus sisältää 63 nelijalkaista Massea. Se on vain pari Masse luokan jokaista oppilasta kohti.

Alkupääomaa et tarvitse lainkaan, sillä tuotteet toimitetaan myyntitiliin.

Masset maksetaan vasta, kun ne on myyty. Myyntiaikaa on toukokuun 1997 loppuun saakka.

Masset toimitetaan rahtivapaasti. Myymättömät Masset voit palauttaa kustannuksellamme.

Project: Palvelu 2000

Design Firm: Stereomedia

Design: Miika Saksi

Photography: Jukka Klemetti

SOFTMACHINE
SELF-PROMOTION

The Softmachine Website comprises three main areas: a "Newsstand" area for up-to-date music news; "Node 246" (facing page); and "Web Jockeys" (below). The "Web Jockeys" area contains download-able RealAudio music clips of popular Japanese singers and musicians—viewers can listen to a clip while visiting the rest of the site. The contents page for "Web Jockeys" features Japanese and English titles, but secondary page body copy (below right) is strictly in Japanese.

Netscape: softmachine<

Back Forward Home Reload Images Open Print Find Stop

Location: http://www.softmachine.co.jp/

soft m@chine...

Nineteen: ninety seven

Japanese ALT culture

Online publishing

coming soon------/// TR A NS EX

STAFF ROOM
publisher: Tsuyoshi Takashiro
editor in chief: Koji Yoshida / editor: Yukiko Fuwa
art director: Hikaru Mochizuki / designer: Osamu Murafuji

NODE 246 NEWS STAND WEB JOCKEYS

e-mail: info@softmachine.co

WEB JOCKEYS

1. **WEEKLY WJ'S LIST**
今週のけっこうクールかも知れないサイト

2. **GUEST WJ'S LIST**
各界のトップWJがチョイスしたおススメ10サイト

WEB JOCKEYS
SOFT MACHINE
REAL AUDIO

3. **OFFLINE DJ'S LIST**
「地上」のトップDJがチョイスした10ヴィニール

4. **WJ'S PRIZE**
誉れ高き殿堂入りのサイトたち

5. **OTHER INDEX PAGES**
ココより使える(?)インデックス・ページ

soft m@chine

Copyright© 1995 SOFT MACHINE Inc.

WEEKLY WJ'S LIST

今週のけっこうクールかも知れないサイト

Web Jockeys SOFT MACHINE®

01: http://www.fpl.co.jp.smachine/
webJockeys/weekly/

Last Updated
16 / 07 / 1996

OFFLINE DJ'S LIST
「地上」のトップDJがチョイスした10ヴィニール

DJ YO-C
●東京生まれ、23歳。高校時代にヒップホップにインスパイアされ、DJに興味をもつ。ロンドンのアートスクールに留学したことをきっかけにクラブ・カルチャーにさらに関心を深め、帰国後は都内クラブを中心にDJとして活躍。昨年末にはヨーロッパ各地でのDJツアーも行った。

アーティスト名／ディスク名 (レーベル名)

BERRi /
The Sunshine After The Rain
(THREE BEAT MUSIC)
オリジナルはハデハデだったけど、このRemixはそのハデさをいい塩梅にまとめたナイスな1枚。

TOCAYO / All Night
(LIMBO)
3曲入りで、いつもどれを使っていいかまよってしまうけど、やっぱりどれも捨てがたい。とてもツボをついています。

CANDY GIRLS / Fee Fi Fo Fum
(VIRGIN)
個人的にとても大好きな部類はこういうやつで、一言でバカ楽しいノリここに極まるといった所でしょうか? すごくGoodです。

SUB-STATE / Take Me Up
(ROGUE TROOPER)
Break Beat + Piano + Techno + Happy Choon!の王道をそのまま突き進んでいる作品で、この"ROGUE TROOPER"というレーベル全部こんなかんじ!!。この手が好きな人はこんなかんじ!!。

X-TROOP / The Scream
(GROOVILICIOUS MUSIC)
今月いちばん人間が沸めた。ブッ飛び度7万点級のドえらい作品。ヒップホップ好きを思わず耳をかたむけちゃう。とにかくとってもクレイジーです。(写真はプロモ盤です)

VARIOUS /
Nights At The Round Tables,
Vol.1 (GOSSIP)
名前がVery Goodで曲もVery Goodです。作者は全部違います。大ケ間違いなしです。(写真はプロモ盤です)

REAL AUDIO

Copyright(c)1995 soft m@chine inc.

246
JAPANESE ALT. CULTURE
Japanese Models
After the era of Kate Moss
vol.3

↑ JAPANESE ↑

From : VIVA YOU PROMOTION
Photo : TAJIEEMAX

• • • vol.1 *back issue* vol.2 *back issue* • • •

© Soft m@chine inc.

TECHNIQUE: "Node 246" is a bilingual Japanese culture magazine. This issue focuses on Japanese fashion models. An interesting use of frames can be found in the "Japanese Models: After the Era of Kate Moss" feature. In this area the designers incorporate six individual scrolling frames. To read the article, viewers click on the "next" button, which then loads the next frame with more of the article.

This is reflected in the viewpoint of Maki Odajima who supervises the individualistic "Amazone". (By Yoshinori Kaneko)

---Each model agency has its own character. Did you have your own marketing when you established Amazone? Odajima(MO) : I thought, "we want to be free, not restricted", anyway. Like, it's alright if I can walk with companions who I can get along well with. What I have continued to hope for for our models is just one thing : Be honest and dignified as human nature, not easily-flattered.
---Yu Fujimoto has presented a

comparison with other agencies?
MO : At first, I want our models to do editorial work definitely. I want everyone to keep flexibility. I want everyone to challenge everything. I want us to act together with that kind of model.

└ next

will change and we'll change it. Through an approach to have people to look at a new type of girl. Also, I want to train my eyes a little, to be new. I want to make an effort to be able to go a little ahead of the media, not chasing it.

NODE 246

next >>

vol.3
Japanese Models
After the era of Kate Moss

>>>>>>>

Graphics on Miwako Ichikawa	01>
Case study of agency: Amazone featuring Maki Meguro	02>
Ayumi Tanabe : Into the world	03>
Models coming up next	04>UNDER CONSTRUCTION
Short story movie: Ayumi vs Eihi	05>
Before and after Kate Moss	06>UNDER CONSTRUCTION

JAPANIMATION MATRIX

MAP/YOSHIHIRO YONEZAWA

70 75 ★ パワードスーツ系
宇宙の騎士テッカマン
TEKKAMAN
80

★ 産業ロボット
機動戦士Zガ
Z GUNDAM
機動戦士ガンダム
MOBILE SUIT GUNDAM
超時空要塞マ
MACROSS

★ 景物系

★ 搭込型
ゲッターロボ
GETER ROBO
勇者ライディーン
REIDEEN
伝説巨神イ
THE IDEO

NODE 246
TOKYO BACKBONE
-1

マジンガーZ
MAJINGAA Z
超電磁マシーンボルテスV
BORUTESU V
ザンボット3
ZANBOT

鉄人28号
TETSUJIN28
★ 巨大ロボットタイプ
グレートマジンガー
GREAT MAJINGAA
★ パーツ合体
超電磁ロボ コン・バトラーV
KONBATORAAV
ガイキング
GAIKING
巨神(ジャイアント)マ
GORGU
巨大ALロボ
★ リモコン操作系
鋼鉄ジーグ
GIGU
惑星ロボダンガードA
DANGEAD A
サイアーマーゴーバリア
GORBARIAN

Country: Japan
Design Firm: Softmachine Inc.
Design: Madika Iwabuchi, Hikaru Mochizuki
Programming: Hideaki Kiko
Features: GIF89a animation

An important area of popular Japanese culture is *anime* (above right), a stylized form of full-feature Japanese animated cartoons or movies.

JODI.ORG

SELF-PROMOTION

Jodi.org is a programmer/artist Website created by Joan Heemskeerk and Dirk Paesmans. Except on the home page, the site contains no intelligible text for the human eye—visiting this site is equivalent to experiencing what a computer might do for fun (or art) on the Web if freed from human constraints. Screens full of color and energy seem to scroll endlessly. Randomly clicking on a data stream switches the viewer to yet another stream, with different colors and different computer meaning.

TECHNIQUE: This experimental site uses embedded Java programming to send screen data incredibly rapidly—viewers who are accustomed to slow screen-draw times while surfing the Web will be amazed at how rapidly screens change and scroll in this site. The site moves and pulsates with computer life so rapidly that it seems as though the display originates from the viewer's own hard drive, when in fact it is originating from a site in the Netherlands. The technology behind this site seems to promise a new era on the Web.

Country: Netherlands

Project: Jodi.org

Design: Joan Heemskerk,
Dirk Paesmans

Features: Embedded Java

AIHKI LOG HOMES

SELF-PROMOTION

The Stereomedia design firm gave the Aihki Website a clean interface that highlights the company's products and gives a short summary of each log house. Miika Saksi, the site's designer, incorporated a stylized contemporary design that included flat primary colors and small colorized photographic images of Aihki log homes for quick downloading of each page.

Country: Finland
Project: Aihki
Client: MY-Rakennus Oy
Design Firm: Stereomedia
Design: Miika Saksi
Photography: MY-Rakennus Oy archives

[http://www.dlc.fi/~aihki]

The Rooseum, a Swedish contemporary art center, holds four or five fine art exhibitions each year. Fountain Design wanted to give the online presence for the exhibitions a light and airy feel, while at the same time keeping the look in line with the artistic and graphic profile of the Rooseum. The typography and graphic style were chosen to convey both an institutional and a contemporary look.

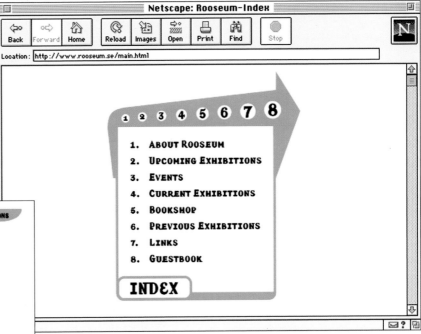

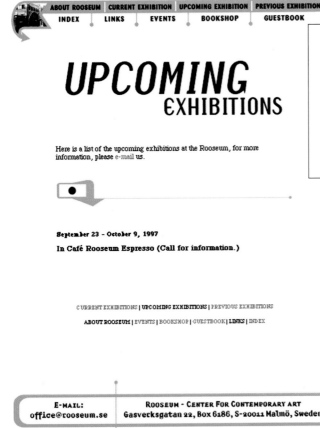

The arrow motif used on headers throughout the site directs the viewer's focus to important elements within the Website.

Country: Sweden

Project: The Rooseum

Client: The Rooseum: Center for Contemporary Art

Design Firm: Fountain

Design: Peter Bruhn

SARA BAILEY DESIGN

SELF-PROMOTION

Sara Bailey is a graduate of the Emily Carr Institute of Art and Design, located in Vancouver, B.C. Her Website features a portfolio of current online design projects, a forum for design-related issues, and student projects she created while still in school. Brightly colored bars divide the two areas of the Website: the navigation area—with its three large numerals—and the viewing area, with its black background. Organizing the site in this way clearly defines where viewers can look for navigation elements and where they can expect to see specific content.

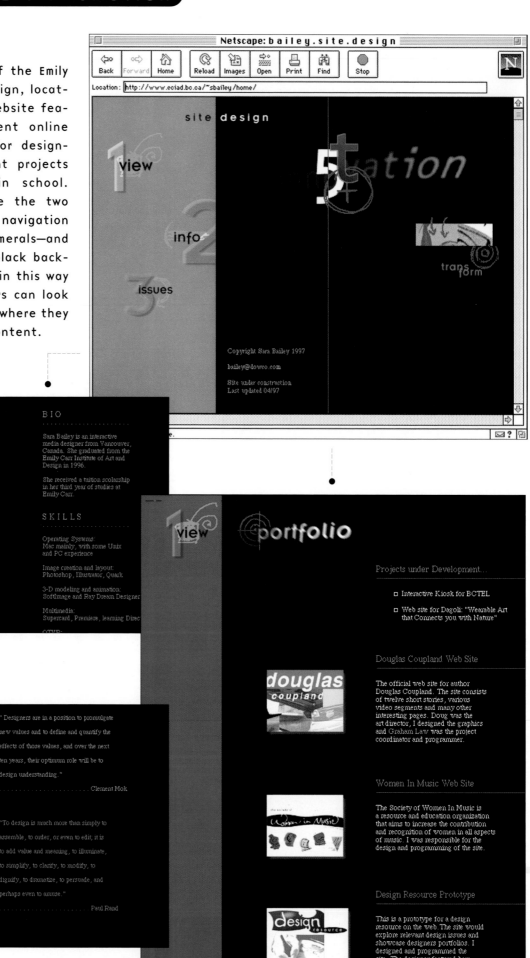

TECHNIQUE: The "innovation" area of the portfolio features a GIF89a animation that cycles through illustrated images and icons, conveying three steps to good design: "communicate, transform, process."

The "design resource" area is a class project and prototype of a Website that could be used as an informational resource by the design industry and the general public. The prototype features unique header graphics with type contoured to fit the various shapes.

Country: Canada

Project: Sara Bailey Portfolio

Design: Sara Bailey

Features: GIF89a animation

The Axiom
Anthony Palacios

www.swanky.org/axiom

21.C 2.96
www.21c.com.au

3p development
www.3pdesign.com

4AD: The Site
www.4AD.com

A New January
www.interaccess.com/primal/january

Brutal
Brutal Gift

www.w3.one.net/~brutal

Art Center College of Design
www.artcenter.edu

artFUX: a hog's head of real fire
www.artfux.com

ATT 1-800-CALL-ATT
www.att.com/callatt

Attik Design
www.attikdesign.com

Christopher Schmitt Design
Christopher Schmitt

www.christopher.org

Bodyflow–Hon Hiew's Website
www.qmm.com.au/hon

Boiling Point Productions
www.boilingpoint.com

Border Equals zero
www.borderequalszero.com/front

BOWLING ALLEY
bowlingalley.walkerart.org

City Vibes
Pulse Interactive

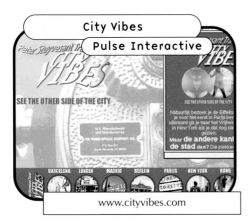

www.cityvibes.com

BMG Alternative
www.bugjuice.com

Alternative Pick
www.s2f.com/altpick

Anti:Rom-the antidote
www.antirom.com

april greiman labs
aprilgreiman.com

Conscience Records
Entropy8 Digital Arts

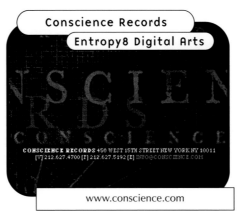

www.conscience.com

backspace
www.backspace.org

Beneath the surface
users.uniserve.com/~jhansen

Blue Dot
www.razorfish.com/bluedot/typo

Blur Studio
www.blur.com

Core-Colors
Takeru Esaka

www.corecolors.jp.co

Byg-Prod
www.orbital.fr/bygprod

Byway
www.bway.net/~qbism

Cafe Orbital–Paris
www.orbital.fr/frameindex.html

China Records
www.china.co.uk/china

Culture Zone
Red Channel Interactive

www.culturezone.com

=cw4t7abs\Marius Dan
Punktprotokol

www.tezcat.com/~antiorp

Cyberdelia
AM Multimedia

www.ammulti.dk/cyberdelia

The Land of D
Dust Productions

www.primenet.com/~xtorres

communikae | digital visual communications
www.communikae.com

Conscience Records
www.conscience.com

Crash Site
www.crashsite.com/TOC

Creating Killer Websites Online
www.killersites.com

EdgeDesign
Edge Communications

www.edgecommunications.com

Digital Mud Area
www.digitalmudarea.fr

Dog & Pony Company
www.dogandpony.com/map/map.html

Dotmov
www.dotmov.com

Double Aught Software
www.doubleaught.com

Evolution of Type
Michael Brandt

www.concentric.net/~brandt58

F U S I O N - L I N E
www.fusion.com.au

F u z b o x
www.fuzbox.com

Favela
www.favela.org/intro/main

Fine Magazine
www.finemagazine.com/fine1/home/home

FIEND
Red Channel Interactive

www.redchannel.com/fiend

Creative Net
www.creative.net/~jlabbati

Culture Zone
www.culturezone.com

DDB Interactive home page
www.ddbniac.com

dFORM
www.dform.com

Funny Garbage
Funny Garbage design

www.funnygarbage.com

Duffy Design
www.duffy.com

Dust Net
www.dust.net

Dust Net–Download
www.dust.net/download

enhanced cd database
www.musicfan.com/ecd

High Five
Verso Design

www.highfive.com

Flashpoint: Adobe Student Design Competition
www.concentric.net/~Brandt58

Fluid Design
www.custard.co.uk/fluid

Font Bureau, Inc.
www.fontbureau.com/index.html

Fox Interactive: Inter-Ocular Brainwave Stimulator
www.foxinteractive.com

Jetset Design
Tjer Geerts

www.bedrijfsnet.nl/~jetset

John Paulsen Design
John Paulsen

www.wolfenet.com/~jep

Online Design Portfolio
Tom Lakovic

www.peak.sfu.ca/~lakovic

153

Ken Leung Portfolio
Ken Leung

www.nw.com.au/~leungk

FSOnLine
raft.vmg.co.uk/fsol/index

FUNNEL
www.funnel.com

Fusionaries by Verso design
www.fusionaries.com

g i g w i d t h
www.cyberg8t.com/gigwidth

MiamiVR
Edge Design, Inc.

www.miamivr.com

Hal Apple Design
www.cinenet.net/halapple/main

Hammer Wheels
www.hammerwheels.com

Hatmaker cmndesign
www.corey.com/hatmaker/hatmaker

Herron School of Art | IUPUI
www.herron.iupui.edu

Milkshake
Milkshake Design

www.shake.com

International Bonejangler
www.bonejangler.com

InterWeb Design oy
www.interweb.fi

Jeff Koke–Home Page
www.io.com/~jkoke

JetPack 01 - The Launch
www.jetpack.com/index01

MyriadWeb
Myriad, Inc.

www.myriadweb.com

gardening minute
www.communikae.com/garden

Glassdog
www.glassdog.com

go2net
www.go2net.com

gopod
www.gopod.com

A New January
Black Vox Studio

www.interaccess.com/primal/january

Homicide: The Case
www.nbc.com/homicide/case

i-MAGIC Front Door
imagic-festival.com/#main

I/O 360
www.io360.com/A/connectwith/links

IIM Beta
www.iim.uts.edu.au/beta

Point b
Point b Incorporated

www.point-b.com

Jonah Weiland's Home Pages
envisionww.com/jonahw

Kabeljau Design
www.kabeljau.ch

kIM gRANLUND
loke.syh.fi/~kgranlun

Kiss
199.35.154.221/threads/juliet/

Pulse Corporate
Pulse Interactive

www.pulse.nl/corp

Rebarsound
Hillman Curtis

www.rebarsound.com

Sabotage Online Magazine
Sabotage

www.sabotage.de

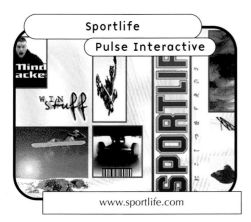

Sportlife

Pulse Interactive

www.sportlife.com

Kolumbuksen WWW finland
www.kolumbus.fi

Leba Design Inc.
www.lebadesign.com

Liquid Design Group
www.liquidesign.com

M e d i a R e n a i s s a n c e
www.MediaRenaissance.com

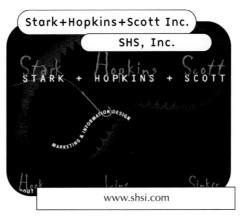

Stark+Hopkins+Scott Inc.

SHS, Inc.

www.shsi.com

mindinmotion
www.mindinmotion.com

MIT Aero/Astro
web.mit.edu/aeroastro/www

MIT Logarhythms!
web.mit.edu/logs/www

MonibDesign
www.adam.com.au/~monib

Strictly Ultra reStijled

Pulse Interactive

www.pulse.nl/strictly

Nude
www.sigma6.com/nude

Nylon Beat
www.mtv3.fi/musiikki/nylon_beat/etusivu.htm

NYU Center for Advanced Technology
www.cat.nyu.edu

Obsolete
www.obsolete.com

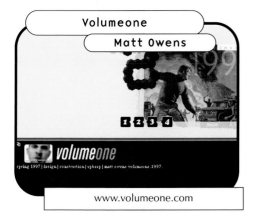

Volumeone

Matt Owens

www.volumeone.com

M. A. D.
www.madxs.com

MCAD Students Showcase/ Mike Lin
www.mcad.edu/home/students/lin/fresh

Mammoth Recording MUSIC
www.mammoth.com

Michael Dziedzic design
www.tiac.net/users/mmilano/mdziedzic

VERSO

Verso Design

www.verso.com

Muffin-Head Productions
www.muffinhead.com

Music Zone
www.themusiczone.com/channelf

myriad design
www.myriadagency.com/~matt

Mythopoeia "The Making of Myths"
www.myth.com

N*WORKS brody
www.nworks.co.uk

New Dream Network
www.newdream.net

Newport Internet Services
www.newportinternet.com

nFlux inc
www.nflux.com

No Dead Trees
www.nodeadtrees.com

Wildpark

Pixelpark Multimedia

www.wildpark.com

Open Data Solutions
www.odsnet.com

Paris: Hotspot
www.dga.com/parishotspot.html

Peak magazine online
www.peak.sfu.ca

Planet Design
www.planet.dk

Poppe Tyson design firms
www.poppe.com

prototype–experimental foundry
www.prototype-typeo.com

quiet-time.com
www.quiet-time.com

Research
www.research.co.uk

Rollingstone.com
www.rollingstone.com/Home

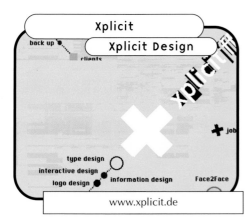

Xplicit

Xplicit Design

www.xplicit.de

DIRECTORY

52mm
92 Horatio St., #323
New York, NY 10014
212.691.5907
www.inch.com/~jinn/52mm

allstarmag.com LLC
7750 Sunset Blvd.
Los Angeles, CA 90046
213.874.7777
www.allstarmag.com

Bau-Da Design Lab, Inc.
480 Canal Street, #1102A
New York, NY 10013
212.965.9205
www.bauda.com

Big Deal Design
5145 Lisa Way
Santa Rosa, CA 95409
707.538.8125
ecst.csuchico.edu/~any

Blind Visual Propaganda
2020 N. Main St., #235
Los Angeles, CA 90031
213.222.9509
www.blind.com

BRNR Labs
269 Via Buena Ventura
Redondo Beach, CA 90277
310.791.8602
www.brnr.com

Chong, Edwin
22018 McClellan Road
Cupertino, CA 95014
408.996.0779
www.nrv8.com

Circumstance Design
164 Townsend St., #4
San Francisco, CA 94107
415.771.2888
www.circumstance.com

CO2 Media
3 N. Court Street, Suite 1
Frederick, MD 21701
301.682.6515
www.co2media.com

Construct Internet Design
448 Bryant Street
San Francisco, CA 94107
415.357.0100
construct.net

Contempt Productions
144 W. 23rd St., #11C
New York, NY 10011
212.242.6022
www.inch.com/~contempt

Core77, Inc.
561 Broadway, Suite 6B
New York, NY 10012
212.965.1998
www.core77.com/info

David, Jay
3 Sugarhill Ct.
St. Louis, MO 63021
314.227.0197
www.inlink.com/~jayok

DCAF Aftermath
209 S. Garey
Los Angeles, CA 90012
213.621.7661

DDB Needham Interactive
(Pepsi World)
3500 Maple Avenue, Suite 1700
Dallas, TX 75219
214.599.5248

Domonkos, Bill
455 1/2 Sanchez St.
San Francisco, CA 94114
415.626.3212
www.bdom.com

Drawbridge Productions
2702 Ridgeview Lane
Walnut Creek, CA 94598
212.344.6465
www.the-eclectica.com

Dreamless Studios
1 Keystone Ave., #36
Cherry Hill, NJ 08003
609.751.9595
www.dreamless.com

eLogic Communications
1608 Pacific Ave., Suite 203
Venice, CA 90291
310.581.6100
www.elogic.com

Entropy8 Digital Arts
114 East 1st St., #20
New York, NY 10009
212.979.9492
www.entropy8.com

fabric8
P.O. Box 420794
San Francisco, CA 94142
415.487.9702
www.fabric8.com

focus2
2105 Commerce St., #102
Dallas, TX 75201
214.741.4007
www.focus2.com

Fordesign
533 Twinbridge
Alexandria, LA 71303
318.449.4888
www.frank-ford.com

form studio, Inc.
1526 31st Avenue
Seattle, WA 98122
206.320.9030
formstudio.com

Grain Ltd. (flex.net/~151)
1311 Allston
Houston, TX 77008
713.861.6964

Hsu, Andrew L.
450 Memorial Dr.
Cambridge, MA 02139
617.225.9228
web.mit.edu/shoos/www

Lin, Mike
www.mcad.edu/home/students/
lin/fresh

Mindcandy Design
1801 S. Lakeshore Blvd., #260
Austin, TX 78741
512.448.3955
www.mindcandy.com

MK Advertising and Design
116 Belvedere St., #2
San Francisco, CA 94117
415.759.6090
www.sirius.com/~martink/
homunculi.html

N2K Entertainment
55 Broad Street
New York, NY 10004
212.378.0369
www.n2k.com

New Media Development Group
(eyecandy.com)
50 Monument Square, Suite 302
Portland, ME 04101
207.879.0199
www.mnetwork.com/nmdg

Ocurix Films
309 W. 106th St., #5B
New York, NY 10025
212.749.8742
www.hypnagogue.com

P2
287 W. 4th Street, #10
New York, NY 10014
212.255.7434
www.p2output.com

Phoenix POP Productions
481 Second Street, Unit 127
San Francisco, CA 94107
415.896.6700
www.3pdesign.com

Pittard Sullivan
3535 Hayden Ave.
Culver City, CA 90232
310.253.9100
www.pittardsullivan.com

Plus Design
2544 N. Crossgate
Orange, CA 92667
714.921.1831
bmrc.berkeley.edu/plus

Powazek Productions
71 Prosper St.
San Francisco, CA 94114
415.865.0720
www.powazek.com

Prophet Communications
355 Bryant, Suite 109
San Francisco, CA 94107
415.442.4804
www.prophetcomm.com

Qaswa Communication
423 Washington Street, Floor 5
San Francisco, CA 94111
415.399.9895
www.qaswa.com

Razorfish, Inc.
107 Grand Street, 3rd Floor
New York, NY 10013
212.966.5960
www.razorfish.com

Red#40
P.O. Box 2709
New York, NY 10008
800.352.4229
www.red40.com

SOME Entertainment
1734 Lazy Z Road
Nederland, CO 80466
303.642.0423

Spirollel Design
7928 Ferrara Drive
New Orleans, LA 70123
504.738.6179
www.thegatlinggroup.com/~spiro

Studio CD
130 North Butte Suite a., Box 111
Willows, CA 95988
916.934.8828
cds@studiocd.com

Syndetic Design
12108 Wycliff Lane
Austin, TX 78727
512.832.8688
www.syndeticdesign.com

Tamura-Murphy, Kevin
8981 Lansdowne Ct.
Elk Grove, CA 95624
ecst.csuchico.edu/~amergeek

GLOBAL SITES
Antart
P.O. Box 755
Strawberry Hills, Sydney
NSW 2012 Australia
612.9212.1735
www.antart.com.au

Artemisia
57 Victoria Road
London N22 4XA
United Kingdom
44.181.245.6224
artemisia.com

Bailey, Sara
2320 Woodland Drive, #3
Vancouver, BC V5N 3P2
Canada
604.879.3301
eciad.bc.ca/~sbailey/home

brody|newmedia
Lerchenfelderstrasse 63
A-1070 Vienna
Austria
43.1.526.4303
www.newmedia.co.at/brody

dust.net
78 Drêve de la Ferme
B-1970 Wezembeek-Oppem
Belgium
32.322731.9622
www.dust.net

Electric Ocean
53 Wale Street
Cape Town 8001
South Africa
2721.246299
www.electric.co.za

Fischer West Design
4 Forrest Court
Mt. Ommaney, Brisbane
Qld 4074
Australia
617.3279.2436
www.fischer.com.au

Fountain–A Friendly Design
Company
Södre Parkgaten 29 A
SE-214 22 Malmö
Sweden
www.algonet.se/~fountain

jetset design
Gerardus Gullaan 4
1217 LN Hilversum
Netherlands
310.35.628.4071
www.bedrijfsnet.nl/~jetset

jodi.org
F. Halsstraat 61
2162 CL Lisse
Netherlands
www.jodi.org

Shimizu, Masayuki
1-3-4 Sakurayama Zushi-shi
Kanagawa 249
Japan
81.0468.71.4572
www.surfline.ne.jp/shimizu/home/

Soft Machine, Inc.
311 4-29-6 Seta,
Setagaya-ku, Tokyo 158
Japan
81.3.3707.0449
www.softmachine.co.jp

Stereomedia
P.O. Box 262
FIN-00171 Helsinki
Finland
358.9.836.1344
stereomedia.net

Vatne, Kjetil
Langarinden 407
N-5090 Nyborg
Norway
475.5190819
kvad.com/kvad

WEB GUIDE SITES

AM MultiMedia (Cyberdelia)
Riihimäkivej 6
9000 Aalborg
Denmark
45.99.34.9971
www.ammulti.dk

The Axiom
8626 Tamarind Avenue
Fontana, CA 92335
www.swanky.org/axiom

BlackVox Studios
910 S. Walnut Avenue
Arlington Heights, IL 60005
847.392.3159
www.interaccess.com/primal/
palemute

Brandt, Michael
100 Angell Street, #2
Providence, RI 02906
401.751.4261
www.concentric.net/~brandt.58

Brutal Gift Expressions & Co.
359 Ludlow, #22
Cincinnati, OH 45220
513.221.0430
w3.one.net/~brutal

Core-colors
311 4-29-6 Seta
Setagaya-ku Tokyo 158
Japan
81.3.3707.0449
www.core-colors.co.jp

Dust Productions
3711 W. Blackhawk Dr.
Glendale, AZ 85308
602.587.0984
www.primenet.com/~xtorres/d/

EdgeDesign (MiamiVR)
P.O. Box 4391
Hallandale, FL 33008
954.458.0572
www.EdgeCommunications.com

Entropy8 (Conscience Records)
114 East 1st St., #20
New York, NY 10009
212.979.9492
www.entropy8.com

Funny Garbage
73 Spring Street
New York, NY 10012
212.343.2534
www.funnygarbage.com

Hi5 (Studio Verso)
512 2nd Street
San Francisco, CA 94107
www.highfive.com

Hillman Curtis
514 A Vermont
San Francisco, CA 04107
415.252.2139
www.rebarsound.com

Jetset Media Design
Gerardus Gullaan 4
1217 LN Hilversum
Netherlands
31.0.35.628.4071
www.bedrijfsnet.nl/~jetset

John Paulsen Design
3850 Klahanie Dr. S.E., #17-103
Issaquah, WA 98029
425.557.2122
www.wolfenet.com/~jep

Leung, Ken
29 Waverley Way
Parkwood, Western Australia 6147
Australia
618.9354.3661
www.nw.com.au/~leungk

Milkshake
1018 Meridian Avenue, #4
Miami Beach, FL 33139
305.535.9047
www.shake.com

Myriad, Inc.
142 Berkeley St.
Boston, MA 02116
617.266.3332
www.myriad.com

Pixelpark Multimedia GmbH
(Wildpark)
Reuchlinstrasse 10-11
10553 Berlin
Germany
49.030.34981.500
www.pixelpark.com

Point B Incorporated
2800 Woodlawn Dr., Suite 250
Honolulu, HI 96822
808.539.3777
www.point-b.com

Pulse Interactive (CityVibes,
Sportlife, Strictly Ultra)
Hogehilweg 10
1101CC Amsterdam
Noord-Holland
Netherlands
31.20.311.6444
www.pulse.nl

Punktprotokol (=cw4t7abs)
www.tezcat.com/~antiorp

Red Channel Interactive (Culture
Zone & Fiend)
P.O. Box 351341
Los Angeles, CA 90035
310.278.8304
www.culture.com

Schmitt, Christopher
202 E. Lakeshore Drive
Tallahassee, FL 32312
904.385.6983
www.christopher.org

Stark + Hopkins + Scott Inc.
1302 White Dove Cove
Cedar Park, TX 78613
512.422.6194
www.shsi.com

Studio Verso
512 2nd Street
San Francisco, CA 94107
www.verso.com

Tiegelkamp, Vicky
Kastanienallee 46
D-10435 Berlin
Germany
49.030.883.8491
www.sabotage.de

Tom Lakovic Graphic Design
3317 E. 29th Avenue
Vancouver, BC V5R 1W7
Canada
604.876.2622
www.peak.sfu.ca/~lakovic

Volume One
P.O. Box 94238
Durham, NC 27708
www.volumeone.com

Xplicit
Ludwigstrasse 31
60327 Frankfurt
Germany
49.69.975727.0
www.explicit.de

GLOSSARY

A

ACCESS TIME: Amount of time it takes a CD-ROM drive (or other device) to locate and retrieve information.

B

BANDWIDTH: Data transmission capacity, in bits, of a computer or cable system; the amount of information that can flow through a given point at any given time.

BANNER: A graphic image that announces the name or identity of a site (and often is spread across the width of the Web page) or is an advertising image.

BAUD RATE: Speed of a modem in bits per second.

BROWSER: A program that allows users to access information on the World Wide Web.

BUTTONS: Graphic images that, when clicked upon or rolled over, trigger an action.

BYTE: A single unit of data (such as a letter or color), composed of 8 bits.

C

CACHE: A small, fast area of memory where parts of the information in main, slower memory or disk can be copied. Information more likely to be read or changed is placed in the cache, where it can be accessed more quickly.

CD-ROM: (Compact Disc-Read Only Memory) An optical data storage medium that contains digital information and is read by a laser. "Read Only" refers to the fact that the disc cannot be re-recorded, hence the term.

CGI: (Common Gateway Interface) Enables a Website visitor to convey data to the host computer, either in forms, where the text is transferred, or as web maps, where mouse click coordinates are transferred.

CMYK: Cyan, magenta, yellow, black (kohl in German), the basic colors used in four-color printing.

COLOR DEPTH: The amount of dataused to specify a color on an RGB color screen. Color depth can be 24-bit (millions of colors), 16-bit (thousands of colors), 8-bit (256 colors), or 1-bit (black and white). The lower the number the smaller the file size of the image and the more limited the color range.

COMPRESSION: Manipulating digital data to remove unnecessary or redundant information in order to store more data with less memory.

D

DPI: Dots-per-inch, referring to the number of halftone dots per inch or the number of exposing or analyzing elements being used. 72-dpi is the resolution of computer display monitors.

DIGITIZE: Convert information into digital form.

E

E-ZINE: A small self-published magazine distributed electronically through the internet or on floppy disk.

F

FPS: Frames per second.

FRAMES: The use of multiple, independently controllable sections on a Web page.

G

GIF: (Graphics Interchange Format) A file format for images developed for CompuServe. A universal format, it is readable by both Macintosh and PC machines.

GIF89A ANIMATION: GIF format that offers the ability to create an animated image that can be played after transmitting to a viewer.

H

HOME PAGE: The Web document displayed when viewers first access a site.

HOTSPOTS: Areas onscreen that trigger an action when clicked upon or rolled over.

HTML: (HyperText Markup Language) The coding language used to make hypertext documents for use on the World Wide Web.

HYPERLINK: Clickable or otherwise active text or objects that transport the user to another screen or Web page with related information.

HYPERTEXT: A method of displaying written information that allows a user to jump from topic to topic in a number of linear ways and thus easily follow or create cross-references between Web pages.

I

IMAGE MAP: A graphic image defined so that users can click on different areas of an image and link to different destinations.

INTERACTIVE: Refers to a system over which users have some control, which responds and changes in accordance with the user's actions.

INTERFACE: The connection between two things that enables them to work together.

INTERNET: A global computer network linked by telecommunications protocols. Originally a government network, it now comprises millions of commercial and private users.

INTERNET SERVICE PROVIDER (ISP): Enables users to access the internet via local dial-up numbers.

INTRANET: A local computer network for private corporate communications.

J

JAVA: Programming language expressly designed for use in the distributed environment of the Internet.

JAVASCRIPT: An interpreted programming or scripting language from Netscape.

JPEG (Joint Photographic Experts Group): An image compression scheme that reduces the size of image files with slightly reduced image quality.

K

KILOBYTE: As a measure of computer processor or hard disk storage, a kilobyte is approximately a thousand bytes.

L

LINEAR: Refers to a story, song, or film that moves straight through from beginning to end.

M

MEGABYTE (MB): Approximately a million bytes.

MODEM: (modulator-demodulator) A device that allows computers to communicate to each other across telephone lines.

MORPHING: The smooth transformation of one image into another through the use of sophisticated programs.

MPEG (Moving Pictures Experts Group): A video file compression standard for both PC and Macintosh formats.

MULTIMEDIA: The fusion of audio, video, graphics, and text in an interactive system.

N

NON-LINEAR: Refers to stories, songs. or films, the sections of which can be viewed or heard in varying order, or which can have various endings depending on what has preceded.

O

ONLINE SERVICE PROVIDER: An OSP is a company that provides access to the Internet through its own special user interface and propietary services.

P

PALETTE DETERIORATION: Refers to the degradation of colors in the system color palette when graphics are over optimized for Web implementation.

PALETTE FLASHING: When color pixels do not align correctly, such as in a GIF89a animation.

PLUG-INS: Plug-in applications are programs that can easily be installed and used as part of Web browsers.

R

REPURPOSE: To adapt content from one medium for use in another, i.e., revising printed material into a CD-ROM.

RESOLUTION: Measurement of image sharpness and clarity on a monitor.

RGB: (Red, Green, Blue) A type of display format used with computers. All colors displayed on a computer monitor are made up of red, green, and blue pixels.

ROLLOVER: The act of rolling the cursor over a given element on the screen, resulting in another element being displayed or a new action beginning.

S

SEARCH ENGINE: A software program that allows a user to search databases by entering in keywords.

SHOCKWAVE: The Macromedia add-on that allows users to create compressed Web animations from Director files.

SITE: A WWW location consisting of interlinked pages devoted to a specific topic.

SPLASH PAGE: An opening page used to present general information for the viewer, such as plug-ins or browser requirements.

STREAMING AUDIO: Sound that is played as it loads into the browser.

STREAMING VIDEO: Video that plays as it loads into a browser.

T

T1 AND T3: High-speed digital channels often used to connect Internet Service Providers. A T1 runs at 1.544 megabits per second, A T3 line runs at 44.736 megabits per second.

THROUGHPUT: The rate of data transmission at a given point, related to bandwidth.

TRANSFER RATE: The rate at which a CD-ROM drive can transfer information.

TRANSPARENT GIF: A GIF image with a color that has been made to disappear into or blend into the background of a Web page.

U

URL: (Universal Resource Locator) Standard method of identifying users or machines on the Internet. May be either alphanumeric or numeric.

V

VIDEO CONFERENCING: Using online video to connect with one or more people for communicating over long distances.

VRML (VIRTUAL REALITY MARKUP LANGUAGE): The coding language used to create simulated 3D environments online.

W

WWW (World Wide Web): graphical Internet interface capable of supporting graphics within text, sound, animation and movies, as well as hypertext linking from site to site.

THE CD-ROM

ABOUT THE CUTTING EDGE CD-ROM

The *Cutting Edge* CD-ROM is an interactive resource showcasing the Website projects presented in the *Cutting Edge* book.

BEFORE OPENING THE *CUTTING EDGE* CD-ROM

1. Be sure to turn off virtual memory. Set your monitor's color depth to 8-bit (256 colors). The *Cutting Edge* CD-ROM will not run properly otherwise.

2. The *Cutting Edge* CD-ROM features links to each of the Website URLs featured in the *The Cutting Edge* book, as well as more than two hundred additional cutting edge URLs.

To connect directly from the *Cutting Edge* CD-ROM follow the "Linking to the Web" instructions below.

TO PLAY THE *CUTTING EDGE* CD-ROM:

MacOS:

1. Open the *Cutting Edge* folder on the CD-ROM. Double-click the *Cutting Edge* icon and have fun. The "Help" button located on each screen will show you how to navigate the interface.

2. For more Web design software links, check out the "Web Guide" section on page 152 or open the *Cutting Edge* CD-ROM and check out the Websites area for more cutting edge URLs.

Windows:

1. Choose "RUN" from the File menu. Type: (the letter of your CD drive) i.e. D:\CUTEDGE.EXE and then click "OK." The "Help" button located on each screen will show you how to navigate the interface.

2. For more Web design software links, check out the "Web Guide" section on page 154 or open the *Cutting Edge* CD-ROM and check out the Websites area for more cutting edge URLs.

LINKING TO THE WEB:

1. To connect to the *Cutting Edge* CD-ROM Websites you need an internet connection through an Internet Service Provider. To connect to the Web from the CD-ROM open your Internet connection by starting up your browser the same as if you were going on the Web.

2. Once you are connected to your provider, open the *Cutting Edge* CD-ROM and choose the Web project you would like to enter.

4. If you would like to have access to all of the Websites at once, open the *Cutting Edge* home page" file in the main folder of the CD-ROM.

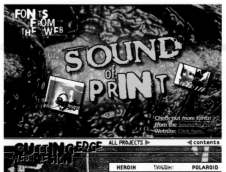

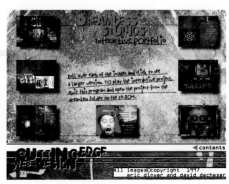